Bittersweet-Full Circles

Frances Riviere

◆ FriesenPress

Suite 300 - 990 Fort St
Victoria, BC, V8V 3K2
Canada

www.friesenpress.com

Copyright © 2016 by Frances Riviere
First Edition — 2016

Interior divider photo by Edith Evans

All rights reserved.

No part of this publication may be reproduced in any form, or by any means, electronic or mechanical, including photocopying, recording, or any information browsing, storage, or retrieval system, without permission in writing from FriesenPress.

ISBN
978-1-4602-9036-1 (Hardcover)
978-1-4602-9037-8 (Paperback)
978-1-4602-9038-5 (eBook)

1. BIOGRAPHY & AUTOBIOGRAPHY, PERSONAL MEMOIRS

Distributed to the trade by The Ingram Book Company

Table of Contents

Acknowledgements — v

Dedication — vii

Part One

The Neurology Ward — 1

Warning Signs Ignored — 13

Forging Ahead — 31

Impending Disaster — 51

Life Goes On — 71

Part Two

Spiders In My Bathtub — 87

Back To My Roots And Three Full Circles — 107

A Willmore Wilderness Odyssey — 119

Camp In Recovery — 145

Wrecks On The Trail, Closer To Home — 167

From The Prairies To The Australian Outback — 179

A Man And His Boat — 217

Closure Denied — 229

The Last Loop — 235

Acknowledgements

My deepest appreciation to the many readers of my first book Washing at the Creek and my many friends for their belief in me. They encouraged me to write my second memoir to complete the story of my eventful, sometimes sad and very often rewarding life.

Thanks also to FriesenPress for undertaking to publish this book; for their encouragement and patience in dealing with me on my first self-publishing adventure. Thanks to their editor who gave me such an encouraging evaluation and helped me to make the very necessary revisions and Astra Crompton my Author Account Manager for her excellent guidance and patience. I have enjoyed the process and learned a great deal about the publishing world from the people at FriesenPress.

Dedication

To my good friends who continued to enquire as to my progress while I wrote this book. Their encouragement and faith in me kept me writing through the difficult pages of my life.

To those whose lives have been touched by mental illness and disease: With you, I share my dreams, hopes, and experience.

PART ONE

The Neurology Ward

At the General Hospital in Calgary, Alberta, in March of 1968, there were, behind a pair of swinging doors, frightening happenings. Above the doors was a sign: neurosurgery. From the hall leading up to the ward entry there was no indication of the hell that lay behind those thick soundproof doors.

This was my first experience with illness of this magnitude. With overwhelming dread, I entered that door every morning for three weeks and stayed there all day. I rotated between visiting my husband of ten years there and caring for our four young children at home on the ranch near Pincher Creek, Alberta. My brother-in-law and his wife cared for our three school-age children, while my sister-in-law and her husband took our youngest daughter, so I could make those taxing trips to Calgary. I was miserable without my children and the farm. I'd spent most of the last ten years in my home. I had to be strong for all of us.

Behind those doors I faced the agonizing laments of neurosurgery gone wrong and brains damaged beyond repair. It all

manifested in noises—ghoulish sounds, shrieking and groaning that came from only a few, but permeated the very nature of the ward. These were not all sounds of pain; some were from those unfortunates that "knew not what they were doing," as the nurses assured me.

Among those unfortunates was my thirty-seven-year-old husband, Ed Bruder. He lay on a bed, sides drawn to restrain him, feeding tubes protruding from his nose, one to empty his bladder and one into his wrist to sedate him. Restraints fastened him to the bed and controlled his erratic movements.

This was the handsome young rancher I married ten years prior—the man on whom I placed my hopes for a happy married life, and with whom I brought four babies into the world.

In my Métis home on Drywood Creek, in the extreme corner of southern Alberta, my family treated minor injuries with herbs and painkillers provided by nature. My mother, who was not Métis, was educated in the healing ways of nature by my grandmother, Nelly Gladstone. Only a very serious life-threatening illness brought out the team of horses and a buggy or sleigh for a trip to the doctor in Pincher Creek.

When I dropped an iron mower wheel, which I had my horse picketed to, on my foot, I sat with that foot in a pail of cold water for the better part of a week. The fractured bone healed on its own, in time.

My cousin Floyd, while still a small child, was transported in that fashion to the doctor in Pincher Creek. These were the hazards of life in the bush in the cold and deep snow of winter. The thirty miles to town was covered in record time, thanks to my Uncle James' well-fed team of horses. Floyd had a ruptured appendix, which brought him near death. After the surgery, he

was confined to the hospital for days, while his small body was rid of the poison that'd had time to spread. We heard that story told by my uncle many times over the years. He had literally saved his son's life.

Now, fear for my children and my husband spurred me on with an adrenaline rush that commenced when I pushed those doors open and lasted until I left late at night. The locked doors in that ward spooked me. Why were they treating the patients like criminals? A ward like this was totally foreign to me. Lack of experience made everything in this unfortunate situation terrifying.

A nurse periodically dumped a concoction of medications into a funnel inserted into the feeding tube, rinsed the funnel with a cup of water, and dumped that down too. At meal time, they came in with liquid food and disposed of it in the same manner. What disgusted me the most was the way they sloshed water around in the container and dumped the contents down, I thought, to clean the container. My husband didn't seem to acknowledge the feeding, but every time they touched him he protested with angry objections—uncontrollable noises with no relationship to language.

"Is he in pain?" I asked.

"No," they replied. "He doesn't know what he's doing, poor soul."

I didn't believe them. How could such screams of agony not be caused by pain? I was exhausted. I sat by his bed, rested my head beside him, and caught naps while he was sedated sufficiently to put him to sleep. Then, late at night, I motored to my sister's place for a few hours of uneasy sleep.

I befriended a young man and his wife, who I met in the waiting room, where I went to read and try to come to terms with

what was happening to us. Over a few days I got to know them well enough to ask what they were doing there.

"They are testing my husband," the lady said. "They think he might have a brain tumour." A few days later she said, "We have decided to operate." She seemed so optimistic. I sat with her in the waiting room while they wheeled away what seemed to be a healthy man. We hugged him and wished him well, and his wife cried.

A few days later, I saw him in a bed, and I wanted to know how he had fared. Then I saw the nurses get him out of bed and put him in a high-backed wheelchair with a head support. His hands hung limp, and when I spoke to him there was no recognition in his blank eyes. I looked at the nurse and she shook her head sadly. His wife said that he would never be the same. They had small children, too. Since that was what they were telling me about Ed—that he would never be the same—the young woman and I felt a common bond and wondered what the future held in store for both of us.

Two weeks previous, in the Pincher Creek hospital, the doctors, baffled for years over his strange symptoms, referred him to Calgary. We made a bed in the back of his sister's car, and took him there and into the Intensive Care Unit, where the best doctors in Calgary tried to diagnose him. I was sure that he was dying. I sat by his bed for hours at a time. I knew that I could not cope with life as it formerly had been. I wanted this affliction to go away so we could all be back in our home again. Not only had enough time passed that I knew I couldn't fix him, but it was slowly sinking in that no one else could either.

This was when and where the intravenous procedures and stomach tube feeding began. I conferred with the doctors to the

point of pestering them. They told me that while his body was otherwise healthy, something was going on in his brain that they didn't understand. A specialist brain surgeon, Dr. R, was trying to diagnose him. He was not likely to die, they told me, but I didn't believe them. He remained in Intensive Care for two weeks.

One morning they drilled holes in his skull and put dye into his brain, so that the x-rays would reveal a tumour if there was one. Back in his bed he didn't seem to even acknowledge the procedure. He'd been prone to headaches for years. They put cold packs on his head to fight the fever. Other specialists joined the team. They opened his eyes and peered in. They were rolled back into his head. I thought that every illness had a cause. Their puzzled expressions gave me some hope. Surely they wouldn't give up. They must not!

My experience with illness of this magnitude was so limited; I thought these specialists would soon have a cure, and we could soon go home. But they didn't seem to have answers to my questions and I grew impatient and doubtful. Even so, the doctors and staff treated me with kindness. His vital signs were good. The problem was in his head, as so many family doctors had informed him over the last ten years of our marriage—in fact, for most of his life. It was indeed in his head, and it appeared that the part of his brain that controlled mobility and speech were becoming increasingly damaged. There was no brain tumour, however.

Ed was diagnosed with Bright's disease when he was a child. Nowadays, that condition is called nephritis or kidney disease. The symptoms that he suffered from were not unlike what he experienced since the time he was a child. Was that his problem? The doctors didn't have the useful information from his childhood. No one thought it of great enough importance to inform

me. They continued to test him for other things, even though they must have known that some kinds of kidney disease, when left unchecked for many years, could have lasting effects. Use of ultrasound to scan the kidneys for troubles was not in practice in 1968. And so the option of kidney disease was ignored, because I lacked the family history necessary to bring it to the attention of the medical world. I thought it was misdiagnosed. The matter was dismissed and Ed fell through the cracks. There was no mention of kidney disease.

What, then, caused the sick spells that kept him out of school and impeded the possibility of him attaining an education past the primary years? "I wanted to run through the puddles in my bare feet like other kids," he told me when I questioned him about his protected childhood.

Between consultations with the doctors, I befriended the nurses and those who came in regularly to see their own people. I tried to cope by dwelling on the good times, like the winter morning on the farm when Ed would pull up to the house with his big team of Belgian horses, of which he was so proud. I'd have all the kids dressed in their warm winter clothing. We'd snuggle down between small bales of hay, sheltered from the wind, and I'd drive while he fed the cattle. Often he took the kids alone, and I caught up on household chores. Or later on, when he had a small bob-sleigh outfitted for a single horse, we scooted around the countryside to visit the neighbours. There were many happy times like these on the farm. I relived them over and over in my mind and longed for their return. How could a man of his ability transform into what lay in that hospital bed now?

At meal time I went to the cafeteria in the basement; the staff there were kind and visited with me while we ate. They knew a lot

about what was happening all over the hospital. It was a welcome break from my constant bedside worries. Upstairs in Intensive Care there were gunshot wounds, broken bodies from accidents, and little children in all stages of barely living and dying. They wheeled them in and out, sometimes with blankets drawn over their faces. There was a man with breathing and feeding tubes. I asked him what happened to him. He said a jealous husband shot him in the mouth. If he was handsome before, it was hard to tell now. Because of him, there was a policeman stationed at the door.

When Ed came out of his sedation, he was horribly agitated and noisy. A man a few beds over kept yelling, "Shut up!" The nurses came running and sedated him again and he went back into an unnatural sleep . . . until it wore off.

While there, I witnessed a small boy of about four years old going through what they said was a brain fever. They removed all except his diaper, and put him in a padded playpen where he thrashed about like a little animal. That was the most pitiful experience I saw in that hospital. The following morning, when I came back, he was covered up asleep in the pen. I was never to know what became of him or what had caused the fever.

After the uneasy evening at my sister's, I drove the same familiar route down Memorial Drive. I was inexperienced at driving in a city. I knew only the route to her place in the southwest and to the hospital. I stayed with them for most of the month of February, through the acute stages of Ed's illness. I went home on the weekends and took my children to our house, where life was somewhat normal. I was smoking heavily then, eating very little, and fast becoming a serious prescription pill addict. I needed

pills to put me to sleep for those few hours, and more in the morning to give me energy for the day.

In the ten short years that seemed a lifetime, the high hopes of youth with which I started my journey into married life were dashed for all time. I was uncertain of everything that the future held for us. I knew only that it was all up to me to raise our family from this point on. I felt guilty for having brought four helpless children into this world and this situation, when the warning signs were there to guide me. That guilt would influence many of my decisions over the years.

Much of the responsibility had already fallen on my shoulders when Ed was sick at home. I had no choice but to get on with the task ahead of me. I needed much more help than I was willing to ask for—especially from my parents, who were not in favour of our marriage in the first place. Ed's family came forward to help with the kids, and I could not have managed without them.

I remembered those last days at home when I phoned his sister every day. I stopped short of sharing my true feelings about his illness. I treated it as if it was a relationship problem. I kept our most serious problems behind closed doors.

After all the tests, Ed was diagnosed with lead poisoning, probably caused by pollution from the two gas plants near where we lived. The gas companies tested the water, found lead, and declared the samples contaminated by the glass bottles they were collected in. I didn't have the resources or strength to fight the two strong companies west and east of our home. Winning a battle with them would not bring Ed's health back. In addition, he had been sick even as a child, long before gas was discovered in our country. I was busy testing the kids for lead, caring for

them, and running our ranch while troubled with Ed's illness; I simply did not have the strength to go to court.

Then Dr. R changed Ed's diagnosis to Intermittent Porphyria. He did a urine phobilinogen test on him. He said he found evidence of that very rare disease of the nervous system. He said that the symptoms of that disease were: intense abdominal pain, numbness and tingling in the extremities, weakness and psychiatric disorders. All this could be followed by a period of normalcy, until it happened again. According to him, the disease was hereditary with a fifty-fifty chance of passing it on.

There followed a regime of intensive testing of the children for this disease. Now my worries were for the kids also. The big question was: Would we be dogged by this disease for years to come? It was a frightening prospect. Being intermittent, it could show up or not at any given time. It could be controlled if caught soon enough. They gave me a list of all the drugs and treatments to be avoided. Ed had repeatedly been subjected to most of them over the years, in addition to shock therapy.

My worries were compounded as I came to terms with this state of limbo in which this disease was causing us to live. I clung to the hope that some miracle would restore Ed's health. Meanwhile, they moved him on to the psychiatric ward, and we began rehabilitation, which didn't make any difference. Attempts at speech therapy failed. He didn't understand what they were trying to do. He responded by flailing his arms around and making annoyed noises. Nothing I showed him concerning his former life bought recognition. I took him pictures of the kids. He looked at them but they failed to bring a smile to his face. He seemed to have his muscles tied in knots. They put warm, wet pads on his legs to relax them, and he screamed as if in pain

and pushed them off. They stopped his trips to the rehabilitation room. One more of my hopes fell flat.

After a few weeks of this, and many dashed hopes, they told me that he would never walk again on his own. Thoughts of taking him to Rochester, New York entered my mind. I sought the advice of his doctor. He said, "Save your money. He may relearn a few things, but the damage is permanent. That might have been a very good plan a very long time ago." So I prayed for a miracle, but no luck there either. He was now bound for a nursing home where he would get minimal therapy and the best care possible.

Now there was nothing I could do except regularly bring my children from home to the Sarcee Nursing Facility. I thought it was important that they not forget their father. These were harrowing trips from which no one benefited. Ed was now so changed. He was angry when we couldn't decipher his garbled speech. His movements were erratic. He was in a wheelchair, and had to be fed. So much changed that even I did not recognize him as his former self. The kids stared at him and wondered in their young minds if that was even the dad that had been so capable such a short time ago. I tried to explain what had happened, but I hardly knew myself. Where was the able-bodied cowboy I'd married, the man who could train a horse like no other, the one who was a perfect husband when he was feeling well?

I was left to worry constantly as to whether one or all of my children were destined for life in a wheelchair. With no insurance to cover the costs of the nursing home and with Ed's personal requirements and frequent travel to Calgary, I was now faced with an additional financial burden.

I remembered with regret the day our insurance company offered us a policy in which some farmers were investing; it covered disability for the head of farm families and was highly recommended. Most farmers we knew were taking it. I tried to make Ed see its value. He refused on the grounds that we were paying too many premiums now and realizing no return for our money. "It will never pay off," he said. "This is just another money grab."

Ed wasn't so much a cheap person as he was afraid of risk. It was the part of his sickness that made him so insecure. He was overly careful, not only with money. I used to tease him about that—when he was in a good mood. I called him "Careful Ed." He didn't like that. There would be trouble between Ed and me when I seriously took the part of my children in teenage life. How would he react to their raging hormones? My own experiences were still fresh in my mind. Over the last ten years I had become very protective toward them. Somehow I knew that we could not go on this way. Ed's acute attack came as no surprise to me; when the head of steam can no longer be contained, something has to give.

I accepted now that he would never fully recover. It was all up to me. I had no idea how to go about it, but I would find a way. I'd fought my way through childhood and on to get an education, and had married against my better judgment, but this was my biggest fight yet.

In addition to pondering my next move, I found myself reflecting more often on how this had all come about.

Warning Signs Ignored

In the spring of 1956, I graduated from the University in Calgary, with a Junior "E" certificate in education. I could now teach elementary grades one to nine. I was young, strong, and ambitious. I didn't recognize the insecurity that followed me from childhood. I'd lived a very carefree life as a Métis member in a family of four children. I'd sensed the struggle of my parents to feed and clothe us but never gave it a moment's thought. We were shielded from the cares of the world by isolation. From a very early age, I remembered my dad planting an idea in my head: I was to make money in order to rise above the poverty that dogged our everyday lives, and making him proud of me became my ambition early in life.

As a teenager, I fought a constant war with my parents for the freedom that they denied. Being the eldest daughter of a possessive father and a mother who was under his influence, I paved the way for the younger girls. With the mellowing that comes with age and experience, my parents became more lenient with

them. With me they laid down the law and expected no objection. "Why," I asked repeatedly." Because I said so!" was always the reply. That attitude was not reserved for my parents alone. It was more a sign of the times. The adults didn't question the doctor's opinion. To the school-aged child, the teacher knew all and had ultimate wisdom. Nothing was questioned.

In 1956, there were more girls dreaming of romance and the security of a happily married life than a fulfilling career. I wanted to do better; I would do whatever it took to become a teacher, even though the odds of doing so were insurmountable in our cash-strapped family.

My parents had high expectations for me and none of them included marrying young. My mother had a high school education. When it became apparent that my education would end at grade nine—we lived in the bush, and it was before the advent of school buses—my mother enrolled me in correspondence school with lessons coming from the Department of Education in Edmonton, Alberta.

I loved it. At least I could work at my own speed and be in control of something in my life. We were living in a small house in the Drywood District. We called it the White House because of the peeling white paint that covered it. My dad had squatted there for the winter. The roads back there were the last ones to see a snowplow. I found a corner in the lone crowded bedroom and spent as much time there as I could. I easily passed that grade, but I longed for the sociability of school life.

The next winter, in grade eleven, I spent the cold winter months in the Catholic Convent in Pincher Creek. Even that was better than being without people my own age. Again I loved to learn, and my marks reflected it. I may have not gotten

an education if it were not for my mother's insistence. My dad showed no interest in the process.

In our home, growing up was not discussed in any meaningful way. As we grew stronger with age, our dad recognized our growing usefulness and put my brother and me to work. My mother was too embarrassed by my changing body to do any more than skim over the necessary facts, in as few words as possible, and handed me a small booklet with limited information. I went to my best friend Joan Whyte to fill in the blanks, and I shut the door between my mother and all intimate subjects forever.

Joan lived with her progressive family in the Drywood District. Her mother was outspoken and truthful in managing her daughters' sex education. As we rode our horses around the country, Joan—four years my elder—acquainted me with the facts of life. At fifteen I was still not allowed boyfriends at home, so we invited them to Joan's house and we increased my sleepovers for the purpose of deceiving my parents. Finally, my mother found out about our secret rendezvous and forbade my visits to my friend's house. Her parents were hurt; they were not privy to our teenage schemes. Throughout my teen years, my mother played the detective and my father the enforcer, as they attempted to rein me in.

"We will control you as long as we can and then kick you out," my mother threatened.

"I'll be out of here before you get that chance," I retaliated.

After university, I was free and would be the one to decide where my life was going—and that included my choice of a life partner. I would simply pick a future husband, set my mind on marrying him, and take whatever measures necessary to reach

my goal. I had used that tactic in getting what I wanted throughout my teenage years and it had often worked.

I was unprepared for life on my own, having never been given the right to make choices and experience consequences. I wanted to leave the poverty and insecurity of my childhood as far behind as possible. I didn't want to be a half-breed any longer. I would leave my formerly carefree childhood and subsequent miserable teenage life behind, and would become a better person.

Throughout my childhood, my dad had been the main mentor and educator in my life. He taught me to handle, drive, and ride the many horses that passed through our hands. To all children he was a hero and best friend, but he did not know how to let go and release me into the teenage world. He tried to tighten his hold on me, but I revolted, and I was determined to get out of the rut in which I was born. I had no choice in the circumstances of my birth, but I did have a choice in shaping my life from here on out. Looking back, I see how wrong I was to withdraw from my dad and my roots. It would take a long time to reclaim them.

While still in university, I began to set my hopes on a young rancher that I thought might hold my happiness in his hands. He lived on a big ranch, had a solid religious background and a respected, extended family. Soon I had his attention. I started to ride his horses on weekends home and got to know his family.

When my dad lost control over me, he seemed to give up. I no longer had to fear him, but I did. After years of having him beat up on my boyfriends and refusing to let me grow up like a normal child, I was very afraid of him. At seventeen it resulted in my running away from home, widening the gap between my parents and me. I approached my dad to discuss the reasons for our conflicts, but he refused. There had never been any dialogue

on growing up between my parents and me, except in anger. Now, with the freedom of choice, I gave up on my first love affair, which started when I was thirteen. I was ambitious; I wanted more than my childhood sweetheart could offer. Most of all, I wanted security. Until now there had been precious little of that in my life.

At first, I was very afraid to bring my rancher boyfriend home, even at eighteen, but I soon realized that my dad really didn't care anymore. Still, when I was out alone with Ed, I was always expecting my dad to appear out of nowhere, and attack as he had my other boyfriends. I just couldn't get over what I had experienced in my childhood.

I often went with Ed to his parental home and stayed overnight. They were good to me, and I had a nice, clean, wonderful room to sleep in for the first time in my life. I loved his parents and wanted what he had. He had a family that seemed to be all that I ever desired. They had the security that I wanted. *I must not let this one get away*, I thought.

Once I started to keep company with Ed, I didn't go back to my parent's place very often. I was totally taken in with the other family. Most things at their place were new and exciting. They were farmers, and I wanted to do all the things that farmers did. I had no idea what that entailed.

Ed owned wonderful horses, and I got to ride them. He and I learned together how to ride jumping horses. I jumped horses and barrel-raced them at the Pincher Creek Light Horse Show. With two horses we won one-fifth of the money that the Agricultural Society put up for prizes. I got the trophy for high point, and we packed home more ribbons than I could ever

dream of in my former life. This was a bonanza to me. I refused to consider any path except the one I was now on.

I was in love with those well-bred horses and the cowboy who owned and trained them. He was handsome, had thick black wavy hair, and was short in stature, but strong like young farm men tend to be. My heart was set on becoming his wife. In this situation, I would have little need for a long teaching career—or so I thought.

However, warning signs soon started showing up all over the place, but I chose to ignore them. During the winter, while I was going to university, I became aware that Ed had a nervous condition. He'd been sick much of his childhood, and because of that he could not go to school. *So what?* I thought. *I do have an education. I'll take care of the business.* I was totally ignorant of what that meant. I chose to ignore anything that stood as a deterrent to my plans for the future. I wasn't going to let anything stand in way of my quest for love and security.

Ed was coming to Calgary and entering the psychiatric ward at the General Hospital periodically. He was on a lot of strong tranquilizing drugs and taking shock treatments. That should have been warning enough, but I thought the treatments would cure him. All I had to do was believe. I went to the hospital while he was there, and I saw all the people in that ward that were suffering with mental illness. I didn't take it seriously. Ed found them amusing. He wasn't one of them. He couldn't be. He just had a little problem with his nerves, and he would come out cured. I waited while they wheeled him into a separate room and shut the door. I knew nothing of shock treatments.

He stayed in Calgary and returned every day for about a week. They had entertainment there too. A big orderly played

the piano, and we danced to the music. We thought he was great until he made romantic advances toward Ed. I didn't know about gay people, but I soon understood his attraction to the men. He was there to change his mind too.

I wanted to know what they were doing to Ed behind that closed door, so I went with him into the treatment room, watched them fasten the wires to his head, and left when they told me to. I was totally unaware of the dramatic results when the electricity was turned on. After considerable time he emerged on a stretcher and was left in the hallway to slowly come around, while they wheeled another patient into that room.

Sometimes they gave him insulin shock in place of electricity. When he came out, they fed him cookies and fruit to bring him around. He and the other patients were expected to have their brains wiped clean of their unhealthy thoughts, and readied for healthy ones to take their place. When it didn't work, they returned for more of the same.

There was a psychiatrist, Dr. G, who made his rounds, and determined after conferring with the doctors and the patients whether the treatments were successful or not. Old Dr. G, it turned, out was a courtroom psychiatrist, one of those who decided whether a murderer was mentally ill or capable to stand trial. We actually thought, in our ignorance, that this made him an expert in his field. We had a conference with him in which I asked, "Would marriage be good for Ed?" He said, "Yes." We didn't ask him about his future wife and children, and he didn't offer any advice. All of my concern was for Ed and none for me. At that point children didn't enter the picture.

I actually thought the treatments were beneficial. But that did not happen. During that winter, he came back for several shock

treatment sessions. I thought that the doctors knew exactly what they were doing, and that they were curing him. I even went out on the walks with the patients down in east Calgary. They were taken for exercise and fresh air, with an orderly in front and one behind. The air down around the zoo and brewery where the General Hospital was located was anything but fresh in 1955; the smog lies thick in the wintertime. Years later, when I was much wiser, I saw *One Flew Over the Cuckoo's Nest*. It reminded me of that experience. How naïve I was.

We got engaged over Christmas 1956. The ring, with its small, conservative diamonds, was like a new toy. I went to midnight mass with my future in-laws. I was proud of Ed; he was so handsome and appeared so normal, in spite of what I'd seen in the General Hospital. I was in love with him. We planned to be married the next summer. I chose to turn a blind eye to all the warning signs that came my way, and forged on with my plans for that day. Being married to me would make everything right. I was strong and willful. I'd take care of everything.

Still, there were many warning signs. When I was a teacher at Summerview School, I purchased a set of *Encyclopedia Britannica* with a nice coffee table. I had my own money now, and I could buy it if I wanted. It was my first experience with a salesperson and my first purchase of this magnitude. I was proud of it.

When Ed came to pick me up, where I was boarding at Gifford's by the Summerview School, I told him about my purchase and how proud I was of my deal. He was furious! But it wasn't his money, and I wasn't married to him yet. It was devastating for me. I did not understand. Then and there, I began to

fear him in much the same way I had feared my dad. But he got over it, just as my dad did.

Other warnings began to pop up too. He was very jealous. I thought it was only because he loved me so much. What a foolish thing to think. But I was inexperienced in any of these matters. I made myself ignore the warnings and forged on with my plans to marry this man that I loved so much.

The next thing I noticed was his bad mood whenever we were doing anything on the ranch. When we were chasing cows, everything that happened was my fault. It was as if I didn't know anything about riding or chasing cattle, but I knew that I did from the experience I gained riding with my dad on the Forestry, which already seemed to be a lifetime ago. Soon after we started on the job, he would get angry and refuse to give me a reason for his mood. I cried in anger and frustration. He sulked until the job was done, and then dismissed the whole episode as if it had never happened. I chose to bask in the many good times as the bad memories accumulated and threatened to explode. Why did I let him abuse me in this way? Probably because the scales were always tipped to the positive side. Good times always followed bad.

I began to help him on the ranch doing chores that were strange to me. I thought it was fun, but I could never please him, in the same way that I failed to please my dad. It was my job to drive the tractor and pull him on the machine that spit out bundles of grain on the stock, all tied neatly with binder twine. I couldn't do that right, either. It would have been different if he had just corrected me, but his dark spells were disturbing. Still, it was not enough to make me see what was happening. To cope, I constantly told myself, "This too will pass."

Instead of heeding the warning signs, I thought of a way to get even. I pulled the binder over a big rock on purpose. The machine rattled, fit to fall apart. Ed grabbed onto a piece of the binder, and I drove on. *There*, I thought, *Now you have something to get angry about*. I stopped short of telling him that I did it on purpose.

I began to get very nervous every time he was upset. As with my dad, good treatment always followed the mental abuse, but I had no name for this treatment at the time. Crying when I was a child angered my dad. "Shut up, or I'll give you something to cry about," he'd say. So I learned to cry alone. I thought that crying now would get me some sympathy from Ed. It didn't work, but it relieved the pressure that threatened to spill out of me.

Me, at age twenty, at my parent's rented house on Indian St. in Pincher Creek, Alberta, 1956.

Ed trained his horses to win in competition. I was to ride them to that end or it was my fault. Because they were such good horses, I was usually able to accomplish that. This was a repeat of what I had gone through with my father, and I did not see it. He was controlling my every activity. Soon we would be married, and things would change for the better or so I thought.

Ed and I were married on July 6, 1957. I went to the church with my soon-to-be brother in-law, Vince. As we were driving up a back alley to the church, he said, "You can still back out, you know." I felt a strong urge to turn and run. I thought about all my family and Ed's, waiting for us at the church. I couldn't let them down now. I had to go through with what I planned.

The lovely roses in the church may as well have been red flags. It was too late to go back now. All these people seemed to depend on me, and I felt that I could not disappoint them. I thought these foreboding feelings were just pre-marriage jitters.

At that time, there were no sessions with the priest before marriage as there are now. After the gruelling ordeal in the Catholic Church, we had a modest reception in the Old Catholic Parish Hall with both families present. I made sure that we rushed off on our honeymoon before my dad had time to get drunk on the dinner wine. I didn't care what happened after that, and I was never to know, because I didn't ask.

As we drove away in Ed's 1952 Chevy truck with the homemade camper, I once more felt the urge to run from this situation of my own making. However, it was too late now, and I would do the very best I could to make my marriage a success. I wanted to prove myself to his family and to show my family how successful I could be as a wife. I'd show all those people that looked down on us Métis what a half-breed could do married to one of their own.

My dad, Bob Riviere, just before my wedding on July 6, 1957.

We had a wonderful honeymoon in Yellowstone National Park in the United States of America. It was the first time that I'd been farther away from Pincher Creek, other than the small city of Lethbridge and Calgary, where I went to university. Now in a relaxed mood, and away from the cares of farming, Ed was the person with whom I wanted to share my life. It was as if he were two people—this one and the one that acted as if he could not handle responsibility. The former was the one I loved, and the latter was the one I grew to fear. For the time being, I accepted the marriage and being a part of his family. I felt secure and where I most wanted to be. I convinced myself that I'd made the right decision.

With Ed's nieces and nephews at our wedding reception in the old Catholic Hall in Pincher Creek. Kids simply loved Ed.

When the honeymoon was over, we returned to the little house in the yard where his parents lived. They had what we called "the big house" because of its size in comparison to our three-room tiny grey siding one. As we grew nearer, I became more excited about the pile of shower presents we left in a heap on the combination kitchen and living room floor. I couldn't wait to own the things that I grew up without in our humble shack. Ed became quiet and moody, not at all sharing in my enthusiasm for this adventure into marriage that I had planned, mostly by myself. It was late when we arrived and little was said before we retired.

During our first day in our new home, we awoke to the long rays of the summer sun peeping shyly over the hill behind the big log

barn and stucco house, transforming one side of the shadowy buildings to a hot-burnt red. A few minutes later, it reached the walls of our little nondescript house, outhouse, and a weathered snow-fenced yard, which seemed to cower humbly downhill from the big house as if it accepted its lesser importance in the hierarchy of life on the ranch.

Finally, the sun lit up the outbuildings, chicken house, and long shake-roofed pig house to the west. There several sows and piglets rooted industrially in the fertile soil, which herds of sheep had enriched over the years. It was like the first day of my life. I had such high hopes.

The time was drawing near for someone younger, a son, to move into my father-in-law's shoes. It was done that way in those old established farming and ranching communities. Growing up on a farm is a learning experience, and usually provides all the preparation required for succession, but that was not a given in all cases. Ed was the youngest son. Taking over the farm was expected of him, and no one asked whether that was what he wanted. The responsibility weighed heavy on him.

In the small house, I viewed my humble surroundings: a small wooden table and chairs, second-hand couch, and an array of articles such as dishes, bedding, and appliances. It was all from a very successful community shower, which was based on my husband's extended family's influence in the district. This was a bonanza, all of which I treated like a box of new toys, the likes of which I never had as a child. At the shower, I was so overcome with emotion that I didn't even thank all those good people. My social skills were that limited.

Now I sat dumbstruck in the new housecoat that I purchased for my honeymoon, along with other skimpy bedtime attire

designed to impress my new husband—all of which were a dismal failure. When he finished the chores and came in for breakfast, I was still in my housecoat. The breakfast I had prepared for him was not what I would have liked it to be. I didn't know how to cook anything. He had cooked on our honeymoon. I had followed my dad around chasing horses until I was seventeen years old and never learned to cook or do housework.

I expected the same treatment and attention I got on our honeymoon, but was in for a rude awakening. "Get dressed!" Ed demanded. "The honeymoon is over.

This was not at all like the romance novels I read while growing up. There were problems in those books, but they always had happy ending. I was hurt and I sensed trouble. Why had things changed so much overnight? I put on my clothes and resigned myself to learn how to cook.

For the most part, I grew up in a shack and in a succession of empty houses in southwestern Alberta, where my Métis father moved according to his wandering, squatter whims, dragging his wife and five children along with him. I was born in 1936, and saw the last years of the Great Depression—a depression that never ended for my family. Moving about the country from place to place, where my father found seasonal work, was not a complicated affair. We owned very little, other than a herd of horses, several dogs, and sparse personal effects, most of which could be transported by saddle or pack horse.

At that time, the old houses deserted by the early settlers and scattered around that farming country of southern Alberta had some old bed frames and cupboards. They were left behind when a settler left for greener pastures, succumbed to some unseen fate,

or was lucky enough to prosper and retire to town. Whatever the previous occupant's situation, my father and mother gathered up the spoils of others and made use of them for as long as we occupied that house. When we again moved on, usually a few of our own belongings stayed behind. Life was simple and I thought it would always be that way.

I taught at Marr School for the 1957–58 term. I often walked to school, stopping at the spring to pick up water for drinking and hand washing.

I believed that being a half-breed was a state to overcome and rise above. As I grew up, I associated my childhood with poverty and hopelessness. When I experienced the satisfaction of sitting at the head of a class of adoring pupils and collecting a pay cheque, it was not the thrill that I imagined it to be. I needed more out of life. I needed to plunge myself into something that would challenge my energy and fill this overpowering feeling of inadequacy that dogged my life thus far, leaving me feeling hollow and unfulfilled.

Was marriage the answer? Surely not a marriage like that of my parents. But there were others, like the ones I saw at the church I attended with my in-laws and husband. St. Henry's was perched on a hill in the Yarrow District, a place of worship for most of the country. The people there were friendly, yet I felt that most of them were a rung higher than I on the ladder of life.

In spite of my feelings of inferiority, I would execute the model marriage, correcting all the mistakes I saw in my childhood; my marriage would be a completely new ball game where I was in control. I was in such a hurry to get started in this new life, so full of promise that I failed to see beyond the marriage ceremony and honeymoon.

Now faced with the reality of what I had done, I was not at all sure that this was right for me. I had brushed aside the red flags that had warned, "Wait a moment and think about this. What is this strange feeling that you have that all is not well?" What of my dad's warning that angered me and gave him no credibility? "Don't marry him," my dad had warned, "there's something wrong with him; his head is too big."

Crazy, ignorant old man! I thought, *Always trying to ruin my life!*

"All Germans have big heads," I retaliated. When my dad refused his consent for our marriage, I remembered the teenage years when he refused my appeals for freedom. So I worked on my mother, who finally signed the papers necessary for us to attain a marriage license. My break from my parents' control was finally complete. I was still thinking like a thirteen-year-old kid.

Forging Ahead

I taught at Marr School, just up our hill and on our land for the 1957–58 term. I was trying hard to adapt to married life, school, and the duties assigned to me by becoming a farmer's wife. Ed's dark moods followed his periods of normalcy. I could not discern why he switched without a warning or provocation. I believed I could fix him by taking from his shoulders as much responsibility as mine would carry. I took over the farm books that his sister had handled before I came on the scene. Ed's formal education was limited to three or four years because he was deemed too sickly to go to school. I brushed the illness aside. With me around, he had only to sign his name on documents. I had to realize my dream of the perfect marriage and prove that I was right in taking on this venture.

His dependency on me gave me a rush of power that flattered that deficiency in me. But always I wanted more. I searched for something or someone other than him to fulfill my need. I

needed someone who would love me and need me unconditionally, not go off into a troubled world that I could not enter.

Our first Christmas together was all that I could hope for. I was newly pregnant, and I thought that was the answer. A baby would garner me favour in both families. I threw myself into teaching and preparing for my baby. I was nauseated and tired—so tired that it was a battle to stay awake. I complained in the hopes of getting a bit of sympathy, but Ed's health concerns overshadowed mine so thoroughly that I completely stopped complaining and kept my feelings to myself. My childhood made me an expert at that. In our family, if the hurt didn't show on the outside it didn't exist.

Ed's doctor appointments became more frequent. Each time they told him that his body was in good health, but he insisted that he was ill and in pain, which I believed was true. I argued with the doctors. They simply were not giving him the attention he needed. He seemed to think that the medical world was treating him unfairly. He was obviously physically sick, and they blamed it all on his nerves and imagination. My hopes for a happy life depended greatly on him, and I was not about to let myself believe that he was thinking up his illness. When his work on the farm was demanding he was sicker. When the job was done, his mood changed, and he was well again, happy, and the wonderful husband I knew he could be. When he became moody and critical of everything, I knew another dark spell was coming.

That spring of 1958, I planted a big garden on the same spot where my in-laws' family garden was for many years. It was big enough to feed the family of ten all those bygone years ago. We were just two people, but I thought it was traditional to plant this

big of a garden, and no one was going to say that I couldn't live up to it.

We never had a productive garden while I was growing up. My mother tried to grow one when we were on Drywood Creek. She knew how it would benefit our health and add to our food supply. My dad had just enough interest to scratch up the surface, with a one-bottom plough, on the rocky knoll where the cabin was situated. When the horses rolled on it and my mother nagged sufficiently, he put up a one-pole fence, and didn't bother with a gate. There was no water anywhere near. It never had a chance. All I can remember eating from that garden was a few wormy radishes and a few leaves of lettuce before it dried right up and the horses rolled on it.

Then she persuaded my dad to plough a few furrows, in a more fertile spot, for potatoes. She attempted to drive the horse, and he was to handle the plough. I heard many arguments between my parents, but the one that ensued from this venture was the best yet. The garden got no farther then turning the sod, leaving ridges there for years.

Now, ashamed that I knew nothing about gardening, I forged on as if I did. I sent for tons of seeds, and used the seed planter, a wheeled affair. The seed poured out in six-inch-wide crooked rows. Since the planter lacked a setting for corn, I spread the kernels by hand and piled soil over them. My father-in law brought me potatoes, cut up with a couple of eyes on each one; Ed dug the holes to bury the pieces. That was the only thing done right. The wide vegetable rows came up quickly in the fertile soil, as did the corn. When the corn plants got heavy, they fell over. I planted them properly but the growing season was over. That garden brought serious looks of concern from my in-laws, and Ed

found it very amusing, as did our friends. Even I had to laugh at its crooked rows.

I did, however, master most of the new duties that I seemed to have inherited. I was determined to be just as efficient as my sisters-in-law. There was much to learn, and soon I realized that it was from them that I would learn the most. I began to ask more questions and let my pride take a back seat.

I wanted Ed to kill the chickens for cooking. He told me I had to learn to do it myself. The first time I laid a head on the chopping block and swung the axe I was terrified. After I chopped off their heads, I soaked their bodies in boiling water and plucked them, as I was told. The smell of wet feathers, coupled with the nausea of pregnancy, made that enterprise a nasty ordeal. Finally, I mastered my fears and became a formidable chicken killer, but the abhorrent smell of hot, wet feathers stayed with me. That summer, I mastered all of my wifely duties to the best of my ability: I cooked big meals, sewed, and did barn chores whenever I needed to, all with a nauseated stomach. The doctor said the sickness would last three months, but it stayed.

Through the hot summer I dragged my ever-growing body without complaint, through its frequent bouts of sickness, entirely oblivious to what was expected of me. Ed constantly wanted me to accompany him while he did his work. He said he needed the company. All I wanted was to stay home and prepare for my baby.

During the pregnancy I noticed that pieces of my teeth were crumbling. The doctor said that the baby was using up the calcium in my body and my teeth were the first to go. We very seldom had milk and green vegetables when I was a child. Soon I

would have to have my teeth removed and replaced by false ones. I didn't want to part with my nice even teeth, but he assured me that the possibility was not far down the road.

In August, it became apparent that my baby was breech. There followed appointments when the doctor and the nurse poked and pushed at my abdomen, trying to turn it to no avail. I was carrying it too low. With the head where the feet should be, it kicked high up instead of where it normally would. I felt like it was kicking me in the heart.

The old hospital in Pincher Creek was still basically run by the Catholic nuns. Caesarean sections were not performed there. To them, there was only one way to have a baby. No one warned me as to what was to come. No one told me that caesarean sections were done as close as Fort Macleod, Alberta or advised me to have one. In fact, I didn't even know that there was such a procedure. Non-Catholics, I found out later, went there for difficult deliveries. Some Catholic mothers in 1958 either had their babies naturally or died trying. I was ignorant of my options and unaware of the uniqueness of my situation.

I went into labor on September 2 1958, knowing nothing about childbirth and even less about a breech presentation. The labor lasted an afternoon and all night, and finally, on September 3, with several doctors present, Dr. Hodgson delivered my baby girl—bum first, legs up. He performed a miracle that morning. I heard the nurse say, "It's a girl," when the bum came into view. I remember very little else of the birthing.

Later I learned that the doctor had reached into me, after cutting a wider opening, and tipped the baby's chin, to prevent strangulation when the head came last. She was a small baby with black hair and rather blue skin from the long labor and difficult

delivery. I woke up in a fog hours after the birth. They brought my baby girl in from the nursery and I saw Donna Frances for the first time. Ed came and looked and then went to the bar to celebrate. He had slept soundly the whole night; having babies was a woman's business, and handing out cigars was a man's.

There followed ten uncomfortable days in the hospital as I healed from the many stitches that it took to put my birth canal back together. Walking was especially painful. No one asked me if I wanted to nurse my baby. A nun brought her in and set her on my breast. At first it was very painful. Donna might have been small and blue, but her mouth was a powerful sucking machine. My nipples grew raw and cracked. I dreaded nursing times for a few days.

She seemed to cry a great deal. I could hear her from my room. I worried and asked, "Is that my baby?"

"Yes" the nun said. "She's exercising her lungs."

I thought surely something was wrong with her, and that maybe I could help her if I took her home.

After about nine days, I started bothering Dr. Hodgson to let me go home. He said if I could walk down the whole hall with him at his speed he would discharge me. I practiced in spite of the pain in my pelvis and healing sutures. On the tenth day he took me by the hand and I forced myself to keep up with him. He discharged me that day.

I knew absolutely nothing about caring for my baby. In the hospital, they brought her to me to nurse, then took her to the nursery to be changed, bathed, and hopefully to sleep. She was weak and recovering from the difficult delivery, just as I was. She weighed hardly six pounds at birth. She was so tiny. The blue of her face cleared up in the hospital. She was beautiful and I

wanted to show her off. Surely Ed would be as proud of her as I was. Surely this was what he needed to take the onus from him and help to make our home happy.

I didn't know how to fold a cloth diaper, and bathing my baby was a noisy, frightful experience. I overused baby oil and baby powder. Soon her head, with her thick black hair, was covered with cradle cap. She never seemed to stop crying. When I nursed her she had projectile vomiting. I was afraid she would vomit in her sleep and choke to death, and was alert to every move she made in the night. I kept her in a bassinet right at my head, and I slept only from exhaustion. With the feeding every few hours and the crying in-between times, I was a nervous wreck. Most of the night, I walked the floor with her, trying to keep her quiet so that Ed could sleep. He complained when she disturbed him. I was depressed and convinced that I was going crazy.

Donna was born at a very busy time of year. The men were threshing and there were extras to cook for. My mother-in-law bought pies and cakes to help me out. I could have told her how I felt, but I was too proud to ask for help. I became increasingly depressed. I didn't know that postpartum depression existed. Ed saw no reason for my mental state or for my crying spells. His mother had done it through the births of ten children. Why was it so difficult for me?

I took to carrying Donna on my hip as I prepared meals, cleaned up, and did housework. That was the only time I felt she was safe, and the walking put her to sleep for short periods. Feedings were followed by bouts of crying. Often, while no one was around, I cried right along with her. When her gas pains subsided, she caught short naps, and I put her on the couch so that I could see her at all times.

One time, when I had Donna propped up there, I put the final touches on the meal. Ed came in for dinner in a sullen mood and completely ignored her as if she were not there.

"Why don't you talk to your daughter or pick her up?" I asked.

"Because she's not mine," he said.

"What?" I said, getting very angry at that insulting remark. "Whose is she, then?"

He named the most decrepit old bachelor he could think of and went silent while he ate. Then he left the house.

My heart was broken. Was he teasing me? I'd have thought so, except for the dark mood that he'd been in for the last few days. He didn't joke when he was ill.

I was so angry, confused, and hurt that I held my baby and cried. He was acting like a neglected child. Could he possibly be jealous of his own daughter? I wanted to tell someone, but who would believe me? Around all others he was a different person.

That night when he came in for supper he was sick. The responsibility of the fall harvest was getting to him and I was his sounding board. As soon as he ate, he went up to the big house to see his parents for a few minutes. I quickly bundled Donna up and left on foot.

It was dark, but it was a warm Indian summer night. When I got to the top of the big hill, I stopped to consider what I would do, and I realized that I didn't want anyone to know what went on at home—least of all the neighbours No one saw him in those moods. They wouldn't believe me. He didn't show that side of his personality to everyone. I had a feeling that his family was much more aware of his changeable disposition than they were willing to admit. I wondered whether I should escape this tender trap of my own making before it closed tighter.

I walked along the top of the long river hill above the bigger farm house, and in desperation descended to knock on my in-laws' door. I knew I'd been away long enough for him to return to our house and discover my absence. His dad Bill came to the door. He studied me for a moment and then reached out and drew me into the kitchen, where it was warm and comforting.

"What on earth is the matter?" he said, relieving me of the baby and handing her to his wife.

"It's him," I said. "I can't stand the way he treats us. He says the baby is not his. He accuses me of things that I don't do and stays mad for days. I don't understand him."

"You'll stay here tonight," he said. "I'll have a talk with him right now."

Mrs. Bruder showed me upstairs to the spare room where I'd sleep. She made hot chocolate, which I took up with me. I cuddled my baby next to me and had the best sleep I'd had since she was born. Now I knew that I had an ally—someone who understood what life was like with his son. The realization was so reassuring that I half decided to try again instead of running.

Next morning, I enjoyed breakfast with my in-laws, picked up my baby, and went hesitantly down the incline to what had become my home. I had mixed feelings now. A part of me wanted to make my runaway work. It was the same sort of action I'd taken when I ran away to my uncle's place to escape my parents. I was seventeen years old then; I had stopped the turmoil in my life, and I wanted to do the same now. At the same time, I loved my husband and wanted to make my marriage work. I was still the fixer, and thought I could do it if I hung in there. I was a fighter, not a quitter.

Ed was definitely feeling the effects of his dad's lecture. Bill was the undisputed head of his family. However, he didn't say he was sorry, but he did change his attitude toward the baby. On the outside, he treated us well for a few days, but inside he was seething that I'd run away and told his parents what he considered our private business. His insecurity began to show in a big way. I didn't understand.

The next time I sensed one of his dark moods coming on, I confronted him. "I tried to leave with the baby once," I said. "Next time I'll have a plan, and I won't go to your parents." That brought a reaction even more troubling than I expected.

"And I'll hunt you down and shoot you," he said in a matter-of-fact tone.

All the fear and resentment that I had for my father at thirteen years of age came back. "If you get pregnant, I'll shoot you, and the one that done it," he'd say. I had been afraid of my dad after that, even though I knew he'd never carry through. I wasn't so sure of my husband. There was no smile on his face; he was dead serious. Never in ten years of marriage did I hear Ed say he was sorry. It seemed as if he didn't remember what happened such a short time ago.

I remembered the time my dad slapped my face, knocking me down, destroying all my years of trust in him. I was so angry. I swore that no man would ever lay a hand on me in anger again and get away with it. Now, as a married woman, I felt frightened and trapped. I thought I had to make the best of this marriage, and be the best mother and wife that I could. I did love my husband. It was his moods when he was not himself that I hated and feared. At that time, I knew nothing about mental illness or abuse. If it

had been physical, I would not have been tolerated it. There were always those wonderful times that followed these upsets.

His parents were good to me but never intrusive. They were getting old and I didn't want to cause them stress. My mother would have said, "You made your bed—now lay in it." I didn't want anyone to know about the bad times in our home life; I wanted so badly to be perfect.

I did, however, complain to my doctor, who was also Ed's. Good Dr. Hodgson, although a family doctor, became a counsellor for us. He had me write a letter to him. I told him of Ed's moods, his lack of sympathy for my problems, and the mental stress he caused me. Then Ed wrote him a letter and told him that he was sick and in pain, and no one believed him, including me. He felt like everyone was out to get him. That he was being persecuted. He blamed the doctor and me. His body was in pain and his stomach upset. The letters served no purpose. The doctor tested all his organs and found him physically healthy. He thought we had a relationship problem. He prescribed more antidepressants for both of us.

One day, convinced that something was really wrong with Donna, I took her to town to the clinic. The doctor suggested that I put her on a bottle. My nervous state, he thought, was being transferred to her through my milk. After several bouts of constipation, caused by bottle-feeding her with cow's milk, three months passed, and sometime in November she began to sleep properly and stopped vomiting at last. Now I was able to sleep better, and with winter and the fall work done, Ed complained less, and life went back to what I always wanted it to be.

Every Sunday, we went to church. It was situated on top of a hill a few miles east of our place. All the back pews were taken when we got there, so we sat in the very first one on the right side. You should be able to sit any place in a church, but those Catholic families filed into the church and into the same pews every Sunday, like cows into stanchions for milking. Soon we were doing the same thing. Everyone visited on or around the big cement step after services

 I'd stayed at that church for my first communion, what seemed an eternity ago. I was a kid from the bush then and not used to being in a strange place with nuns and the priest that my mother had avoided as long as she could. My dad wasn't interested in church or first communion. He wasn't home long enough for the priest to catch him there anyway.

 Now grown up, I was able to appreciate the beauty of the old building. However, it was always a hassle getting ready. I had to have my family shining clean, or so I thought. I was simply doing as I saw done. I had to wear a hat of some sort, to show that I was dressed up for church. It made me feel that I was accepted, that I was one of them. I devoted the whole service to keeping my baby quiet, and when I failed, I took her outside. I felt out of place in my environment, just as I had when I was a child. But after church was a different story.

 Most of our best young friends were Catholics. Visiting there was the best part of going to church for me. We would either ask some of our friends to dinner or a picnic, or they would ask us, and Sunday was always a good day. Ed loved company. It took his mind off his sickness. Often we went swimming at the creek; in bad weather we played cards indoors all afternoon. It was a time for us women to compare our babies and all that we held dear. It

was a time, too, when I learned so much from my sisters-in-law, who were so much more experienced than I (they were all older, since Ed was the youngest of the Bruder boys). Life was good on Sundays and I made sure there were people around.

Rather than pull away from the church, I poured my efforts into becoming a churchgoer, even to joining the Catholic Women's League and serving on the council. I was treated well there, and through those farm women I began to gain confidence.

Christmas was always a happy time. Brenda, age four, Lana, age one, Wayne, age five, and Donna age six.

I lived for the happy times, family gatherings, and visits with our young friends. To all outer appearances we were a model couple. Except for that one attempt at running away, I never complained to anyone but the doctor. My new family accepted me into their fold and I began to feel that I belonged. The good times followed the bad and kept me going without complaint, and eventually I began to accept this as normal. I was too proud to

admit that my perfect marriage was not turning out as I planned. I was still trying to fix it alone.

Before Donna was born, Ed had bought a pinto pony from Otto Bonertz, a farmer in the Yarrow district. Since we were expecting to have a family, it followed that if our unborn kids were going to be riders like us, we had to prepare for that eventuality. We went to pick him up with our Chevy half-ton truck with the wooden stock racks. He was in a corral on Yarrow Creek.

We backed up to the bank and proceeded to load a vicious little stud that quickly made Ed dubious of the great deal he'd made. Since he was only three years old and small, we were able to drag him, with the aid of a bum rope, over to the truck. Trying to be nice to him didn't help. When we touched his head, he bared his teeth, and struck at us with his front feet. Touching him anywhere on his rear caused him to kick. We jumped out of reach, and stared at him in disbelief.

By tying his halter shank to a longer rope and snubbing it to a ring at the front of the truck box, we managed, by combining our efforts, to skid him—now off his feet—into the box, dropping the end gate behind his prostrate body. He rose quickly to his feet, and found his nose no more than six inches from the iron ring at the front of the box.

The price had been right; actually, it was a real bargain. However, this didn't appear to be a kid's pony. We spared him no bumps in the potholes on the way back to the farm.

"Some kid's pony you bought," I said after I got the nerve to talk about it at all.

"We'll have to break him just as if he were a big horse," Ed said. "And I'm too heavy for him, so I guess you know where that leaves you."

At home, that miserable little horse wouldn't back out of the truck. We threw the rope between his withers (shoulders), pulled him up onto his hind feet, and then over backwards. He hit the ground with a grunt, got up, and stood there with his feet braced, ready for the next round.

Ed came up with the name Keno, from where I'm not sure. He was tied in the barn in a narrow stud stall, where we fed him through an opening in the hayloft above his head. After a few days of being dragged out to the water trough and back he began to lead. By watching what his teeth were doing we could tie him up. Then we had to climb up onto the manger over the front of the stall to keep from being kicked. We showed him to our friends, always with the warning, "Stay away from his hind end!"

Ed had a remarkable ability to communicate with horses. He was firm but kind to them. I had to marvel at Ed's remarkable horse sense. He understood how a horse thought; he was a horse whisperer long before the expression became popular. He trained Keno from the ground up.

During that late fall of 1958, I stepped up onto Keno after I had somewhat conquered the much harder task of motherhood. Ed said, "He won't buck," and he was right. But ponies are miserable little things, and Keno would conveniently catch me off guard and take off for a merry run. Because he was small, I was able to circle and stop him. As soon as he knew he was beaten, he stopped. He never tried to buck with me, but several times he lay down and rolled me off. Keno seemed to have his mind made up that we would not easily tame him.

Next spring, when I rode him on a trail ride up Yarrow Canyon, he ran up and down the scree slope like a mountain goat. On the level trail he ran away. I had to jump off and snub

him to a tree to stop him. Every time I got near another horse he jumped in the air and nailed that horse with both hind feet.

"I'm not riding him again until you get him cut!" I complained to Ed.

We bred one mare to Keno, and then got him castrated. The transformation was remarkable. He was a little horse with the smarts of a big one. Later he carried our first kids around the yard. The constant wear from his feet created a trail that lingered as a happy memory of when we had such high hopes of making our kids riders like us.

The kid's legs were so short that they toppled over. Ed objected to them riding so young. He was paranoid about their safety. I waited until he went to the field, and I tied the saddle strings front to back across their legs, essentially tying them on. I gave them connected reins and a switch to start Keno. They loved it, and refused to be taken off until their heads began to bob and they were going to sleep. Although very small at first, they were soon accomplished riders, and very capable of using the switch to keep Keno moving. He was a useful ranch horse, and a fixture in our yard, where he also served as a lawn mower.

During those ranching years, we moved cattle from the ranch on Drywood Creek to our mountain pasture in the foothills and rounded them up for branding and treating the sick ones. But that was working, and was not the same as abandoning one's cares and absorbing the healing effects of the mountains that I loved.

Sometimes I left the cares of my life on the farm to a babysitter, and I climbed a hill out of the river bottom. I sat and gazed

at the mountains, remembering the sights, sounds and smells, trying to recapture my childhood memories.

Ed, myself, Donna, Lana and Wayne on our ranch on Drywood Creek in the Marr District.

There my imagination traced a trail from the mouth of a canyon, up over the summit, made a round trip and came back to where I sat. I could practically smell the flowers that grew in the cool mountain meadows and the spicy sap of the sub-alpine fir high on the mountain passes. Then I walked home feeling

refreshed—but guilty. I was pulled between freedom and the captive life of a wife and mother. I returned to the hilltop many times to reminisce and fight the depression that often visited me in married life.

We did infrequently make an effort to trail ride, but with the preparation time necessary it was often not worth the effort of securing a babysitter, a day off from farm work, making lunches, and trucking horses. We took 4-H kids into the mountains. Ed camped with them and their parents, and I came home to look after the kids and do the chores. We rode up Pincher Canyon with 4-H kids when I was seven months pregnant with my son Wayne. Afterwards we had a wiener roast at my grandfather Frenchy Riviere's place at the mouth of Pincher Canyon. Off in the pines sat his old cabin where I'd spent happy hours as a child; on the hill behind us was his grave in the spot chosen by him many years ago. For a precious few moments I sat in the shade of a huge pine tree that memory made a friend of, and my mind traveled, like a time machine, back to my childhood.

 That same fall I shot a spike bull elk with my .303 army rifle. Ed packed me across the creek. Teetering on my stomach on a seismic line up Yarrow Canyon I waited for the elk to appear in my sights. Ed went to get help to drag it out. A friend, Ray Rowley, was in the canyon on a horse. I lugged my pregnant body back to the road, practically dragging my heavy rifle, and found my dad's truck and camper, which was luckily up there that first day of elk season. I climbed in the back, and fell asleep.

 That was the only elk bagged in Yarrow Canyon that first day of season. Ed was proud to have a wife who could hunt.

Ed on his big horse Cougar.

I started hunting after I married, more to please Ed than myself. In our Métis family the men did the hunting. But now, as a married woman, I went hunting every fall, whether I was pregnant or not, and I filled my tags and made him proud. I joined in when the men sat around drinking beer after the hunt. I joined them, more for Ed's satisfaction than my own. My heart was not there. It was always in the mountains, riding for pleasure. I dreamed of the day when our family would be grown and I'd have time once more to visit the trails of my childhood. Little did I know how long that would be, and what life had in store for us.

Deer I carried home on my good horse, Black Jack.

Impending Disaster

Fourteen months after the birth of our first child, I was again pregnant, no thanks to the Catholic Church's doctrine on birth control. Still, I embraced this challenge with the same enthusiasm as the first. I had driven the team the summer before that special euphoric feeling that drives away the memory of pain, when a mother first sees her newborn.

Winter came early that year, and in late October our country was blanketed with snow. Upset with his inability to finish the fall harvest, Ed's sickly symptoms worsened and he periodically stayed in the house with blinding headaches and an upset stomach. It was early to start feeding the cows, but necessary. I assisted my father-in-law, in spite of my big belly, in harnessing the team and feeding them the hay that Ed had loaded the day before—when he felt up to it. We were an unlikely crew of two, one growing old and one seriously pregnant. I had used the team to hay the summer last and I was used to harnessing horses when I worked for my dad and the neighbours It impressed my

father-in-law and he told me so. It was important for me to please him. I still hadn't shaken that feeling of inferiority that I tried so hard to hide.

When I was fifteen, my dad gave me the responsibility of driving a team of horses in the hay fields for neighbours I had to harness them, hook them up, and cut and rake hay all day long. Even though I knew my dad was keeping tabs on his willful teenage daughter, I enjoyed the work with my favourite animals, the fresh air, and camping out all summer. Now I was living a life so different that it seemed to be only a dream.

On November 16, 1959, my son Wayne Edward was born in St. Vincent's Hospital in Pincher Creek. It was an induced delivery, and except for the massive dose of castor oil that bought on labor, an easy one compared to my first.

Two weeks previous, on my due date, we came out of the river bottom with Ed on a tractor and me driving the truck through two feet of drifted snow, at -15°C. Winter was upon us in a big way.

There followed two weeks of overtime in which I stayed in the cramped attic apartment of my parents, at the top of the heritage home owned by Matt Brown, on Indian Street in Pincher Creek. The Browns, an elderly couple, lived in all but the attic apartment, where my dad was holed up for the winter. The sitting room ceilings above the couch and in the bedroom were slanted and low, cutting down on living space. Crowded in there were my parents, Bob and Mary Riviere, my teenage sister Zilda, and my five-year-old sister Wanda Lee. Into this situation I moved with my toddler, Donna. I hoped to be there only a few days while I

waited for my baby. This was too much like the crowded shacks my family of six lived in when we were growing up.

Donna ran around in the limited space, oblivious to the complaints levelled at both of us. Soon the hospitality, as a whole, wore thin. Winter raged on, and I was thoroughly ready for the inducement when it finally came about.

It was a pleasure to give birth in a normal way after what I had endured with my previous delivery. The next morning, Ed came to the hospital to see his new baby boy. I said, "Go and pick Donna up out of that firetrap and take her home for your mother to look after." My dad had found some miserable places to live, but that one was the lowest yet. All that could be said for it was that it was warm; after all, heat rises.

After Christmas, Ed's parents made the transition into town to retire, leaving their house of so many years to us. The changeable weather that we were accustomed to in Southern Alberta produced one of our famous chinooks, turning the snow into rivulets of rushing water and giving us an opportunity to move into the empty house.

I packed up our new son, went up to the big house, and set him in the corner of the empty living room, where he slept until the move was complete. He was the first one of our family to sleep in that house, and we made a big thing of it.

Now we had a bathroom, running water, two bedrooms upstairs, and one down. It too was a cold house in winter. It demanded constant attending to the fire by providing coal for the big iron furnace in the basement and hauling it upstairs with a coal hod for the combination wood, coal, and electric stove in

the kitchen. This house was a castle compared to what we moved out of and what I lived in growing up.

The coal that the Ed's parents left in the basement when they moved did not last for the winter. That necessitated a trip to Hillspring, a hamlet east of us that was not much more than a train stop and a few houses and nondescript messy yards. A boxcar was parked at the railway sliding. From this Ed shovelled coal into the box of our truck. We hauled it home, and he shovelled it through a small window and down the coal chute, which delivered the coal to the dirt floor of the basement, near the furnace.

The furnace was a huge iron beast with one vent through the floor into the sitting room. This and the cook stove provided what heat there was for the whole house, upstairs and down. For a person who was often sick, Ed was remarkably strong and capable of hard work, which helped to make his illness more confusing.

It was miserable at that train siding, with its cold iron rails and lack of shelter, out there on the prairie. I was uncomfortable, scrunched into that small truck cab with two small kids. There was nothing to see but run-down houses and the junky back yards. Ed insisted that we accompany him on this and similar excursions because, as he said, he needed the company.

Besides hauling coal and going to town, and leaving the babies with his mother to go grocery shopping, we stayed close to home that winter of 1959–60. Visits with my parents were very few. I had a new life now, and it demanded all my attention and time. We went to their place at Christmas, but they never visited our home. Only at our wedding did my parents ever associate with

Ed's folks. Métis were hired help and common labourers. Our men got into their fields but very seldom into their houses.

One of my brothers-in-law once said to me, "You are a very good person for a Riviere." I was so estranged from my roots and disillusioned with my upbringing that I mistook that insult for a compliment. How wrong I was. The prejudice I knew as a Métis child had followed me into my marriage, and I didn't even recognize it as such. Still thinking of that statement, I told my husband. "Oh yeah," Ed said, laughing. "We called you those half-breeds up the creek." To me it was not a joke. It was a remark I would resent for many years.

Now that I knew how to deal with farm life, my two kids were my main focus. Like the farm women of my time, I washed on Mondays, scrubbed floors and washed the kid's hair on Saturdays, and prepared for Sunday—the Catholic day of rest. I cooked extra-large meals for visitors, washed dishes, and changed baby diapers all day. Still, life was good on the farm. We were living in that wonderful river bottom location among the huge cottonwood trees and wildflowers, where I loved to be. I thought Ed and I would grow old there together, and I had the encouragement of his loving and supportive family. The care of the cattle and horses on the ranch was a new and interesting experience for me. We should have been successful ranchers and happy in our situation.

Washing the clothes was a tiring procedure, but I took it in stride. The machine was electric, but the water I carried from the taps. After filling the machine three times for washing, and three for rinsing, and carrying the water out into the yard to dump, my back and feet ached for the rest of the day. Ed put me up three

long clothes lines that extended from the clothes stoop across the pond to the old log shop roof. In winter, the clothes froze stiff on the clothesline and, to some extent, freeze dried. There was always a full line of cloth diapers. Besides making three hearty meals and caring for small children, washing was an all-day event. Washing my kid's hair was a special operation. I remembered my mother rubbing a bar of soap on my long hair as I craned my neck over the wash basin. Then she poured diluted vinegar over to rinse out the soap. If there was conditioner to be had, we were ignorant of the fact. She did the best she could with what she had, but my kids would benefit from my less-than-desirable experience. I put a table beside the long kitchen sink and laid each one there in turn. With a comfortable rolled-up towel under their necks, I gently applied tearless shampoo without getting as much as a drop of water in their eyes. I washed their hair like this until they were able to do it themselves. Caring for my children was my chief priority. I'd see to it that their growing years would be better than mine.

The farm chores of winter followed the hard work of summer. We spent all summer preparing to use up all the fruits of our labor in the winter, then we'd do it all over again. But that was farm life, and I was happy when Ed was feeling well. The rewards were many; farming is a wonderful lifestyle, and I had much to be thankful for. We hired a man to take some of the pressure off of Ed, but Ed was very critical of his farm helpers. I think they too experienced his mood swings out in the fields.

Our biggest events of our ranching year were branding in the spring and selling calves in the fall. We fed the free branding help a huge meal. In most cases, that entailed whole families. In a few

days, we moved on to a neighbouring ranch until all the calves were branded and doctored. The kids had scores of playmates all spring, and I had all that welcome company.

We raised calves that often topped the sales. Our whole family went to the sales and they were happy, social events. They were important because they provided all our income for the whole year. So much depended on those prices. At that time, Ed was happy. I never heard him complain about his health through either of those events. Handling stock didn't bother his nerves like farming did.

Still, his ill health was a growing concern. His complaints and trips to his doctor steadily increased as they shifted him from one mind-altering drug to another, trying to divert his mind from his fixation on his ill health to that of his healthy physical condition. It was not working. With a growing concern for his welfare and that of our babies, I became increasingly worried. I too turned to prescription drugs between pregnancies to dull the anxiety and confusion. Good times were always followed by turmoil; as the peace diminished, the trouble took on new life. Still, we forged on trying to live a normal life and raised our young family as best we could. They thrived on farm life and were healthy and happy. All was great—except for that nagging feeling that all was not well in our home. The pressure was mounting little by little.

When my son was fourteen months old, my second daughter, Brenda Lynn, was born on February 13, 1961. The delivery was complicated because she was turned toward the back, and so emerged against the normal grain, but at least she was not breech. I was much better now at caring for my babies, and her birth was a happy occasion for our family. As with the others, she had colic

for three months. I now had an arsenal of remedies to fight the problem, but most didn't work.

Church was now becoming a harrowing experience with three little kids, and my devotion to its doctrines was fading even faster. On one thing Ed and I agreed: it was time to convert to birth control, in spite of the Catholic Church and its unreliable rhythm method.

Two full years went by and my body was finally getting a chance to get back in shape. Ed talked me into having one more baby so that Wayne would have a chance to have a brother. "Then," he said, "our family will be complete." There was little I could do at the time to please him, so I embarked on another pregnancy, more for him than for Wayne's sake.

On October 15, 1963, my third daughter Lana Marie was born. She was a small baby, but full term. She too was breech, this time coming feet first. The day I went into labor we were in town shopping. Stuffed into our 1952 Chevy truck was a very uncomfortable, pregnant me with three kids tromping over me and a cranky husband. To add to my discomfort was the extreme Indian summer heat that we often have in October. It was stifling hot in the truck with no air conditioning, and even worse out in the sun.

"I wish I could have this baby right now and get it over with," I said in desperation. With that thought fresh in my mind, I felt a slight pang low down in my body, and my water broke with a flush of fluid, soaking my clothes and the truck seat. Luckily we were already in town because Lana was born in less than two hours from that time. We dropped the kids off with Ed's parents and barely made it to the hospital.

I was not disappointed with another girl, but before the happy day was over my mind was made up. I would take responsibility for my own bodily functions. There would be no more children brought into this volatile situation where I was feeling less secure with each passing year.

Soon after I came home with the new baby, I was dealing with the inevitable colic. I was weak and run down from walking the floor with the baby most of the night, caring for the others—now five, four, and three years old. I was doing all the same household chores and often those at the barn to take the pressure from Ed's nerves and allow him more time to harvest.

Over the next four years, I threw myself into being the best farmer's wife and mother to my children that I possibly could. I did my share of the work, butchering beef, chickens, ducks, and geese; I learned to make butter, cheese, and soap—not all necessary, but to prove myself and possibly collect some attention and praise. Making cheese was an interesting enterprise. No one had used the old cheese press in years. We resurrected it and the butter churn. Soon we thought it more expedient to sell all the cream and buy back the butter. There was no shortage of cream, since we milked three big Holstein cows by hand. With so much skim milk I was able to make all our cottage cheese, a much more healthful product than we could buy. The cheese venture soon wore thin too. There was a cheese factory a few miles east in the small town of Glenwood, Alberta. With four small children and all the farm work, those first learning years were a busy time for me. I had precious little time to think about my own welfare. I spent all my time proving I was a good wife and mother.

Ed continued to complain about his ill health and visited the doctor often. They kept changing his pills from one tranquilizer to another, mixed with mind-altering antidepressants. He continued to have his good times when all appeared to be well. There was no use in me complaining. It had never resulted in anything but arguments and a shower of health complaints from Ed. I learned to keep my problems to myself. Then, with me doing my very best, he would drop into one of his dark moods. Again my shortcomings and his health became his focus of discontent. The strangest thing about Ed's illness was that after he had experienced a bad spell and blamed me for most of his problems, he would completely forget the whole episode and never mention it again, as if it had not happened. Confused and hurt, I harboured much resentment but hid it to prevent conflict. Entirely confused, I lived for the periods when he would again return to normalcy and be our loving husband and father. Each time I built up my hopes they were dashed. Our home life became a festering sore that was bound to break open at some point. I feared for my family. More and more it appeared to me that their welfare depended solely on me and my ability to be strong for them. Where would it all end? I had no doubt that it would. It was getting steadily more disturbing. How much more could I take and still carry on with this accelerating situation?

"If you don't stop insisting that you're sick, someday you will really be sick," I told him one day when I'd reached the end of my patience. It seemed to me that if he devoted less of his time complaining about his health, and more to feeling positive, it would do all of us some good. I had precious little time to spend thinking about my personal problems. My days were spent mainly in worrying about and caring for him and the kids.

But the latter suggestion only angered him. "You've been talking to the doctor," he accused, as if we were conspiring against him. There was no mistaking Ed's anger. He would turn pale around his mouth, his eyes would become piercing, and his face turned ashen. I called it his "grey" look. My mother had a similar transformation when she was especially angry with me, when I was a teenager. I was as frightened of him in that mood as I was of her then, and I think he sensed my fear as he withdrew into utter silence until the mood passed. When there was a noisy outburst, I could have stood up to that and defended myself, but I had no defence against those sulking silences.

One mid-morning, when Ed was doing the chores, there was a knock on the door, and there stood the love of my teenage life. I met Rusty when I was thirteen years old and he was twenty. I fell in love with him, and we carried on our love affair in secrecy for five years while my parents did everything in their power to break us up. I'd given him up to marry into a more promising situation. Rusty was checking to see how I was doing. He expected to be treated as a friend by both Ed and me. It was this event that brought home how very afraid of Ed's jealousy I was. I knew that he would accuse me of infidelity if he knew that Rusty had called, however innocent the situation. With three of my babies watching and wondering who this visitor was, I assured Rusty that all was well. "Now you'd better leave." I said. Rusty looked hurt, shook my hand, and left—for a very long time. The guilt that I felt for even speaking to Rusty was overwhelming. How very sick I had become in seven short years of marriage! I was afraid of the jealousy and the trouble it caused. Ed would have treated Rusty fine but I would have paid when he was gone.

After pouring out his troubles to every doctor he saw, Ed was down to one family doctor: Dr. Hodgson, who had delivered all four of our babies. I went to that good doctor in desperation to ask for more pills to help me to deal with Ed's ever-increasing mood swings. One day I was in his favour and the next the cause of his illness. I was living in a state of utter confusion, tolerating the bad times in order to enjoy the good.

Our illness was invisible to the general public. Except for pouring our troubles out to the doctor, we both concealed it. As Ed's illness worsened he became more insecure and overprotective concerning the kids. He worried about money and complained when I spent it, especially without his knowledge.

One afternoon, when I was returning from town, I came upon a roadside yard sale and stopped to investigate. I saw a small cabinet that I liked. I bought it and continued on home. When I showed it to Ed, it triggered an episode so disturbing that it left me puzzled beyond belief. I cried the whole time I was getting supper.

Another time I wanted to buy a new saddle. I had never owned a new one and it had been a dream for many years. He strictly forbade me spending the necessary money. I had a small savings account left over from my first year of teaching. I bought a saddle with it, brought it home, and dropped it in front of him. "Not your money!" I said.

He was fearful for the kid's safety beyond all reason. I wondered how they would ever grow up in this uncertain world with him refusing to allow them to take risks. What would happen when they were old enough to drive cars? Every fibre in my body cried out to stand up to him and fight, but I knew if I did it would

turn physical. At all costs to me, our children would not experience violence in our home.

The ranch house we called "the big house" shortly after sickness took Ed away in 1968.

Donna started school in 1964, followed by Wayne in '65 and Brenda in '66. With the babies growing and me becoming more efficient at managing our family life, I was able to immerse myself in raising them and become even more numb to Ed's complaints about his health—which grew steadily worse.

We had happy Christmases, family reunions, and picnics—all a lot of work for me. That was alright, so long as Ed stayed in a good mood and was distracted from his health problems. He loved company, playing cards, and socializing with people of his choice. Every Sunday after church, I either invited company in

or suggested that we visit some of our young friends or family. Although it caused me more work in preparing meals and taking care of the kids, it brought harmony into our home. It was worth it.

Going out without the kids was a difficult matter. Occasionally we hired a babysitter and attended a dance at Twin Butte Hall. These outings were disastrous. We'd leave home in good moods, with every intention of enjoying an evening of dancing and sociability. In the '60s it was still possible to have a drink before you left home to get you in a celebrating mood, drive to the dance, and drink outside of the hall; everyone did it. Very often a neighbour would suggest that a few couples come to his house after the dance for drinks. These were setups for domestic disputes. For us it was all fun, except for on the way home, when we were alone. Booze seemed to bring out the symptoms of Ed's illness, jealousy being one of the worst. It would start with him accusing me of being unfavourably involved with someone during the night—all news to me. Sometimes he went to bed angry and remained that way in the morning. Other times he acted as if nothing had happened.

On one such occasion, feeling unfairly done by, I stood up for myself. "It's all in your head, like the doctors say, and not true," I said, whereupon he raised his fist and backed me into a corner in front of the kids. He was on the verge of hitting me when Wayne, at seven years old, stepped between us and yelled, "You leave my mother alone!" Ed lowered his fist, looked as hurt as I'd ever seen him, and backed shamefully off. Shocked out of his disagreeable mood, he transformed instantly into the loving father and husband that I so hoped would one day come to stay. But that was not to be. After that, I refused to go to any more dances or social

events, except those that involved his family and didn't include any men for him to be jealous of. That was the only time that he threatened to hit me, but conditions did not improve for long.

As the tension mounted, I also refused to travel by car with him and the kids, except when absolutely necessary. They were noisy and full of life. One day he said, "From now on, keep them quiet while I'm driving." I tried, but to no avail. We stayed home a lot more then.

That fateful summer and fall of 1967 was the worst of our last ten years of marriage. The difficult times became more intense. He made it through the summer haying and chores with periods of normality quickly followed by those of constant complaining. I helped all I could in the fields to lighten his load. As the fall farming drew near, he became more troubled. We hired help, and he made it through the breaking of some new ground.

Christmas was a happy time, as usual. Ed enjoyed receiving Christmas cards long before Christmas; I learned to send many cards so we received many for him to open. We visited with our friends and families, and many of them came to our place. Between Christmas and New Year's, we did only the chores and had fun for a week. Those are happy memories, because without the stress that seemed to come with responsibility, Ed was in a good mood. My life became a succession of schemes to keep him happy and to keep his mind from himself.

As was normal, the excitement of Christmas and New Year's was usually followed by a sort of coming down, as life settled into routine. The kids were happy and healthy; I had by now accepted so much of the responsibility for raising them that I ceased to depend on him anymore. Having him involved seemed to add

to his stress and insecurity and brought on more mood swings. I was having trouble sleeping and would spend most of the night sitting up worrying about how I could fix this situation. The doctor gave me pills to sleep, and I was tired during the day. He gave me pills to wake up, and that worked for a while. I now had premonitions of myself as chief provider and protector of our four children. I felt up to the task so long as I could stay well.

My biggest worry was that I would not be able to pull it off; if that happened, what would become of my kids? One thing I knew for sure: their father was not capable now, or ever, of caring for them on his own. In order to set my mind at ease, I made a will, making members of his family the kids' guardians. That gave me some peace of mind. I filed it away in our safety deposit box without Ed's knowledge.

The winter of '67 was a cold one with deep snow, making it more likely that we'd be confined to the house, except for chores and feeding cows. The snow piled up until it was impossible to use the tractor. Ed dragged hay to the cows, little by little with his saddle horse, using an old car hood for a sled. He was proud of his well-broke, strong quarter horse, Coke, and I was proud of him. Being self-sufficient was important to Ed. Some ranchers, unable to reach their hay, had to have it dropped by helicopter.

In January 1968, Ed's condition worsened. He lay around the house babysitting our only child not in school while I did most of the chores. His brother Vince fed the cows. He began to go to the doctor every few days, always complaining that he was increasingly sick and in pain, and that they were doing nothing for him. His mood swings were more frequent. They usually culminated

in his vomiting, as if to relieve the strange pressure that he felt and no one understood.

I did my best to please him. He watched from the window while I fed the horses and cows at the barn. I returned to the house only to find that I'd done something wrong. I could tell by the look on his face that he was displeased. The chores were a relief after being cooped up with him, as a winter of mounting tensions grew more stressful with each day. The kids were all in school now, except for Lana, and I could start the chores immediately after driving them up the hill to the school bus.

On one particularly icy morning, I milked the three Holstein cows, brought the milk to the house in two trips, separated it, and returned with the skim milk for the pail bunters. There was a slick sheet of ice by the gate leading into the horse corral; afraid that something would fall on it, I spread some hay over it, hoping to lessen the chance. That was the corral where Ed rode his half-trained colts in the summer and where the footing was excellent, because there was nothing ever fed there.

Watching from the window, he saw me spread the hay. By the time I got to the house, he'd worked himself into a frenzy over the fork of hay. Baffled over his behaviour, and confused with my inability to please him, I proceeded to the pig house to feed them, and on to the chicken house to pick up the early eggs before they had time to freeze. When I returned, the grey look was wiped from his face. He seemed to have forgotten about his ruined footing in his horse corral. Like so many of these episodes, he forgot, but I did not.

Now I had just enough time left in the morning to figure out what to cook, which had to be something that wouldn't upset his stomach. On this day I would accompany him once more to

the doctor's office and home in time to catch the school bus. He wanted me to sit and observe his dialogue with the doctor. Back home he had the same complaint: the doctor didn't understand and didn't care. He tried still another new pill, hot chocolate, or milk chocolate bars between meals to settle his stomach, and the lump on his wrist was from tension that called for another bout of pills. The doctor failed to pin down the cause of all this pain that he complained about.

The visits to the doctor increased. I summoned his brother to feed the cows more often and I became the main chore person. His drug consumption was horrendous as the doctors tried to pacify his insistence on being ill, while his body gave little indication of what caused all his pain. Bad spells were usually followed by vomiting, as if to relieve some mysterious pressure. He continually complained of headaches.

Life at home was becoming unbearable. I was worried and tired, and his sickness had become mine too. I'd tried in vain to keep four healthy children quiet at his worst times and predict when his moods would develop. *Something has to give,* I told myself, *before I go crazy.* Reasoning didn't work. I seemed to be a sizable part of his problem. Like the doctor, I didn't believe that he was as sick as he claimed to be.

One night, in the middle of February, he was particularly ill. He didn't eat his supper. He said he was dizzy, and by bedtime he said, "I don't think I can climb the stairs."

I made him a bed in the living room on the hide-a-bed, and he retired early after ingesting several pills. I read the kids their bedtime story as I did every night, and tucked them in bed upstairs, each with his or her small hot water bottle. That was a

cold place to sleep. Then I went to bed with him, and he appeared to fall into a deep peaceful sleep.

Next morning, I got the kids to the school bus, and was about to leave him sleeping while I did the chores, when he woke up. "I don't think I can walk to the bathroom," he said. I helped him out of bed and supported him as he staggered there. I was frightened really frightened! After he was back in bed, I phoned his brother Vince. "You'd better get down here real fast." I told him. "Ed can't even walk alone this morning.

Vince was bigger than Ed and also stronger. He walked into the house, scooped him up out of the bed and carried him out to his truck. "I'll take him to the hospital," he said. "I'll phone you." Ed said not a word.

Vince returned after the trip to town. He did the chores. He said that Ed had mumbled a bit on the way, but had said nothing he could understand.

I prepared to drive into town to see for myself and talk to the doctor. I may as well have stayed home. Ed was not talking. He was making strange noises and waving his arms around. The premonition of impending doom that had haunted me since Christmas was coming true. I went home to meet the school bus, and told my children that their daddy was sick and would be in the hospital for a while. We were almost eleven years into our marriage and had four small children—the oldest being ten years old. I was thirty-two years old, and I had no idea how long that "while" would be.

I went to see him every day for the week he was in the local hospital. Friends and family came to visit him too. He pulled the covers over his head when anyone except his family visited. He couldn't get his words out right, and appeared

angry and frustrated. The doctors were baffled, and after a week of confusion, they finally admitted that his case was beyond their expertise.

I washed all of his clothes because I still believed that he would need them when he came home. One blue T-shirt that he especially liked and wore a lot I did not wash. I spent each night that week curled up in bed, hugging that shirt that still smelled of him and praying that he would recover. But he did not recover. He spent months in General Hospital in Calgary and then began his life in a series of nursing homes. Over the following year, the children and I continued to live in our home, and life went on as near to normal as I could manage.

Life Goes On

In the middle of January of 1969, there were two feet of snow on the level, and much more in drifts. We had been snowed in for a week. The drifts on the long hill leading to the school bus stop made it impossible to get the kids out of the river bottom. One morning I saw their faithful pony Keno run down the big hill behind the house with the rest of the horses. One of his front legs was dangling below the knee, broken. I had a sizable problem. There followed a talk in which I tried to prepare the kids for the obvious. This was no time for weakness on my part. He would have to be put down.

Luckily they were farm kids. The two elder children, Donna and Wayne, knew that sick animals and those chosen for butchering were shot on farms. Nevertheless, it was a very sad morning. He had taught them to ride, had been their companion around the yard all their lives, and we all loved him.

As I did when I was younger and had problems, I phoned my Uncle James. He was a bear trapper on the Forestry years ago.

In those days, the bears were trapped and shot when they killed the cows that ran there. When I was a kid, he shot old decrepit horses for bear bait. I plugged my ears and crawled under the covers in bed to smother the crack of the rifle. He was so good at putting animals down humanely that I now trusted him with our most precious.

Uncle James owned Riviere's Construction. He had Caterpillars and other powerful machinery. In no time he came down our long hill pushing snow in front of his big 4 × 4 truck. Out of sight of the kids, I held Keno with a piece of binder twine. Uncle James put a .22 bullet in just the right spot between his eyes. He dropped immediately; a small trickle of blood leaked from the hole and it was over.

I got my horse and dragged Keno by the saddle horn through the deep snow, across the frozen creek to the farm bone pile for our dogs and the coyotes to devour. The kids didn't even hear the shot, but they knew what was happening and I hoped they were accepting it as humane and necessary.

It was a lot for such young minds to process. I told them stories of all the animals I'd owned when I was a child and tried to get across the idea that animals come and go. We read stories of young people and their animals. I was surprised to hear from them that they wanted dogs, cats, and rabbits too.

Later that week, Uncle James' grader came down the hill and cleared the road, so the kids could go back to school. He followed the grader in his truck, and when he came to the house he sized up our situation with a critical eye. "You shouldn't be here in the winter without Ed," he said. "What if it was one of the kids or you instead of a horse?"

For two years, I had refused to leave the farm. I milked two cows, raised pail bunters, calved sixty head of cows (with help), and raised pigs, besides managing a garden, getting the kids to school, and dealing with teachers. One of the hardest tasks was hauling the milk to the house for separating and then carrying the skim milk back to the barn for the bunters.

Many mornings my preschoolers spent time in a safe box stall with a new calf or two while I milked the cows. They loved playing with the calves and never complained. A highlight of milking time was watching through the stall boards as I squirted milk into the cat's mouths and across the alley into theirs. Sometimes I found a nest of very new kittens and put them in there too.

My brother-in-law Vince showed up to check on me one morning while I was separating. He said, "I'll fix one thing for you. I'll put the separator in the barn." That solved one of my problems, but there were many more.

Among my biggest projects was putting on a branding, getting the cows to pasture at the foot of the mountains, and dealing with gas people. Again Vince came to help me with the branding and chasing the cows.

When Ed left we had four wiener pigs. I endeavoured to raise them to market weight and sell them. That project gave me plenty of reason to question my skills as a pig farmer. I locked them up in a cement-floored pen in the school barn, which we purchased when the Marr School closed. This could have constituted cruelty, for they were never to see the bright light of day or root in the soil until they were ready for market—and only briefly then. I was well aware of how destructive pigs can be, and these weren't going to get into my garden.

They ate the scraps from the house and shared the skim milk with the pail bunters. Cleaning the barn for the little pigs was not a huge problem. Pigs are really clean animals if given a chance. But little pigs grow quickly into big pigs, and confined to a small space they emit a disgusting odour and pose a sizable cleaning problem.

I had no idea when a pig was ready for market and they grew to a size that I could no longer cope with. By now they were eating huge quantities of grain that I had to buy and I was afraid that my profits were being eaten up. I decided to sell them to the Auction Mart in Pincher Creek

I had helped Ed load pigs before and, with the help of a neighbour, I anticipated no problem. I backed the truck up to the chute and opened the end gate. The chute was attached to the round corral about a hundred yard from the pig barn. The pigs had never seen the full light of day or experienced an area bigger than a 12 × 12 foot pen.

We had to bodily push each one out of the barn, and then, blinded by the bright light of day, they squealed and ran in four different directions! A pig's lack of neck makes it impossible to lead or pull it. We had to run down and capture each animal and push and beat it across the corral, up the chute, and into the truck box. With each one we had to close the truck and start over with the next one.

Thus ended my first and last venture at raising pigs. The two of us had a hearty laugh and retired to the house for a drink before I finished up by hauling them to the stockyards. They were docked a little for being so big, but they brought a decent price. I never figured out my expenses.

With three gas wells on our place, I had to negotiate payments for leases and pipelines. Through it all we kept up our visits to Ed, who was moved to Southland Nursing Home in Lethbridge, Alberta. It was all getting to be too much. I couldn't expect my brother-in-law and my nephew to help me forever. Vince had his own ranch to run, and Ronald had his education and work on his dad's farm.

In the spring of 1970 I sold all the livestock, except our horses. That spring I began to make plans to start what I believed was a new chapter in our lives.

I rented the farm on a share basis to a neighbour who was a good honest farmer. I had an auction sale and sold the farm machinery and a lot of shop equipment. I watched the buyers drive away with my hopes and dreams for the last decade. I stood on the step and cried. No amount of money could compensate for the hope I lost that day.

I was never satisfied to have given up my teaching career so soon, to raise a family, deal with Ed's health problems, and learn the skills involved in becoming a farmer's wife. I'd done all that to the best of my ability. Although I did these things by my own free will, I felt cheated all those years. This unfortunate situation that we found ourselves in now opened up an opportunity for me to catch up with my teaching career, but it turned out to be my first serious mistake. I moved the kids away from that wholesome farm life. With the money from the auction sale, I bought a house in Pincher Creek. I moved out of my beloved ranch home and rented the farmhouse to a family. After Christmas holidays in 1970, I took over a grade four class at St. Michael's School, for a teacher who was on sabbatical.

That was a bittersweet movement. I was happy to be teaching again, but I was still overworked with managing the farm and a house in town, dealing with renters as well as gas and pipeline people, and making frequent trips to Lethbridge to care for Ed. I was still determined to keep the kids in contact with their father. The brain damage had changed him so dramatically that they seemed hardly to know him. They had been very dependent on me for the last few years of Ed's sickness at home. Now their welfare depended solely on me. It was a responsibility that threatened to smother me. I bypassed all other stages of recovery and went into survival mode, where I stayed for many years.

The trips to the nursing home were taxing. The kids raced through the halls, exercising their cramped legs after the long car trip, ignoring their father altogether. They seemed to amuse the patients, but they did not amuse me. When I bribed them with promises they settled down, and we all dreamed of ending this visit, buying the promised treats and getting on the road home.

At the nursing home, the orderlies taught me how to transfer a disabled person from a wheelchair to a car and back again; it was all about technique and a strong back. I didn't have to ask for help anymore. I took him and the kids to parks for picnics several times. It was impossible to tell whether he enjoyed these outings or not. I certainly put a lot of effort into them.

Trying to hold the family together by arranging a Christmas outing, when Ed was still in Calgary, I loaded the kids up and went there to take him and them to see the city lights. The kids were delighted, but it was impossible to read Ed's reaction. I wondered whether he was even seeing them as they were, or if they appeared to him only in a blur. His eyesight too had been affected. Glasses were out of the question, since he didn't have

the coordination to handle them. Later on, in Saint Michael's nursing home in Lethbridge, Alberta, many of his teeth required fillings and still later on pulling. With so few left, he normally would have had them all pulled and replaced by false ones. Again, he could not have handled the dentures. I motored to Lethbridge and wheeled him across the street to the clinic for the appointments—all of this from a man who had 20/20 vision and one small filling before the acute attack. I felt helpless as our situation seemed to spin farther out of control.

In the early days of Ed's confinement, I rented a hospital bed and brought him home for a few days at Christmas. I spent that Christmas nursing him. We wanted to feed him his favourite foods. We overfed him on rich treats, and I spent Christmas afternoon cleaning up the bed as he rid his stomach of the problem, first from one end and then from the other. In disgust, the kids went out to play, and I became aware of another fact about myself: I was a teacher, a mother, and a lot of other things, but I was so not a nurse for my husband. There was no satisfaction in that experience for him, for me or for the kids. It was after that ordeal that I realized there could never again be any degree of normality unless there was a great change in his condition for the better—a situation the doctors assured me was not to happen. From then on his life would be spent in one nursing home after another, and his lifespan would be normal. I decided to go on with my life but stay married to him in order to preserve all the land for the kids and give each of them a home base.

Ed never accepted his disability, in spite of the few things he relearned. His goal was to walk again, and he never gave up hope. At first I was angry with everything and everyone, including God.

I felt hopeless, depressed, and out of control. Since I couldn't control our lives like I'd tried to for ten years of marriage, I searched for whatever I could, resulting in meaningless relationships with other men and a string of geographical "cures."

In an effort to further my education, I sold my house in Pincher Creek in the summer of 1971, bought a new trailer in Calgary, and moved it to Strathmore, Alberta, a small town east of Calgary. Strathmore was smaller than Pincher Creek but close to the University of Calgary. For six months, a housekeeper got all four of my kids off to school and supervised them until I came home. How difficult it was to study and do homework again and care for the kids. Nearly every weekend I drove back to take care of business at home and connect with our friends there.

The place I sold on Main Street in Pincher Creek became a lucrative piece of real estate, and the education would add very little to my paycheque at St. Michael's School when I went back to teaching. I was still far away from the degree in education that I craved. It was just an interesting geographical cure, like many more that I embarked on over the years, chasing the fulfillment and happiness that dangled like a dream, just beyond my reach.

In the summer of 1972, I moved my trailer back to Pincher Creek and started a ranching company with a friend. By combining our cows and land we made Fran-Tel Ranching a lucrative business. By this time, booze had become my answer to the hurt that dogged me and never seemed to let up. It eased the pain and built up my ego, but multiplied my problems.

My "best" friend, alcohol, garnered me a whole new crowd of friends who accepted me as I was. In a bar setting they laughed, danced, and told stories with me. They helped me to forget my

worries, if only for the night. I believed that I could divide my time between taking good care of my children in a responsible way and still have my mind-altering drug. But alcohol is insidious, an addiction of both the mind and body. It was tightening its hold on my life.

I continued the visits to my husband, taking my children along so they would have some semblance of having a real father, a man that they became duty-bound to visit, even though they had very little remembrance of his true nature. His illness had a profound effect on our lives, keeping us all captive for a very long time.

That same year, between Christmas and New Year's, my new mobile home burned to the ground in the night, at my ranching partner's place. My family escaped, but my son's little friend, Donald, did not. As everyone jumped to safety from the escape door, he went back for his pants or something. He was found in the master bedroom, where he had died from smoke inhalation.

It didn't matter at all that our Christmas presents were gone, along with most of our belongings. Ed had been in that trailer the morning before. He was home for Christmas, but was at his sisters when the fire occurred. We would never have been able to get him out alive. Before New Year's, Donald was laid to rest, and two families were devastated by grief.

For the next ten years I would not allow my kids to stay in a trailer overnight unless I was there. I made my rounds every night whether in a trailer or house, and I cleared the way from every bedroom door to a fire escape before going to bed. Healing was much slower for me than for my children. They bounced back, and my paranoia lessened with time. The authorities said the fire started in the utility room. A fire is like a suicide. "If only I had

done this or that," people often say. No amount of speculation or blame can ever make it right, but life must go on.

That summer I moved my family back to the ranch, where we camped out while doing the haying. The renting family was still in the house. It was our best summer yet since Ed had left for a series of nursing homes. The kids helped with the work, and we moved back into the house in the fall.

A few years later, our ranching company broke up due to the influence of liquor and stress. By this time, booze was affecting every aspect of my life, and I used it more often to dull the pain. I never got past the survival step in recovery. I never thought about my own welfare. I had to be strong and do whatever it took to give my kids the best upbringing and education I was capable of under the circumstances.

I regret not reading the book *Seven Steps of Recovery When You Lose a Loved One*, which a nursing home staff member had once showed me. "You should read that book. It will help you to recover from your loss," she'd said. *I didn't lose him,* I told myself in my ignorance, *I'll do it my way.*

The pattern had been set in motion, and I brought a series of drinking men into my life. These relationships all ended in unpleasant breakups and resentments. I was a mother bear to my children. So much as a word of discipline directed toward my kids sent a man packing. I was doing my best to feed, clothe, educate and fill that hole left by Ed's absence. However, good men are not usually found late at night in bars, and I spent a lot of time there.

My real love was for my husband only. Short-term relationships meant very little to me. Control over men gave me a sick sense of satisfaction. In my sick mind I'd been let down by my

dad, my first love, and my husband—all innocent of the charge. My own life was spiralling out of control.

During the '70s and early '80s, there were graduations and weddings for me to take care of. For these occasions, my son Wayne took his dad's place and accompanied his sisters down the aisles at their weddings and through first dances. We took Lana's wedding to the Rehabilitation Unit grounds in Lethbridge, Alberta, where Ed was living. On a warm fall day, with coloured leaves on the ground, gentle breezes stirring them up, and the sun lending its warmth, Ed gave her away from his wheelchair. He showed little emotion, but for that day I hoped he was a proud father. Illness had cheated him of so much more.

My fourth daughter, Carmen Lee, was born on February 19, 1979. Her father, Ken Gilbert, was eleven years my junior. We planned her birth. This pregnancy made me feel young again, and she filled the vacant place in the cradle that my other four children had all but evacuated. At one of the lowest times of my life she brought joy and purpose. I had finally done something that was purely for me.

By this time I'd made another geographical cure. I was living with Carmen and her father in yet another house trailer that I'd bought in Pincher Creek. For the first two years of Carmen's life we were both drinking far too much. Life was hectic in our home because of it. I was coming to the realization that this had to stop, and for me it did. After a moment of clarity, I saw where I was headed and it was not pretty. I had taken my last drink.

"We just can't sit and watch Carmen grow, like in the song," her father said.

"Maybe you can't, but I can. Either you come along with me or I'll go alone," I retaliated in anger. He tried to quit drinking a few times, but it was not for himself, and it didn't work. I was prepared for this eventuality. With my drinking problem newly out of my way, I gave this relationship up as a learning experience and forged on with the raising of our child. She loved her father, but his drinking was unacceptable. She had to know and understand that. He came to see her occasionally, usually on her birthday and Christmas. I did my best to make up for his absence. Without the drink, I was clearheaded and determined to enjoy every minute possible with my daughter. With that break-up, I moved once more—this time back to the farm.

The only constant thus far in my life was my husband. He was placed in one nursing home after another, finally settling in St. Michael's in Lethbridge, which was over an hour's drive from my home back on the farm. He managed to use a computer to make holiday and birthday cards, play cribbage, and feed himself reasonably well, giving his life more purpose. With help from his new friends and support group, he took part in handicap riding. I brought him the saddle that he was so proud of, hoping it would bring him some pleasure, something familiar, a reminder of a life that didn't go like it was supposed to. His greatest preoccupation was with walking again. But all the therapy in the world was not going to accomplish that, and life's struggle went on for all of us.

Now, in middle age, with a young daughter and a mind free of the effects of alcohol, I began to heal and finally move past the survival stage to that of recovery. For twenty years I'd lived for my family alone. Now I wanted to take some quality time for myself, which was long overdue. That, I believed, would necessitate one last move. It was a move that I would live to regret almost as

much as the others. I would forever miss my home on Drywood Creek, but a move closer to the mountains where the good riding was pleased me too.

PART TWO

Spiders In My Bathtub

I moved to the Thornton house in the Twin Butte District in 1986, hoping my life was back on track. Now, at fifty years old, I wanted a relatively quiet home, a place to reflect on where I'd been as I began to move on. There had been much sadness, times, and events that I regretted, and many poor choices made as I chased after my youth. Except for my youngest, Carmen, four of my kids were grown up and embarking on their various interests. I was proud of their accomplishments and my part in bringing them to this stage in their lives.

Now, however, I was thinking that it just might be time to give my own future some thought. I'd never been handed much. I'd become angry with the loss of my dream marriage, moved into survival mode, and stayed there for twenty years—married but forever in limbo, never again able to live a normal life with a man. Staying married to my husband saved the land for my children, and my priority was to leave them each a piece of land to serve as a home base. I hoped that I was finally in recovery from all that

had passed. I thought it was long past time to give my own future some priority.

Over the next few years, I concentrated on repairs to my new property: fences, road, house, and as many rides into the back country as possible. In 1988, I sold my heavy old horse trailer and bought a new one. I had it custom made. It was a three-horse diagonal stand, with interior lights and a roomy saddle compartment with swing-out saddle racks. It was my dream trailer. I put a camper on my truck, so I could stay wherever my day ran out. This was as close as I'd ever been, in thirty years, to the freedom that I craved.

There had been my "running away years" filled with useless geographical cures and a series of recreational vehicles that represented freedom of movement for me as I tried to run away from reality. Since I was a child, I'd solved my problems without help from anyone. It never occurred to me to ask for it when I was most in need. For the first time in my bittersweet marriage, I put myself into the equation. The march of time was catching up with me. That camper and horse trailer signified my ticket to the freedom that had always escaped me.

"For the rest of my life, I'm going to do exactly as I please," I told my friends, "and I please to ride as much as possible until I can't ride anymore." It sounded like a joke, but I was dead serious.

I moved into a house that was at least a hundred years old. It had seen several improvements over the years, though none to the foundation, which was a good place to start. Why would anyone remodel an old house by building a relatively modern kitchen over an open water well and put the door on the north side? It didn't occur to me at the time, but I was setting myself up for an

interesting, troublesome future in this old house. It was as cold in winter now as I imagined it must have been a hundred years ago.

I remember the house when I was a kid, back about 1944. Only the high part with the steep roof was there then. There was a well outside near the north door. The door was padlocked tightly, even when the owner, Ms. Rankin, was out in the yard. The north window seemed to be much higher than it needed to be. At any rate, it was too high for kids to peek in. I don't remember much about the house or the slumping weathered porch to the west. There were no trees close by, but there was a forest of them in the back.

I remember only the things that made the greatest impression on me: the height of the house exaggerated by my own small size; the wobbly wooden steps that became a seat for my brother and me as we listened to the constant bickering between our dad, Bob, and his employer, Ms. Rankin, who had no intention of entertaining a pair of half-breed brats any longer than she was forced to. My dad worked for her, but I couldn't figure out why. They carried on a series of arguments about everything that came to two active minds, forever competitive. Jean's anger only served to amuse him.

My dad had a circular wood saw set up in the yard. He hauled the logs in from Ms. Rankin's various properties in the Twin Butte area, sawed them into stove-length blocks, and sold them to the residents and businesses of Waterston Lakes National Park. Sharing the proceeds of this adventure was another topic of discontent, and she nattered on about his dishonesty. He teasingly offered to shove her into the dangerous big saw and have no more lip from her. All of this my brother Bobby and I took seriously from our perch on the wobbly old steps.

I remembered my dad telling my brother and me, "Stay away from that hole in the ground. There's water in there." Consequently, we lifted the flimsy lid and peered into the forbidden hole as soon as he turned his back. Perhaps it was memories like this that made me feel kinship with this old house. It certainly was not good sense.

Now, fifty years later, with memories like these, my focus was on pleasure riding. Although I was familiar with the Forest Reserve, where I had followed my dad on horseback over the skinny trails and shale banks and over high summits, across fast flowing creeks in flood and miles across the country into Gladstone Valley, I was not familiar with the back country of Waterston Lakes National Park. Now, Waterton Park was in my backyard.

When a friend, Nona Bonertz, learned that I lived in the Thornton house and had time to ride, she was soon calling me on my phone. "Have you ever been to Twin Lakes?" she asked. I had not, and I was interested. That was the beginning of a long friendship between the park, Nona, and me and Carmen. Perched on a narrow trail high on the summit between Lower Twin Lake and Peck's Basin, I gazed down on a scene that took my breath away. From that moment on, I was hooked on seeing the rest of that picturesque back country.

Soon, an accomplished rider, Dorothy Lang—another person who knew the park—came trucking up to the staging area with her red pickup and two-horse trailer. One by one they introduced me to the wonders of the backcountry in Waterton Park. Once over a trail, I was soon back—often alone and often with friends—eager to share this wonderland.

My youngest daughter, Carmen, entertaining the neighbour kids.

Photography opened a whole new experience for me. When a teenager, I managed to acquire a camera of some kind—a little quick-shot thing like Kodak sold. They took small black-and-white photos on film, always in the wide angle mode—so wide that the subjects were often too far off in the distance to make out. The negatives were small and almost impossible to read.

But I snapped away, then waited weeks for the mail to return the prints, only to be disappointed by the quality. Until the advent of coloured film, I took all our kid's photos with my snappy little camera and Ed's bigger Brownie. I diligently gathered photos of each child and fashioned them into baby books—my treasures. Most of them were unfortunately among the irreplaceable memorabilia damaged in the trailer fire. From the water-drenched books I salvaged what I could. I spread them

out to dry and watched them curl up in the effort. I put them into an old-fashioned album that smelled of smoke and they brought back terrible memories for years.

Sixteen years after that fire, I had the money to buy a good camera, an AE1 Canon with both wide-angle and telephoto lenses. The local drugstores developed the film, and I moved with renewed energy into a whole new era of photography. After a short course in darkroom techniques that tweaked my interest, I embarked on one of the most rewarding hobbies of my lifetime. I built a darkroom upstairs in my house and bought equipment secondhand. I was absolutely fascinated with the process. Black-and-white pictures materialized like magic before my eyes. I spent hours in the glow of safety lights and the smell of chemicals.

I read photography books and learned to use the SLR camera under different conditions. I studied the works of the masters until they were old friends. When photography workshops came to my attention, I signed on and travelled the Alberta foothills west of Turner Valley, Alberta and the Banff Parkway, in a convoy of amateur photographers accompanied by professionals. I was like a sponge soaking up all that information.

With this knowledge, I went to my beloved mountains for rare flower and scenic shots and rode the foothills ranch lands recording old homestead buildings. I was so into photography that I began to see everything through the opening the size of the 35mm slide. My albums of photos and slide files grew until it was necessary to add more bookshelves and cupboards in my house.

I started a photography club in the Pincher Creek District. It flourished for a few years. It interested some members enough to improve their technique and equipment. Some went on with

increased talent and some to sell their work. I like to think that I had some small part in their success.

I made note cards of the wildflowers and old buildings and framed others for sale. As time went on, and the old buildings succumbed to the ravages of nature, my photos became even more important, creating a new market. I didn't make much money from my photography. Success for me was measured in pleasure, accomplishment, and escape from the worries of the world that were still dogging me.

My good friend Dorothy Lang and me. She and Nona Bonertz showed me the wonders of Waterton Park.

Then technology changed my perspective on photography. I grew weary of the smell of chemicals, and sold all my darkroom equipment. Photoshop took its place, and I embraced

the computer age—then, reluctantly, the digital camera. Times changed so dramatically that I could hardly keep up. My youngest child, who grew up following me through the mountains, as I had my dad, graduated from high school; once more I was alone—this time, I knew, for good.

As my short-term memory faded, my long-term began to surface. I spent endless hours riding alone in the mountains reflecting on where I'd been and trying to make sense of all that had happened to bring me to this point.

Many years later, I try to make sense of all those bittersweet years, now lived only in memory. I have come to enjoy the sociability of riding with friends, but it was during my alone times that I did my best thinking and reminiscing. I kept a journal on all my experiences, and I added to the numbers of essays that I felt compelled to jot down—not once thinking that I may be a writer.

With only my horse for company, the peace of the mountains comforted me like a warm blanket. That must be the feeling that my grandfather Frenchie had at his hermitage, there on Pincher Creek. I thought about how it would be to wake up in the morning in that shack as he had and go to sleep there, enjoying the solitude but never lonely. Back to my riding roots, in my home near the mountains, every moment was even more precious with the passing of the years.

Many times in my life, I'd heard my friends say, "You shouldn't ride alone." But I'd respond with, "I'll take my chances. Life is a game of chance and risk. I am perfectly comfortable with my horse." Accidents haven't happened very often, but there have been a few over the years.

There was the cold rainy morning when my three-year-old horse, Fancy, fell with me on a rocky river bottom in Kananaskis Country. That rattled every joint in my body and left a permanent bone bruise on my hip where my camera case failed to cushion my fall. I recovered sufficiently to ride another horse the next morning, but that horse took a year to get over a sprained ankle.

My daughter's big barrel racing horse Yoshi bucked me off on the side of a mountain, when the lead shank of a packhorse slipped under her tail. I consumed a record amount of Tylenol that week while hunched over a cookstove preparing meals in an outfitting camp. That same horse threw me off into the bushes when she flew over a big log, clearing it like her life depended on it.

While loading a horse that belonged to my cousin Floyd, I was knocked out for a while when she hit me between the eyes with her head. That broke my glasses, but it didn't prevent me from loading her and riding in the mountains all day. I have a permanent dent in my nose cartilage from that experience.

Then there was the time I tried to lead a young horse across a stream in Smith Canyon. He jumped right on top of me, knocked me down and missed me with all four feet. Again I was alone and very lucky.

Once I found a solid tree branch among the leaves—with my head—when I was chasing a cow. I had a concussion and a headache for a day. But none of these accidents were as serious as in 2007, while alone on the trail to Rowe Lakes in Waterton Lakes Park, when I nearly killed myself and my best horse, Spinner.

It was a perfect fall day, the same as many I'd enjoyed over the previous twenty years. An ideal day to ride, I was to go with two friends, but when they phoned to say they would be late, I

decided to go on ahead alone. Most of the trails in the parks are groomed for hiking, and as such are not a challenge for a horse, so long as you stay on them. Spinner and I knew every stone and stick on that trail. I was not anticipating any trouble. My only concern was bears, and I was as vigilant as always. I knew better than to get careless in bear country, but there is always room for human error.

I crossed the big avalanche area, and was rounding the corner into the timber, when Spinner sensed the presence of wild animals. Agitated, he whistled through his nose and craned his neck to the upper side. There, through an opening in the trees, was not a bear but two rams facing off.

I grabbed my camera. This was the picture of a lifetime. With a short hold on Spinner's reins to control him and trouble focusing my camera, I leaned heavily on my left stirrup. That was mistake number two. Mistake number one was in failing to tighten my cinch enough when I left my rig at the staging area. The extra blankets that I used to compensate for Spinner's twenty-year-old swayback played their part, and my saddle turned!

It all happened so fast. As I tipped over, I pulled Spinners head around to the right, tipping him off his feet, and over the edge we went! We landed in a heap, fifteen feet below against a tree. That tree broke our fall. Had it not been there we would have tumbled down the steep mountainside and over the boulders into the ravine far below. He came up on his feet. Somehow I was at his head —still with a good hold on his reins, and demanding that he stand still. "Whoa," I yelled. He stood shaking on the steep rocky mountainside, his saddle under his belly. He wanted to go down. I knew he was a goner if he did. I tried to loosen the cinches and release the saddle, but they were too tight. It took

all I could do to hold his head and attempt to control him. I had trouble standing. It was not only steep, but covered with mossy boulders. He kept fighting to stay on his feet, and I kept fighting to keep control of his head. I kept saying, "Whoa, Spinner!" I knew he would obey me if possible.

My expensive camera equipment was scattered about the rocks. Whenever I could, I reached down, picked a piece up, and tossed it under the bush where my hat lay. I hoped to pick it up after this episode, if I still had need for it. I have no idea how long we were in this predicament. It must have seemed longer than it really was. Soon it was impossible to control Spinner. I had no option but to take a big chance and hope for the best.

In desperation, I turned Spinner's head toward the trail above us and, throwing the reins at him, I slapped him on the neck and yelled, "Go, Spinner!" He shouldn't have been able to climb that steep rocky bank with the saddle under his stomach, but he did.

I expected him to run off if he made the trail. I didn't care, so long as he made it to safety. He stood there, even though the rams were still butting heads above him. He waited while I climbed up the bank, grabbing on to the berry bushes, and pulling myself up to where he stood on the narrow trail, saddle still under his belly.

When I got to him he wanted to leave. He was in such a state that I was afraid if I fought him too much he might slip off the trail again. He was terrified of the rams above us. I hoped that my friends would show up about now. I tried in vain to loosen the saddle. I could not, so long as I had to hold his head with one hand.

I was happy to see two hikers coming up the trail. One was a man. He didn't know anything about the rigging on the saddle, but with my instructions he was able to loosen it. It fell to the

trail under Spinner. With his help I re-saddled. The helpful man slid down to where Spinner and I had landed, and gathered up my equipment, retrieving my camera and case, telephoto lens, and my empty lunch bag. Even on foot they were cautious about venturing down to where I told them we'd fallen. The woman kept saying, "Be careful, Jim, be careful!" My cell phone and wide angle lens were missing along with my lunch, which had mysteriously escaped its bag and was now squirrel food.

I thanked my helpers, led my horse to a safer place, and sat on the side of the trail, thinking about how close that was. Other than a very sore finger that the reins had injured and a skinned knee—the one that I had the joint replacement on seven years before—I didn't seem to be anything but shaken up. Spinner was already forgetting his ordeal.

I rode up the canyon, and tied him to the rail at Rowe Flats, where I waited for my two friends. At first I thought, *I won't tell.* Then I remembered that I didn't have a lunch. I needed their help to find the rest of my equipment on the way home, so I swallowed my pride, and said, "Sit down here. Give me some of your lunch, and I'll tell you the craziest story you ever heard."

Had either Spinner or I broke a leg, or had I knocked myself out on that tree, we would have been dead at the bottom of that ravine—out of sight. It didn't keep me from riding alone again, but it did reinforce what I already knew: safety comes before the picture of a lifetime.

Carmen was seven years old when we moved from the ranch on Drywood Creek. I wasn't moving out of my home because this place was an improvement; I was selling it to my daughter and son-in-law so they would have the best possible opportunity for

a successful future in ranching. I thought it better that I move entirely off the place and build a new life for my youngest daughter and me. There was a quarter section of land with this place, and the Twin Butte store and post office were not far away. We were only a few miles from my other children.

My first concern was with the road from the highway to the house. It was barely more than a trail, and sagging so low as it was, the drifting snows of Alberta winters were certain to render it impassable with every winter storm. I hired my cousin, Floyd Riviere of Riviere Construction, to raise the road and gravel it. Thus began the spending of what I had left from the sale of my home, after paying too much on the new purchase in the first place.

After about a year of putting up with a bathtub that threatened to fall through the rotten floor into the crawlspace, I decided to create something more fitting to a soon-to-be teenager and me. I had lived with a musty, spider-infested old bathroom in the other house for years.

I hired a carpenter and instructed him to cover the walls with cedar and replace the high, old-fashioned window with a smaller, more modern one. We put in a tall-sided soak tub with jets and replaced all the old-fashioned fixtures with modern ones. When finished, the room was even smaller than before, and the spiders that I'd hoped would disappear with the old walls and rotten floor seemed to like the new tub even more.

The open well, now under the kitchen, was the ideal breeding place for lizards, spiders, and frogs, because it kept the basement perpetually damp. It overflowed with the run-off every spring, flooding it, shorting out the electrical appliances, causing even more debt. The plumbing company reluctantly wrestled new

ones through the trap door that led down into what my grandchildren called "the hole." I reluctantly paid the bill and made light of the situation by bragging that only at my house could you listen to frogs croaking in the dead of winter.

When we went for our morning showers, there were spiders in the bathtub, regardless of my expensive renovations. When the water hit them they curled up in little balls, but that did not impede their ability to bite. As we know, the "itsy bitsy spider" goes up the water spout and comes down again when the rain stops. This we found was true of the bath drain as well. I knew that there was an endless supply of them below the tub, but I never really knew whether they survived the hot water to come back up the drain or navigated the slippery tub to get there. In time we learned to sidestep them until they gave up the struggle and exited via the drain. I bathed and sidestepped spiders for the next twenty-odd years.

My grandson Ty, when he was about to enjoy Grandma's jet tub, felt sorry for a poor shrivelled spider, and attempted to rescue it by picking it up. The spider was not as kind as he. Later that evening I noticed one of his fingers was swollen and rather red. He was going to suffer in silence, but upon questioning offered, "It might be the spider."

That old house apparently was devoid of insulation. The floors were like blocks of ice, and the only warm place was up against the wall heater in the sitting room—all variables that I might have taken into consideration when I determined to buy this run-down old piece of property.

However, this old place near the mountains offered a splendid opportunity for me to catch up on the riding I so loved. I rose early and checked the weather, made a lunch, and loaded

my horse. With my gear in my horse trailer I then trucked off to the mouth of one of the canyons that I knew so well from my childhood.

The Chinook winds in our country are notorious. To forecast the weather, I checked out the long grass in the small lake east of my house. If the slough grass was swaying like ocean waves and the water dark and brooding, riding in the high country was not only unpleasant but dangerous on the summits.

Years of trailing after my dad in the mountains had acquainted me with most of the good round-trip rides in the Forest Reserve on the eastern slopes of the Rocky Mountains. The events of the last twenty-five or thirty years had separated me from the back country. There was precious little time—almost all of it was taken up with farming, raising a young family, and dealing with Ed's health problems—to ride for pleasure.

Now at my new place, with my children grown and me on the doorstep of old age, I had lots of time to reflect on my past life. The years had been difficult, wrought with regrets and trying times. I had been very young when a twist of fate weighed me down with more than I could handle alone. I did the best I could, but it had never been good enough for everyone.

I toughened up over the years. It was difficult to hurt me now. I was enjoying life riding in the mountains, travelling, and driving down the road with my youngest daughter, pursuing her barrel-racing dreams that so long ago had also been mine. I tried to give her the chances now that I'd missed myself. For a few years I lived again through her, and with fewer demands on me now, I finally enjoyed the freedom that I so craved.

After living in a string of nursing homes over the years, Ed was now in Lethbridge, closer to home. The kids and I made regular visits to see him. We still brought him home for the day at Christmas. Now he was so institutionalized that he wanted to return after a few hours. He had learned to use a computer to play cards, and could feed himself, though with much trouble. But basically he was in the same shape as he had been all along. A few things were relearned, but the brain damage was irreversible. There was some speculation as to whether he ever had porphyria. The prospect of an exact diagnosis was all but forgotten with the passing of so many years. Many doctors had attended to him, some without my knowledge.

My mind often travelled back to what seemed a lifetime ago, when we were living in Pincher Creek, and I was teaching school; that was the time when the pressure was the greatest on me, and my brother-in-law had suggested I accompany him and his wife to the local bar. "The outing will do you good," he'd said. "You've had too much on your plate for the last two years."

"How about the last ten?" I'd said. That was approximately the duration of my marriage thus far.

That night was the first time that booze did anything for me. I was happy. I laughed, and I relaxed for the first time for so long. That was the feeling that I craved, and that was the beginning of a habit that worsened over the next ten years. At first it was insidious and slow. I was going out and drinking only on weekends. It seemed so innocent. But soon the booze was coming home and being consumed during the week for a pick-me-up. Alcohol is cunning, baffling, and powerful. First you control it, and then it controls you—and, if given time, can kill. I had forged on, raising

my family, running a farming business and teaching school, much of which was done under the influence. The company I kept, and the decisions I made in those years, were not of the best choosing.

Somehow I managed to care for my children, still make the nursing home visits periodically, and bring Ed home on holidays. Foremost in my mind was always the preservation of the farm, so that one day the kids would benefit from it. In order to do that, I had to stay married to a man that was incapable of being a husband, and my chances of ever having a normal life with a man again were nil. But I was young then, and I wanted to live. I had convinced myself that it was a catching-up time for me.

My first grandson lived largely with us and was more of a brother to Carmen than a nephew. Cameron was born to my second-youngest daughter Lana, when she was just sixteen. For a while they both lived with me. Lana's second child, a girl, was born a year later. Hoping to give her a better life with both a father and a mother, we put her up for adoption, a process more heartbreaking than the virtual loss of my husband to the nursing home twelve years previous.

Lana called her beautiful baby girl Leah Marie. I wrote her name in my family birthday book, and started counting down the years until her eighteenth birthday when I would go in search of her. Each September 29, I opened the book, pictured her there in the hospital again, and cried for her. Was it grief, or was I feeling guilty? I tried to answer that question. It had been my decision to give her up, with Lana's consent and by the advice of several counsellors. I was forty-three years old then. I would be seventy before that question was answered.

As time rushed on, I felt again like a kid, back when I'd ride the mountain trails with my dad. I needed a means to get my life back on track. Riding was my therapy of choice. That, too, was when I began to write more essays on any topic that occupied my mind for any length of time. Once down on paper, I was able to move on until I felt the urge to write again. When I was in a restaurant, I scribbled on a napkin, and in the middle of the night I scribbled in a notebook placed on my night table. I kept a tablet near the bath, and produced pages blotched so badly that they were hard to decipher. With absolutely no idea why I was doing it, I threw the scraps of paper into a box and forgot about them for a few years. To satisfy my urge to ride, I averaged fifteen trips a year over the trails of my childhood, did wagon trail camping trips across the prairies in Alberta and Saskatchewan, and worked for two outfitters in the Rocky Mountains of Alberta. In keeping with my urge to record my experiences, I religiously kept a journal of my life, both on the trail and off.

For years I led a double existence. In one, I took back my life and immersed myself so deeply into it that I thought only briefly of the other. In the other, I visited Ed in the nursing home periodically and coped with the problems in my life, most of which I now had better control. For the next twenty years, the park and country to the west were my escape from the cares of the world below. Up there with my camera and horse, I did my best thinking, hoping one day to tell the story of the hardships, the loss, and the joy that my children brought to my life, with a happy ending to my bittersweet memoirs.

This "new" place that I moved into was where I planned to live and do all the things that interested me in this sober life. I was still as ambitious as when I married. I wanted to travel. I wanted

to ride and teach school in Australia. I wanted to seize every opportunity to make up for lost time and really experience true freedom. I was still the rebel that I'd been all my life. I had lost my identity and pride as a Métis child, and I wanted that back too. However, it soon became apparent that there were many more challenges ahead for me. There were many loose ends in my life's journey.

My granddaughter Jen Anderson with me after our happy reunion.

Back To My Roots And Three Full Circles

With the new millennium lurking, it became all too clear that I was approaching the autumn of my life. There were too many loose ends left dangling in my quest for recovery and some semblance of serenity. I needed to do something just for me.

When I was a kid, I asked my Uncle James whether we had Indian blood. He replied, "Not enough to worry about." I didn't know it was something to worry about. I spent many happy hours playing with native kids when I followed my dad, gathering horses on the Indian reserve. My brother and I stayed in a bunkhouse or sometimes a tent with Indians where my dad contracted haying. Some of those kids stayed with us at our riverbottom home. We never entertained the idea that we were different when we were small. It was adults who caused us to doubt our identity. This happened when my brother and I heard a white man say, "You can trust an Indian or a white man, but never trust

a half-breed. That's a bad mixture." Someone had stolen the gas from his car and he blamed the only Métis around. I knew that my grandparents had disowned my mother because she was in love with my dad, and that he was called a half-breed. Little kids have big ears.

A few years later, at a school picnic, I won a race that a girl, Jennie, from another school was expected to win. Out of the teacher's earshot, she shouted, "We call you Rivieres 'those half-breeds up Drywood Creek.'" I slapped her face. I wasn't sure why. Maybe it was the accusing tone of her voice.

I began to notice that our lives were different from anyone that I knew. We lived in a small log cabin that belonged to relatives, two miles up the creek from where I would begin my married life. When not there, we moved about the country, squatting in old houses that were empty. We had few possessions; what we did own were horses and dogs. I was a happy, carefree child, following my dad around, learning to ride and survive in the same manner that he did. In most cases, I was unsure about right or wrong, because in my mind, my dad was always right.

I got very little education in the way of skills for living from my parents. I had very little in common with my mother, and with each year of my youth, the gap widened between her and me. She treated me like her mother had her. It came somewhat together years later when I became the caregiver in her old age. I moved her out of her home and into a nursing home when it became apparent that she could no longer take care of herself—an act she never forgave me for. When they shuffled her from one nursing home to another, I moved her, with the help of my kids. I was on call for most of her problems, and we grew closer but never intimate. Neither of us ever spoke of our differences when

I was young. My mother didn't care to talk about those days. We remained strangers, even when we both knew her life was coming to a close. I, however, was grateful for the time I had to make up for the little effort I put into understanding her.

My dad taught me to stick up for myself. "Hit first," he said. "You can talk when he's on the ground." It was obvious that that was his motto. I'd seen him fight that way so many times. He never lost. I hated fighting. My dad was a friendly man who loved to tell stories, but he reacted violently when crossed. I hung onto many of my resentments and fears.

By the time I neared my teens, I lost track of who I was. I didn't know that our people were once proud buffalo hunters who lived a nomadic life. That was never taught at home or at school. It may explain my dad's wandering ways. For us, culture was viewed from one standpoint only—either native or white. I thought that our way of life was something to overcome. I kept that attitude for many years while I struggled to get an education and prove that I was more than just a half-breed.

That attitude stayed with me for forty years, until I found my way back to my roots, when I joined the Métis Local in Lethbridge, Alberta. I had always felt that I didn't belong, and that something vital was missing from my life. I learned that I was a Métis, and I belonged to a distinct race of people—neither white nor First Nations, but both. I got my lifetime Métis card and took part in helping to build a strong Métis Nation by attending conferences and taking a leading role in teaching people about our culture. I had completed another full circle. Finally, I knew why I'd slapped that girl's face so long ago. I was moving on, but was still haunted by the past, where many things were not explained.

In 2005, I was elected president of the Métis Local in my hometown. I worked tirelessly for six years to help get an office and build a thriving Local in Pincher Creek. After retiring as president, I become an Elder for the Local. An Elder's duty is one of offering support and being there in time of need. It is a respected position. Finally, I had my questions answered. I knew at last that I was Aboriginal—as proud and free as my ancestors. Was this a part of the freedom that I chased for most of my life? My geographical cures were not that different from my dad's.

One day, after a long spring ride, I returned home with the hope of collapsing into my favourite easy chair, to enjoy a ginger beer and recover from my increasingly sore back and knees. Passing the kitchen table, I noticed something different. Scribbled on a scrap of paper with a dull pencil was a note with handwriting that time-traveled me back forty years. *Do you remember me?* it said. *I worked for Geoff Hardy years ago when you used to ride a little horse called Arrow.* I felt weak in the knees. I remembered alright. My desire to be with him had driven a wedge between my dad and me—like the situation that tore my mother from her parents.

This was Rusty, my childhood sweetheart back when I was thirteen to eighteen years old —the same Rusty that had shown up when I was married, had children, and too afraid of my husband to invite him in. I'd sent him away then and spent all those years wondering where he was. I had searched through phonebooks, contacted those with his last name, but no one knew him. I had all but given up seeing him again. I wondered if he had a family that would resent my reappearance in his life. Would he even want to see me if I did find him? Was he old

and sick or dead? I gave Rusty up to pursue a more ambitious dream—a dream where fate had intervened.

The note went on to say, *I'm in the Stardust Motel in Pincher Creek. I'd like to see you. —Rusty.*

The picture that I still entertained of Rusty was that of a handsome young man of twenty years old. In my occasional dreams of Rusty, he was young. When I finally caught up with him, he disappeared and I woke up. I thought that if I went quickly back to sleep, the dream might continue, but dreams are fickle, and I kept trying in vain to resurrect them.

In the next hour, I went through a whole array of emotions. I remembered how I had loved him more than forty years ago when I was so young and inexperienced. I believed that first love never really dies. The sight of that handwriting was the same as on the secret love notes he'd written me when I was still a child. He was seven years my elder. His return kindled a spark in my heart that I thought was dead.

The frightening memories of the way my parents and I had helped to end our relationship, and the fact that their actions had alienated me from the dad that I loved, all came rushing back. In my mind, Rusty was still as I'd last seen him. I had no way of knowing how forty years would have changed him, or how he would react to my aging. A part of me still wanted to keep that youthful memory that I unconsciously protected for so long.

By the time I got to the motel, I was shaking with fear of the unknown. I was once again the kid, rushing to be with him, defying both the wishes of my parents and my husband, both no longer a threat.

When he opened the door, he said, "What happened to your long hair?" His voice was the same, and his hair was still thick but

entirely white. He had a retired air about him that bore no resemblance to the young hard worker that I knew. "I have something for you," he said, producing an elaborate artificial plant arrangement. Seeing it bought back memories of the shiny trinkets he'd given me so long ago.

He doesn't even know me, was my first thought. My tastes had changed, and artificial plants were the lowest form of household adornment that I could imagine. He was wearing what he thought would impress me—a cowboy costume right out of the '50s.

"Thank you," I said. "It's lovely," I added, lying. I spent the next hour trying to connect this stranger from the past to the young man I'd loved so long ago. "You don't have to stay here," I said. "You can stay at my place."

He came the next day to Twin Butte, and stayed a few days. I took him around the country to visit people who were young when we were. He'd been back a few times but hadn't put much effort into finding me. His marriage had not lasted. He'd been free for years. He thought I didn't want to see him. The anger I covered up began to surface. I was angry with him because he changed so much, and because he hadn't looked for me as I had for him. I was angry with myself for spending so many years of my life keeping the dream alive. *What a fool,* I thought.

By the time he left for home, I let go of my anger. He was a stranger now. I hadn't really known him in the first place. Chances are that my life would not have accommodated him. But young love does not die easily, and as he disappeared from view I cried and cried. I'd been visited by a ghost from the past, and it was my youth that I was grieving. Forty years back I had pushed the grieving process aside. I was trying now to move on.

Rusty came back to visit several times after that; he brought me fruit from his home in the Okanagan of British Columbia. We became good friends, with a special bond that only we could understand. We loved one another in a different way now. We still had that spark of young love that belonged to our youth. With him coming back into my life, I felt I'd come full circle. His return brought peace and serenity and closed one of the chapters in my life that needed closing. Forty years of watching and waiting had come to a bittersweet end. I was ready to take some time solely for myself. The loss of my youth was a burden on my shoulders, a burden that I was loath to acknowledge. I was feeling the shadow of age closing in.

Back in 1989, I experienced bouts of sciatic pain in my lower back and legs that was so severe that I sought the help of a chiropractor. He jerked away at my miserable body, making my joints creak and groan, charged me dearly, and told me to return for more punishment which I did with poor results.

One fall day, when it rained and was unfit for mountain riding, I slickered up for a ride close to home, coming back in time for the school bus to deliver my ten-year-old daughter Carmen. I didn't notice any problems with my back as I cooked supper that night. At about seven p.m. I felt a stabbing pain in my lower back. I thought, *I'll just exercise that out.* Getting on my stomach on the floor, I instructed Carmen to jump a little on my lower back. I felt that that might jolt it into place, much like the chiropractor did with his quick jerks, when I still believed in him. When I tried to get up, I couldn't move, and there I remained until Carmen phoned my brother Bob, who happened to be in town. I groaned

and moaned as he helped me into his car. Off we went to the hospital in Pincher Creek. I was there for the next four days.

After several x-rays and massive doses of ibuprofen, the doctor diagnosed me with osteoarthritis and told me that it was incurable. From now on I'd be on anti-inflammatory drugs. He said, "Your knees, especially your left one, is in much worse shape than your back. Eventually you'll need an operation to replace that knee joint." I was fifty-three years old.

"How about riding a horse?" I asked.

"All people who ride have bad knees," he answered. "You shouldn't ride."

I disregarded his advice and increased my trips into the mountains on the premise that he didn't know anything about riding, and that I had no time to waste.

However, my disease was not resting. I did my best to ignore the clicking in my left knee until it became a scraping of bone on bone. I continued riding until the fall of 1998 when I found myself on crutches more than on a horse. On January 13, 1999, I had my first complete knee joint replacement in the Municipal Hospital in Lethbridge, Alberta.

That was a very painful ordeal. I was in hospital for a week, while a machine that I grew to hate made sure that my knee would bend ninety degrees, and they taught me to function with a new joint that was obviously foreign to my body. There was no way that I could go home to my place and drive the twenty miles to town for frequent therapy, let alone in the winter.

I ended up at my daughter Brenda and son-in-law's place that first night after I left the hospital in miserable condition. My leg was bruised and swollen to twice its size. I was sporting a seven-inch stapled incision, the whole apparatus held in place

by six screws that fanned out into the bone above and below my new joint.

No sooner had they helped my walker and me to an easy chair than the door opened and in came the baby we'd given up for adoption, now eighteen years old. She'd found us before we could find her. It was an exciting and shocking in my present condition, and was emotional for all of us. She looked like my girls, and especially like her birth mother. She had that same long curly hair. Still, she was a stranger. She had another family that she now belonged to. For the first time in eighteen years, I realized that I had to let go of that tiny helpless baby I had guarded in my heart all those years. I didn't want to give up that memory that I had abused myself with for so many years. Whenever she looked away, I stared at her, trying to connect the two. I was shocked and happy at the same time, and everyone else was shocked at the sight of my gruesome leg.

Her adoptive mother Charlene provided us with an album of baby pictures over the years as she grew up. The first six months were missing. By some cruel twist of fate, I had mentioned porphyria on the adoption papers. I was told by the specialist that the disease was hereditary, but could be controlled if detected early. Still reeling from the suddenness and severity of Ed's acute attack, I didn't want to send her unknowingly out into the world. I thought they should be aware. Sadly, that decision resulted in the delay of six months she spent without parents. The doctor was skeptical as to his diagnosis, but the damage was done. The disease that plagued my family's lives followed her, too, for eighteen years. Now I wished I'd taken the picture I had gone to the hospital to take, instead of running out crying.

After some of the emotional scenes played out, this new girl quickly became one of our family, almost as if she'd always been with us. Her older brother Cameron suddenly had a sister. After meeting her adoptive mother, I knew she was a good mother to Jennifer, who now had a new name. Charlene was her new mother, but I'd always been and would always be her grandmother. We had a lot of lost time to make up. I would have to give up the image of that little baby on her birthday; now we could have her physically, but that tiny baby face had a permanent home in my heart.

With my children: Lana, Carmen, Donna, Wayne and Brenda.

She attended most of our family gatherings. We made her birthdays special, celebrating them with her half-brother Cam, who was born three days before her, one year earlier. She stayed

with me when she visited. We tried in vain to make up for lost time. She'd missed so many sleepovers. In spite of the happiness she brought to my life, I couldn't shake the memory of that tiny child lying in the hospital, so alone in the world. Did I do the right thing for her, as I intended? Many years would pass before I would get any closure to that question and lay it to uneasy rest.

Although my knee was done the winter before, I knew during that spring of 2000, when I tried to ride my horse, that it was not yet healed. Later that summer, I was in riding shape and determined to make up for lost time and broaden my horizons. I searched through magazines, looking for adventure that involved riding. I remembered the words of Walter Karp, one of my riding partners: "The Willmore Wilderness is where you should go. I hunted up there and that North Country gets into your blood. Once there, you can't get it out."

As if predestined, I uncovered an advertisement in *Photo Life* for a horseback trip into that country, with an outfitter named Dave Manzer and a professional photographer, Darwin Wiggett. The words of my friend echoed in my ears, and I began to plan what became a whole new phase of my life. I contacted a like-minded friend with a desire to find out for herself why I obviously loved the outfitting life. We submitted our down payments and moved forward to plan what we knew should be the trip of our lifetimes.

A Willmore Wilderness Odyssey

1993, my friend Edith Evans and I drove into the Big Berland staging area north of Hinton, Alberta. We were about to embark on what we imagined was the mountain adventure of our lifetimes. How sweet, I thought, to be a guest, free of the toil and responsibility of packing horses, cooking for fussy guests, washing dishes late at night, and pleasing the boss. The boss was the outfitter and responsible for all such mundane chores, wranglers, and cooks. This wasn't my first trip; it was only my first trip here, and as a guest.

But where was the marvellous man that came so highly recommended in the Wild Rose outfitting brochures, which I pored over so diligently before we decided to spend our precious fifteen hundred dollars each to embark on this adventure? I had some experience in outfitting with my Uncle James years ago, when I was a kid. Edith and I were both accomplished riders.

Horses supplied, comfortable sleeping quarters, gourmet meals, and wonderful vistas—like none elsewhere in the

world—boasted the brochures. We dreamed of lying around camp, resting after long, rewarding scenic rides, waiting for the amiable cook to prepare a stunning meal, sitting around a campfire until we were pleasantly tired and ready for the warm sleeping bags, snuggled in rainproof tents, maybe even on a bed of fragrant spruce boughs. We couldn't wait to meet this wonderful man.

Where was the welcoming party? Why were the only humans at this Big Berland staging area, in the Willmore Wilderness, members of our party? The photographer, Darwin Wiggett, from Leduc, Alberta; Jeannette Buckingham, and her partner, Hans Weidner; my friend, Edith Evans, a rancher from Fort MacLeod; and me, a rancher—this made up the guest party.

Darwin was a wiry, outdoorsy young man, about twenty-five years old, very friendly and easy to know. The night before, at his house in Leduc, Alberta, he showed us slides of that awesome country north of Jasper Park. We went back to our motel that night pumped and full of chocolate cake that Darwin's wife, although she was not present, had generously supplied. Jeanette and Hans both appeared to be interesting people. I was anxious to meet them.

I thought of my riding partner, Walter Karp, who had been on hunting trips in the Willmore Wilderness. As he and I moseyed up the trails in Waterton Park and the Castle River watershed, he expounded on the wonders of the Willmore until I was almost tired of hearing about it, never thinking I'd have the opportunity to experience what he held so dear. He said, "The Willmore will change your way of viewing the wilds forever." He told me that there actually was such a thing as the "pull of the north." I wanted to find that out for myself.

Noticing a group of horses tied off in the timber, I ventured over, thinking that maybe I'd find the outfitter preparing for our departure into the wilderness. If he was there he sure wasn't in a hurry to meet us.

We were a group of amateur photographers, except for Darwin Wiggett, who was to show us the finer points of using cameras and tripods to photograph the breathtaking scenery, flora, and fauna of the Willmore Wilderness. Darwin was an experienced photographer and had had several exploits with Dave Manzer—the outfitter, in previous years. He spoke favourably of his experiences.

There were fifteen horses tied in the trees; some wore riding saddles and some packsaddles. They were gaunt from the lack of water or feed—or both—and several had cinch galls. Some were very skinny and raw from chain hobbles. I thought they were a sorry-looking bunch to be going into the mountains for ten days.

At this point, I began to wonder what I had gotten myself into. The fifteen hundred dollars was a gift from my brother, who had recently passed away with cancer. It had been a long hard struggle to see him waste away as he did. I needed to get away from my place down at Twin Butte near Waterton Park, some twelve hours away from here.

So far, I did not like what I saw. Thinking it was not my problem, and that I was too involved now to get out anyway, I stretched out on my car hood in the sun and dozed off.

I awoke to the sound of a small, red truck chugging into the clearing, travelling at a considerable rate of speed. It stopped beside my car. Out of the driver's side there emerged a young man, nothing like the description that I had of Dave Manzer.

With him was a big kid, and judging from his baggy pants and lack of western clothes, someone from the city.

"Where is Dave Manzer?" I asked. The elder one gave me a puzzled look and said nothing. The younger said, "Sebastian doesn't speak much English. He's from Montréal. I'm Jeremy, and Uncle Dave will be along soon."

Soon, as we were to learn, was one of Dave's favourite expressions. It meant anywhere from fifteen minutes to the next day. We were very ignorant as to what was going on. So was Jeremy. If Sebastian knew anything, he was not about to enlighten us. To add to our concern, the day was wasting away.

"Oh well," I said. "The days are long at this time of the year."

The others were looking to me for some assurance, since I was the only one with pack trip experience. I asked Jeremy if either of the boys had done pack trips before. He said. "No," and left it at that. I asked Darwin what it was like doing these trips previous years. "Good,' he said, "but his wife was here then."

One thing that we could agree on was that we were all thirsty, and somewhere over there, behind a grove of willows, we could hear a gurgling little brook rippling along, teasing our dry throats. Hans jumped to the rescue, produced a plastic container, and headed in the direction of the water. No sooner had he entered the willows then he commenced to yell. I thought maybe a bear was thirsty too, and hopefully not hungry. There followed a string of German words that we did not understand—and probably just as well. He did indeed come back with the water, but his boots were full and his pants were wet up to his thighs. A silly grin spread across his face. We soon learned how humorous and good-natured Hans was. "Damn root," he said, "grabbed me by the foot." I knew I was going to like this man. I knew also that

he did not realize how uncomfortable those wet boots and pants would become before they saw a campfire that night. He didn't seem in any hurry to change them. We didn't have a leader yet, and these boys were obviously useless without one. Darwin was beginning to look a little embarrassed.

In an effort to find out more about our situation thus far, I asked Jeremy where Dave was. "He's probably somewhere between Grand Cache and here."

"How far away is Grand Cache?"

"About one hour," he said. "Dave hired an Indian to wrangle, and an Indian woman to cook. Neither is coming because they are sick. They said spinal meningitis has hit their camp." These boys were to take their places and the rest appeared to be "make do."

At about 4 p.m., the elusive Dave pulled in, in a big red truck carrying a few more horses. He unloaded the horses, packsaddles, chaps, sling robes and other necessary gear. With a friendly "howdy" meant for all of us, he handed the boys each a horse and headed for the trees. Coming back, he shook hands all around and introduced himself as Dave Manzer, his wrangler Sebastian, and Jeremy, the camp helper here from the city of Edmonton. "You girls from Twin Butte and Fort MacLeod," meaning Edith and me, "know how to ride. I have just the horses for you." Not too sure of what he meant by that, I felt maybe someone in this company rode less well and that Dave knew it.

Dave was a rather small man. It was obvious that he was carrying no extra weight, but a lot of hard muscle that outfitters acquire after years of lifting heavy pack boxes called panniers, and pulling pack ropes. He had a slight accent that I couldn't place, a well-groomed beard, a ponytail protruding from under

his cowboy hat, and a sparkle in his eyes that was charming, especially to women; I had a feeling this was the case, since he instantly affected me that way.

"We'll have lots of time to get acquainted in camp. Get your equipment, and we'll pack it up," said Dave, as he reached for a tarp and spread it on the ground. There followed one of the most impressive mantie jobs I had ever seen. Everything went into manties (equipment wrapped in tarps, and tied with ropes). On the top of one pack, with loving care, he fastened a guitar case. In addition to doing most of the work, he was giving Sebastian orders on how to help, all without the use of the French language and with supposedly endless patience. Neat tubular bundles resulted, all identical and each with a special hitch to keep them that way. I was impressed! The others, except for Darwin, were seeing this procedure for the first time. He had their undivided attention.

After tightening the cinches and securing the packs on the packhorses using the well-executed diamond-hitch, and with the help of Sebastian, now learning how to pull ropes, Dave introduced us to our saddle horses. He had done his homework well, choosing horses for each guest according to what he thought their riding ability to be. He gave both Edith and Jeanette comfortable-looking mounts that looked as if they might have some spirit, Darwin a nondescript appaloosa, and Hans a little fjord called Eeyore. Then, leading a sorrel gelding up to me, he said, "You can ride this one. He's young. His name is Cabbage Head."

Six loose packhorses would travel up the trail in as orderly a fashion as possible, with Dave leading, then the wranglers, and lastly the guests, as Dave instructed.

Dave Manzer, guide and outfitter of Wild Rose Outfitting, in the Willmore Wilderness, with Eagle's Nest Peak in the background.

When he released the pack horses, they took off in all directions, drawn by the smell of water and prospect of a mouthful of grass, the latter made quite impossible by the leather nose-bags Dave attached to the head of each. Stirred up by the activity, the saddle horses became overly anxious, thinking the packhorses were leaving them. A scene of disorder followed. With some effort, I gathered Cabbage Head up, gee-hawed on his reins to get him to turn, kicked him into gear, and began to gather up

packhorses to send up the trail behind Dave. I thought that my ability to chase horses would surely impress him. However, I was opening an opportunity for him to put my skills to good use. I had yet to learn what an opportunist this man was.

Dave did not conform to my idea of an outfitter. Those that I knew were born into the trade. Most were the sons of outfitters, and this life was what they knew as children. They grew up pulling robes tight on packs, wrangling horses, and pleasing rich tourists for a share of their money. Dave was obviously different, and it showed. He was a teacher and an entertainer. He was charming and he knew it. I inched up past the packhorses until I was up beside his saddle horse. "Nice saddle," I said.

"My wife left it to me when she divorced me and took half of the outfit with her," he said with an amused grin

"Well, that's better than nothing; you could be skin-assing it up to the trail."

"I think I can get along with you," he said.

"You're not from around here originally, are you?"

"No, I came here seventeen years ago from Nova Scotia."

After travelling on a half-decent road for a short distance, we came to a sign that said no vehicles past this point.

"Is this really a true wilderness, where there are no roads?" I asked.

"Roads are either nonexistent or abandoned," Dave answered.

As I rode along with Dave, he explained to me what we were seeing: exceptional landforms in the mountains that now surrounded us.

"In this big, awesome country, you can spend your whole summer surrounded by mountains," he told me.

"That sounds like heaven to me," I said, just as Dave asked me to follow the packhorses for a ways and alert him to any shifted packs. I felt rather proud that he recognized my ability to spot troubles. It never dawned on me that he was putting me to work.

After Dave watched Edith and me mount a few times and take care of our horses, he turned that responsibility over to us, while some of the others simply stood and waited for Sebastian and him to deliver their horses, groomed, saddled, bridled, and ready to mount. It was not long before it was obvious who was going to supply the most entertainment on the trail.

Hans's mount Eeyore was a small fjord—and small, at that, even for a fjord. Hans was a regular-sized man, not overly big, and not small either. His legs hung down so low that on the deep trails he could almost touch the ground with his feet. Eeyore went up the trail, choosing his own speed and place in the string, stopping to rest if he thought he needed it and catching up with a burst of speed. He didn't really do anything obnoxious. He just did as he pleased, and Hans, willing or not, went along with him. He pulled on his reins, but pulling on Eeyore's reins was like pulling on the side of a barn. Being inexperienced, Hans just gave in to Eeyore's whims and, treating him kindly, went along for the ride.

Hans was a good sport. He laughed with everyone while Eeyore made a spectacle of him, and anyone else that had to deal with him. Clown that he was, Eeyore took care of his rider. His saddle or pack seldom moved on his back. His feet were sure in rocks and bogs. He endeared himself to everyone in camp and on the trail.

Dave was now in his element. He worked harder than two men, and went straight away to make a wrangler out of Sebastian.

Upon reaching the camp on the Big Berland, the boys, under directions from Dave, with Hans and Darwin lending a hand, unpacked and unsaddled the six packhorses. The camp was set up ahead of time. Jeremy loved the big bat-wing chaps that he used on the trail. He loved them so much that he kept them on all day, riding or not. The chaps held the city pants up, where they belonged, and ended the friendly ribbing that we did over those low-slung pants.

We picked up our gear as it came off and took up residence in the sleeping tents, which Dave assigned. He had Edith and me in one tent, Hans and Jeanette in another, and Darwin in with him and the boys.

Dave rolled up his sleeves and went to work cooking supper: macaroni and the most delicious sauce, all cooked up and vacuum packed at Peers, Alberta, where his headquarters was located. For dessert, we had cookies, most of them burnt. It is surprising what tastes good after a three-hour ride.

We were all ready for bed by ten or eleven o'clock. Edith and I had the stove set up in our tent. Dave said it was for it that tent. I don't know why he gave us the stove except that he might have thought that we would know how to use it. It did look like a bit of favouritism. Whatever his reason, that stove was just what we needed to take the chill out of tenting on that first cold night. However, the fire soon expired, and we found out how cold nights can be that far north. Neither of our sleeping bags were up to it; Edith introduced me to a hot rock wrapped in the towel in my sleeping bag. I didn't think I needed it that night, but the concept was good, so I stored it away in my memory bank. I knew there were much colder nights to come this early in July.

Sleep came easy. Edith and I finished discussing the day's events and the people who would be our companions for the next nine days.

That first morning we spent in and about camp, just taking it easy, as I learned was the way after a move to a new location. Dave, an accomplished blacksmith, replaced several horses' shoes. We all helped to clean up the camp. In the afternoon, Darwin gave us a seminar on lighted tents, flower vignette, backgrounds, and lighting in general. It was easy to see who the serious photographers were. Hans was at the top of that list. Jeanette was a close second, under his influence. Edith was there mostly because of the mountain experience, but she ended up making several of the best pictures over the ten days. I was deep into photography. I soaked up all the information that Darwin had to offer. This was an experience of a lifetime, and I was fascinated with his techniques and enthusiasm. This was a good day also to observe a few characters that would make good material for my day-by-day entries in my journal.

Jeremy was thirteen years old. Dave brought him to the wilderness because he was the son of a good friend and needed to get out of Edmonton for the summer. He was useful as a bull cook (cook's helper). He soon found a soft spot in my heart, because he was so much like my grandson Cam, similar in age, size, looks, and character. Everyone seemed to pick on him.

Since Jeremy was the lunch maker, he slid me an extra chocolate bar, which I stuck under my hat until out on the trail. I taught him to saddle and unsaddle his own horse. Dave was too busy being guide and cook in addition to teaching Sebastian to pack. I told him wild stories from my own childhood. He loved them

because he was a city kid and knew nothing of my life in the bush. He opened up to me and we discussed aspects of his young life that he knew I understood. I never tired of taking pictures of Jeremy—block of wood on the splitting block, axe in the air, and the bat-winged chaps flapping back and forth.

Sebastian was a serious eighteen-year-old kid—French, from Québec, and the perfect picture of a handsome wrangler. He soon became a favourite subject for our cameras. He could speak English, but appeared to be shy about his ability. He told me that his horse experience consisted of a job at a riding concession, where he saddled horses, helped mount guests, and rode the same trails day after day. That was precious little experience for a job packing horses and navigating the difficult, seldom-used trails in the Willmore Wilderness.

John, a wrangler from Georgia, USA, and Bob Silverthorn, who taught packing techniques in Wetaskwin, Alberta, rode into camp in the afternoon with another six pack horses, including Bob's two mules. Dave frowned upon mules. Off to the side, he said to me, "Why would anyone want to use a mule when he could use a horse?" I agreed.

We had a very good cook now, in either John or Bob. John's down-south accent was fascinating, as were Bob's spurs with the immense jingle-bobs. That night, Dave brought out his guitar, and with his amazing command of music, he sang and played cowboy songs, entertaining us around the campfire. By now, I saw how multitalented he was, like none other I had ever encountered in the outfitting business. Bob accompanied him by shaking his jingle bobs in time to the music. All of Bob's equipment had his brand on it, including his spurs. Obviously, he was prepared to impress us with his appearance. His cooking had already done

that at suppertime. He was a big man of about fifty years old. He liked to talk. John was a polite, quiet man who addressed women with, "Yes ma'am, no ma'am," and little else.

"They are both married," Dave made a point of telling me. "We'll take a ride up Hidden Creek tomorrow," he later added, as we wandered off to bed. Again I laid our fire, making use of that extra luxury. I got warm and stayed that way. Edith complained of being cold. Warm sleeping bags are a necessity in the Willmore where it's cold every night.

On the third day, Bob cooked a first-rate breakfast of bacon, eggs, and muffins. We helped with the dishes, Jeremy made the lunches, and we embarked on a day's ride up Hidden Creek as Dave had promised.

The dude horse is an under-rated animal. I have never ridden better horses than those of Dave's; they were tough, surefooted, lean, and in mountain shape, besides being gentle and people-proof. Cabbage Head, Dave told me, didn't get that name because he was stupid, but because of his passion for eating up the cook's cabbage. Cabbage Head, I soon found out, didn't like to stand still. Spinner, my horse at home, stood perfectly still every time, long enough for me to snap a picture from his back. All outfitting horses have a strange mode of travel. They jog to catch up and stay in their place in the pack string. I found that annoying. So I began from day one to reform Cabbage Head. Finally, I got a good flat-footed walk out of him, and Dave let me lead. Later, another guest rode Cabbage Head and he went right back to his old ways, probably glad to get rid of me.

The ride up Hidden Creek turned out to be three hours up a creek that disappeared underground and reappeared on the trail

many times, making several crossings as it meandered down a large mountain basin. Bob was a "take your time and enjoy everything" sort of a guy, and Dave was a "see everything you can, but keep going" guy. They complemented one another.

Beside a picturesque little falls, as we ascended from the basin, Bob suggested that we stop for a photo shoot. After all, that was part of the reason we were here. Bob took his time to build a small fire. Out of his saddlebag came a little teapot and tea. He called the bag his survival kit. It contained dry matches, noodles, and jelly powder for electrolytes. He made a delicious sweet tea. He had two plastic cups and we gladly shared them. We were cold and damp from the constant dribble of rain. That was the most appreciated tea I ever drank.

Some photographed the falls, but most took advantage for a pee stop, while others sat around the fire and talked. I downed my tea and went in search of flowers to photograph. Never had I seen such an abundant of luxurious mountain sorrel. Memories of the falls, the warming effects of Jell-O tea, and the spectacle of so much mountain sorrel stayed with me when I went into our tent that night. Bob, ever the teacher, doused the fire with water, even though it was raining, and inspected the ground for trash. We mounted and continued up the mountain.

We climbed much higher to alpine meadows, where mountain heather grew in large patches. Dave instructed us to take different paths across the delicate alpine meadows. "A single horse track closes up after you pass and leaves very little disturbance, whereas a single file string of horses cause much more damage." Everyone tried to conform, except Eeyore, who went where he pleased.

Bob Silverthorn showed me the sphagnum moss that the Indians used to line baby cradles with, and also used for

absorbing menstrual blood. "It grows only in old-growth forests and is the last moss to survive, crowding out all others, eventually," he said. Bob obviously liked being a teacher. I decided to be an attentive student. While enjoying this wonderful wilderness and photographing its splendid vistas, one may as well absorb as much knowledge as possible.

We spent about an hour and a half up there on top of the world. Everyone was wearing slickers for warmth, whether it was raining or not. It was cold up so high. I was fascinated with the rare alpine flora and got right carried away, missing the photo-shoot taking place behind me. Darwin was using the guides for models. I missed some good people in nature shots, but I had to capture as many of these flowers on film as possible, not thinking that we were going to live and photograph in places like this for the next seven days. Just before we left that paradise on top, John and Bob went on ahead to start supper, and Dave stayed behind with us.

On the way back to camp, Dave regaled us with stories of his exciting past in this country, and imparted his trail wisdom, all learned from scratch because he came to this country a greenhorn from Nova Scotia—young, clever, and ambitious, and determined to stay to learn the ways of the wilderness.

He said, "There are trails here that are two feet deep, caused by horses travelling single file. Some are so deep that your feet drag on the ground." We all cast knowing glances at Hans on Eeyore. He grinned. "In the marsh bogs, the rainwater soaks into the ground, and the environmental impact of horses is much less. Very quickly, flash floods result from the run-off. Downpours of rain turn small mountain streams into roaring torrents, rolling large rocks, washing out banks, and changing the course of a

riverbed. The creek might have been a trickling stream less than an hour before."

"We were marooned for a week out west of Rock Creek, in the Eagle's Nest camp with guests once," he went on. "I swam a horse out and rode four miles to a phone to notify relatives. Then I swam back across on the way back to camp. The guests were not unhappy to spend that extended trip doing day rides until the creek went down and all but disappeared completely." I believed him, because I knew that any creek, caught between deep gorges could do just that.

The clouds were hanging low this day and rain could come at any time. "Why have we not seen any game in this great wild country?" I asked.

"Because we are not that far from the Big Berland staging area, and more people can get in here. Game moves farther back."

That night, after a welcome supper, we sat around the campfire while Dave entertained with his music and song, and we talked over the day's ride. John and Bob had seen twenty head of Rocky Mountain sheep on their way back. They were high up, away from any chance of human interference. We were going back into the wilder country, and I couldn't wait to get started.

"Tomorrow," Dave said. "We'll be up for breakfast at seven a.m. We are moving camp to Eagle's Nest. You'll need a good rest, and it looks like rain."

And rain it did—all night, pelting down on our tent. I got up and moved all of our equipment away from the canvas sides of the tent. Wherever a tent is touched, it will leak. Still the rain seeped under the floor-less tent, soaking the tarp that served as a floor.

What a pleasure it was to don dry clothes the next morning. I had mine stuffed into the foot of my sleeping bag. We headed into the warm cook tent, where the odour of a hearty breakfast and the cheerful morning greetings of John and Bob dispelled my apprehension about what this trip had to offer.

The cook tent was called a pyramid. A long vertical pole in the middle held it up. There was a long table, fashioned from poles, that stayed in each camp after you left, and an accordion-like tabletop that folded up to fit a pack. Dave, being a blacksmith, had remodelled the conventional camp stove to warm water and gave it extra flat space. Everyone sat on the pack boxes around the table. Bob, saying grace in the Cree Indian language, impressed me. He then asked for a good day, a safe moving day, and encouraged Edith, who had lost her mother the day before we left home.

The rain let up, and the sun shone down on the wet tents. The Big Berland, flowing closely past the campsite, was a thunderous torrent, carrying trees off the shoreline and eroding part of the campsite itself. A huge tree had fallen towards the water and spanned the whole river.

"Anyone want to cross over to the other side?" Dave said. No takers came forward.

Early that morning, before we rose from our damp sleeping bags, Dave wrangled the horses and, with Sebastian's help, saddled both the pack and saddle horses. Each horse would wear the same equipment for the whole trip. Meanwhile, the boys lit the fire and prepared the delicious breakfast with which we were now stuffed.

Soon Jeremy made the lunches and distributed them. I helped because I knew that moving day was a big deal. Lunches out of

the way and dishes done, preparing the tent for tearing down and packing up was an enormous undertaking.

We were to tear down our own tent. In our case, the stovepipes needed cleaning with a wire brush. I began that chore, but Jeannette, who apparently was an expert at cleaning pipes, immediately joined me. I stood and watched her do it, complimenting her on her superior technique, thereby avoiding the chance of getting sooty myself. I hoped that she would show me how to do that at each camp. Wherever my expertise lies, I was not about to make it cleaning stovepipes.

At the Big Berland staging area, there was a conventional outdoor biffy. That was the last toilet with walls and a roof that we would encounter for the next ten days. We resigned ourselves to using the makeshift outhouses dreamed up by the outfitters at each campsite. Here it consisted of a log strung from tree to tree, just high enough to sit on and use the hole dug behind it. It faced away from the camp, had thick brush at the back, and an open trail in and out at the front. A plastic bag hung on a tree branch, the purpose of which was to eliminate the possibility of toilet paper littering the area. When the bag was full of soiled paper, Dave unceremoniously dumped it on the fire, not caring particularly that his guests were gazing into the burning embers enjoying a wilderness experience. Later at another campsite, we piled the chainsaw dust by the makeshift biffy, and threw a handful over the log with each use. Dave was an environmentalist. His poor wrangler's first job at each new campsite was to clean up the biffy site and pick up every can that some careless outfit left behind. He burned what he could before he moved camp and filled pack boxes with the debris as they emptied.

Since no one likes interruptions—or to be rushed—while sitting there on the log, Dave devised a method of warning that the toilet was occupied. Hanging on a nail on the centre pole of the cook tent was the roll of toilet paper. When it was missing, someone was obviously using it. So simple but ingenious, I thought, when I recovered from the initial shock of the whole procedure as explained by Bob Silverthorn, accompanied by a look of sheer humour on John's face, who was obviously delighted with our embarrassment. Bob preferred a different method of dispensing with the paper. It consisted in giving each of the guests a lighter and having then burn the paper on the spot. Dave chose to ignore that part of the instruction and later said, "He got that idea out of some book." I never knew that relieving yourself in the bush could be so complicated, but with so many people using a camp it all made sense. Taking the paper from the tent pole under the watchful eye of so many people remained painfully embarrassing.

Breaking camp took from 9:00 a.m. to 1:00 p.m. that day. Darwin helped with the tent folding, learning from Dave. Then he showed us how to meter off a white tent, the grey card of photography and a black log, getting the best results from each. I was fascinated with the logic in what he had to say.

Dave decided that Bob would guide us up the South Berland and Hidden Creek to a campsite at Eagle's Nest. We took only one packhorse, carrying oats and a small tent. We had our slickers and what was left of our noon lunches.

Dave, Sebastian, Jeremy, and John were to take a shortcut over Desolation Pass, get to camp, and ready it for us when we arrived, well before dark. We rode off into what had become a

constant drizzle of rain, our day planned with the utmost of care and wisdom—or so we thought.

Eeyore by this time had figured Hans out. He slowed down to a creep, and Bob had to ride behind him with his horse tramping on his heels, at which time he burst into a display a speed, nearly unseating Hans. Then, after a few yards, he slowed again to a crawl.

With our guide behind the pack, I was now leading. Since I'd never been over that trail, I periodically lost it. Bob would find it again for me while I rode behind Eeyore. With these two impediments slowing our progress, I again began to question my choice of wilderness experiences. However, the sheer amusement that Hans and Eeyore made helped to add spice to the ride. I wondered if Hans realized that our tramping on Eeyore's heels was causing his burst of speed. Han's heels hung down so low under Eeyore's belly that they could not possibly be effective.

At one point, I got a switch from a willow. "Whack him on the rear with that, Hans, and he'll keep up better," I said. He tickled him with it, and Eeyore switched his tail.

We were making very slow progress. When we sat still in the saddle for enough hours, in the drizzling rain, the cold began to seep deeper into our bodies, regardless of what we were wearing. Bob and I were the only ones trotting back and forth from the lead to poor, slow Hans at the rear, and even we were getting cold.

We crossed Hidden Creek a half dozen times as we wound up the valley, sometimes on rocks and sometimes through the water. The willows were dripping with the accumulating wetness. Making a fire would have been very difficult, and time was now becoming a factor. Thanks to Eeyore, this ride was taking far too long.

Hours later, we left Hidden Creek and emerged into a long valley, where there was an old road reclaimed after the Willmore gained wilderness status. The culverts were removed and lay to the side. The willows were creeping in to leave only a trail once more. This made me happy. How wonderful it was to see a place where wilderness was valued, as it apparently was here.

We had been on the trail for hours. We were tired, wet, and hungry. All were anticipating the warmth of the campfires, the smell of supper, and a chance to get out of those wet clothes. I can only imagine the state of discomfort Hans must have been suffering from Eeyore's short choppy steps and bursts of speed. He was the only very inexperienced rider. I felt sorry for him. He smiled, never complained, and made jokes about his sore bum. Sometimes guests unknowingly think that hard treatment is part of the wilderness experience. I knew it was not. Sitting a horse properly can alleviate the pain considerably.

"How far now, Bob?"

"Right around the corner and a short distance into camp."

"I smell smoke," I added. "That must be from Dave's fire in the cook tent." Our hearts warmed to the thought of a warm tent and food.

By this time, it had turned much colder. With the mountains so socked in and cold enough to be snowing up there, night was fast closing in. Far across the valley, there was a soft faint light in the timber.

"Is that the camp?" I asked, with my hopes soaring.

"I'll ride ahead and make sure. I think it is where we are supposed to be. It's the best camp in the valley," Bob said, and was soon off at a gallop. After a few minutes, he galloped back, a puzzled look on his face.

"It's the camp, all right, but it's occupied, and not by our outfit. I checked out the next best site, and it's occupied too. Dave's not at either. Darned funny how he's not here hours ago. We'll have to go to that site over there on the point."

The campfire circle was full of water; there was no wood left by the last campers, as there should have been. Campers had obviously used up any dry trees that were once around. True to the wilderness code, the previous outfitter leaves some wood, cut up and ready for the next outfit. He leaves also rails that are used to set up tents, tables in the cook tent, and sometimes wash stands. They are usually leaning up against the trees to keep them from rotting on the ground.

At least now the guests could dismount and tramp around to get their circulation moving again. Bob kicked some of the water out of the fireplace. We had no saw. Bob had an axe on his saddle. He managed to start a fire with lower dry branches covered with black lichen that we call old man's beard. We all went in search of more dry branches covered with the lichen.

The horses were happy. They had lots of oats. How ironic! They were fed, but we had only a few potato chips and granola bars. Of course, we had that tent, but no sleeping bags. We pulled up stumps to sit on and prepared to await Dave's arrival.

Darkness arrived, and the drizzle continued. With only an axe, it was hard for Bob to get bigger wood to create an effective fire. That was why this campsite was the last one left. This was not a good situation. We tried to tell amusing stories and joke about being hungry, but it was hard to keep it up as the hours passed and still no Dave.

I tried to ease their worries for themselves by turning their attention to what may have caused the delay. In fact, I was

downright worried about what might have been the fate of that pack string up on the mountain pass. The mountains can be unforgiving to even the most experienced people. Bob was worried too. Some of the guests considered calling off this venture as soon as possible. They had enough after this day.

"You're probably comfortable compared to what Dave, Sebastian, Jeremy and John may be right now," I told them. "This morning, Jeremy put his Driza-Bone Australian slicker over a short sleeved T-shirt. He's probably wet by now. Those slickers are cold on the skin and not always as dry as their name denotes. Dave is definitely not causing you to be cold and hungry because he planned it that way." I didn't hear any more plans for deserting, but I was sure they went on thinking that way. It was stupid for our party to head up the trail with so few provisions. I kept those thoughts to myself.

"Some of the campsites aren't as well-kept as they are farther into the wilderness. We are only a three-hour ride from the staging area at Rock Creek, and more people can access the sites. Some of them don't really care how they leave the site," Bob said, as if his apologetic tone of voice would help us under these circumstances. "Dave will get here sometime with the food, sleeping bags, and tents. But when I don't know." Something had surely happened to the pack string up on that mountain pass.

An hour, then another, went by. Bob made periodic trips out of the clearing to check for the big beam flashlight that Dave carried. We attuned our ears to the night sounds, hoping to hear the approach of horses. There was nothing except the blackness of the night putting a wall between the Hay River flowing between steep banks down in the valley.

Midnight came. Eeyore came and draped his head between our bodies by the inadequate campfire. Someone fed him potato chips, and he smacked his big floppy lips. You could always count on Eeyore to inject some humour into the most dire of circumstances.

I counted the hours before daylight and the possibility of the sun rising to warm our chilled bodies. Bob got up and set up the small tent. With no blankets, the tent was of very little use. The fire, such as it was, offered the only relief from the cold. Bob searched out and cut up just enough wood to keep it burning. We were tired now and hungry, but all we could do was warm up one side of our bodies and turn to warm the other.

"Maybe if we all lay close in the tent and cover up with our saddle blankets we can generate more heat than this fire does," suggested Bob. Chilliness had crept into our very bones by this time. The rain was no longer dripping from the tree branches. It was thickening up to form ice.

We lay down in the tent, with only a pack tarp between the ground and us. If you have never covered up with the smelly saddle blanket, damp from the sweat of an eight-hour ride and rain, you cannot imagine what this experience was like. "I'm pretty big, and I'm relatively warm, if anyone wants to cuddle up close to my back," offered Bob. "You're welcome." Everyone hesitated. No one wanted to get too familiar with the person next to him. I was past the point of caring, so I moved in behind Bob, as close to him as I could get. Better, I thought, pulling up my wet saddle blanket. Completely exhausted from cold and passing of time, I began to absorb a small portion of heat from his big back. I thought I might even doze off. Bob went right to sleep and began to snore with such gusto that his whole body shook.

The others began to laugh at this ridiculous situation. A few got up and went back to the fire. All except Bob were wide awake, disillusioned, suffering from the cold and hunger, and prepared to ride out to Rock Creek at first light, and give this whole thing up as a bad venture. Bob's snoring was driving me crazy, so I got up to join those at the fire.

At 1:00 a.m., I thought I heard something far off down the valley. I went into to the tent and shook Bob awake. Together we went to the edge of the clearing and, sure enough, we could hear a shout. We spotted a faint light as the sound drew nearer. Dave was bringing in the pack string, guided up the trail by the powerful beam of that big flashlight. He headed for the best campsite, so Bob waved his flashlight to signal him into camp. The light came towards us and searched for the one place where they could cross the Wild Hay without falling off its sharp banks into the fast-flowing stream.

By the light of those wide-beamed flashlights, the crew unpacked the whole string. Now we were in possession of our sleeping bags, only to find parts of them soaking wet. That was from travelling through willows, wet with snow from the blizzard that the crew had encountered high on the pass and nearly to the valley below. To make matters worse, one of the packhorses had fallen in a river crossings and soaked everything in his pack. We got into some of the panniers and found croutons and chocolate bars to satisfy our hunger until morning. The wranglers had the misery of not only being hungry, but having spent all those hours trying to put that string of loose pack horses over a summit in a blizzard, largely in darkness. They were soaking wet, and their hands and feet were nearly frozen.

Into the small tent, nine people crowded, with sleeping bags or not, and tried to rest a few hours until daylight. The only consolation was that Bob made a makeshift lean-to and went to it, taking his snoring with him.

I woke up several times in the next three hours, cold, damp, and uncomfortable, thankful that the smell of horse blankets was at least under me now. Hans never left the fire. He chose that over sleeping in a pile of wet bodies in the little tent. His sleeping bag was on the horse that fell in the creek. The outlook for the rest of the night was dismal. With four more bodies occupying the tent and a few more sleeping bags—however wet—there was hope for a little more heat. The night was only a few hours longer. Tomorrow would be a better day.

Camp In Recovery

In the morning, there were icicles hanging from the ends of the tree branches. The whole campsite was a mess of panniers ruffled through, but covered with tarps. The fire was breathing its last and Hans was almost doing the same, now walking about to get his poor joints working, remarkably the only one in a good mood. I don't know why Bob took special interest in my wellbeing. Maybe it was because I was more sympathetic than angry after that miserable night. On the other hand, maybe it was because I was the one who took him up on his offer of his warm back the night before. His sleeping bag, secured in the waterproof cover, was dry and warm.

"Get rid of your damp clothes and climb into my bag and go to sleep," he said.

He didn't have to tell me twice. I slept the sleep of the dead in that lean-to until well into the afternoon, oblivious of the hustle and bustle of the camp, now in recovery mode.

When I finally crawled out, there were sleeping bags hanging from lash ropes strung between trees, a roaring campfire, and a stack of wood. The cook tent was up and functioning, and, best of all sunshine. Dave had risen early after his miserable experience. He was quiet—probably still exhausted. Edith, Hans, and Jeannette wanted to be taken out early. Darwin, because he was largely the reason we were here, was feeling responsible. Dave appeared detached and offered no sympathy or explanation for their discomfort.

I wanted to know what went so wrong up on that mountain. I found Dave sitting on the stump in front of his shoeing equipment. I sat down beside him and asked, "What happened?"

"It rained all the way up the mountain and then turned to snow so thick that it was impossible to see the trail. Above timberline, the wind was howling, and the pack string wanted to go back. It took an hour to get them to string out again. Coming down off the mountain in that blizzard was hell. Those damn mules of Bob's were the biggest causes of trouble.

"Dewy refused to budge off the top, so I dragged him partway down and tied him to a tree. When I returned, the boys had lost control of the horses; they were scattered all over the mountain. One by one, we had to find and tie them up. Then I heard a crashing from below, and up the trail came Dewy, dragging the tree. I tied to lead him. He planted his feet near another mule and refused to budge. We thought he'd follow now, but when the pack string left he just stood there preparing to stay until he died—and he nearly did." An amused look came across Dave's face at this point in his story, as he glanced over to see how I was taking it thus far.

"Too funny!" I said, and started to laugh. Then we laughed together, and Dave's mood lightened up by several degrees. "What then?" I asked.

"We tied all the horses up again; I dragged him down the mountain once more and tied him to a tree that he could not drag, even if he did knock it over. Back up the mountain, I rode and got the pack string moving. I alternated between pack string and dragging Dewy all the way down the mountain, through the snow-covered trees and willows."

"Where did the snow stop?"

"Somewhere near the valley bottom, it turned to rain again accompanied by fog. By that time, it was black dark."

"Did Dewy join the pack string?" I asked.

"Once off the mountain he trotted along. I hate that mule!"

"I can't blame you."

"We crossed the river several times because of the way the trail winds around," Dave continued. "It was black dark, but BJ in the lead knew the trail. At one of those creek crossings, a packhorse got crowding when we came down the bank; at least one of them fell in the water. The water was so fast that I heard the rocks rolling. Jeremy and Sebastian did their best, but being inexperienced, they were often of little use. John and I had more than we could handle at times. You saw how Jeremy was dressed. He was freezing."

"Yes" I said.

"The mountains are unforgiving, and the weather unpredictable. In this country, you expect the best but prepare for the worst. Some things don't work out as planned." Dave said.

"Like taking a shortcut?" I said.

"I guess the guests are pretty discouraged," he said, as if I were not one of them.

"I'll cheer them up," I said as I headed for the cook tent to have the first decent food since breakfast the day before.

While I slept, Bob cooked a hearty breakfast, and already people were in better moods. Like most wrecks in the outfitting business, this episode would make a good campfire story and all would be forgiven—but not forgotten.

Bob and John left in the afternoon, taking the mules with them, but not before John caught me alone and said, "I thought I should tell you. Dave is preparing to ask you to come back and cook for the next two trips, booked for twenty days. Just thought after what happened yesterday I should give you a heads up so you're prepared."

"Thanks Bob. I don't see how I could possibly do that, anyway. Yesterday doesn't matter to me. I have a teenager at home and a place to look after."

"Well, now at least you know," he said, as he and John mounted and rode off, leading the mules tied head to tail—a leading technique that we call tailing.

After they left, we erected the guest's tent. Edith and I agreed not to be selfish with our stove. We moved in with Hans and Jeanette. We were now three women and Hans sleeping side-by-side in our sleeping bags. In the small margin between us we kept our gear and personal effects. Such close proximity did wonders to acquaint each with his neighbour

Hans was a well-organized man; Jeanette had long since learned to tolerate his perfectionism. She went along with him. Edith seemed to enjoy all the good-natured ribbing between Hans and me. I got a real charge out of bugging him. My corner

was such a mess that Hans couldn't stomach the sight of it. My camera equipment was in a tangle of clothes. Hans was forever shining his lenses and polishing his camera. Good photographers do that, but I thought Hans carried it to extremes. When he finished with his own he tackled Jeanette's equipment.

I cleaned my lenses with my shirttail. That horrified him. I have a habit of poking around for some time before I am comfortably settled at night. I get up several times to do what I forget, stoke the fire, and last of all I go out to pee for one last time.

"You are my nemesis," said Hans.

We were often chilly after a particularly cold night, after the fire died. Hans and Jeannette had better sleeping bags then Edith and I did.

"Complain! Complain! Complain," said Hans.

"The next time I come back to this country, I'm bringing a double sleeping bag and a fat man to share it." I told him.

"I don't doubt that a bit," he said. "In the meantime, get over there on the other side of Edith Avenue and stay there."

He just laughed at the hot rocks in the foot of our sleeping bags, especially when one burned a big hole in my towel. We had so much fun in that tent that it became a highlight of our trip.

Dave built us a shower outside our tent door. It consisted of a tarp suspended from a makeshift tripod with a hook at the apex. From the hook we hung a special bag which Dave bought in some mountain equipment store. From the bag, warm water from the cook tent trickled down over our bodies, though inadequately. Being situated on a slight slope above our tent, the water from the first shower ran right under it, soaking sleeping bags and the clothes in the alleys. News of the poor quality of the shower spread quickly and we ceased to use it at all.

Every morning, Darwin called us early to photograph at first light. It was nice to dress by the stove and return to a warm tent. I had to rise even earlier to light the fire. Those little tin stoves get hot fast.

Wanting to share the work, and being the only man in our tent, Hans decided to lay the fire. I lay quietly in my messy corner, watching him rise, shivering and muttering. When it didn't catch, he returned to his bed, discouraged. Then I got up, cut small shavings with the jackknife I packed, and touched a match to them; then I placed a few bigger sticks of kindling on top and went back to bed. The fire crackled, and soon the tent was warm. After that, they called me Chief Fire-maker."

When Hans finally mastered the fire lighting, he took over that chore, roasting us out of our beds every morning. Thereafter, I decided to make educating Hans on the ways of the wilderness my project. A few lessons on how to sit a horse and move with it, I hoped, would make his riding experience more enjoyable. He didn't flaunt his smarts. He was a clever man. He heard what I said and used the advice.

Dave was obviously cook, outfitter, guide, and, largely, a wrangler. Sebastian was learning fast. Jeremy was getting out of everything that vaguely resembled work. I showed a special interest in him. For the rest of the trip he did what he could to please me. Whatever Jeremy's background, he didn't like taking orders. Pointing out his faults was not working with him. Several remarks passed around among the guests, but I defended him.

So far, our day trips were near camp, where Darwin was teaching us how to master the ever-changing light in the Willmore Wilderness and how to use our cameras and tripods to the best

advantage. Each night brought more rain and fog than usually burned off by noon.

Dave played and sang old cowboy songs, tales of experiences on the trail, ballads from his native Nova Scotia, and a song of his own. The music raised our spirits above the continuing rain, and diverted his attention from the problems of understaffing and uncooperative weather.

Wood was no longer a problem. Dave put a harness on that little fjord pony Eeyore, and dragged old dry logs from the valley. He used his chainsaw to cut them into blocks, and put Jeremy to work splitting them. I was captivated by this great awesome country. Gazing out over the Persimmon Range, I wondered what adventures lay out there, if only the weather would cooperate.

"What will we do tomorrow?" I asked of Dave.

"We'll ride."

"What if it rains again?"

"We'll ride."

"Good enough," I said, and off I went to make sure there was sufficient kindling for Hans to get the stove fired up for the night.

Back here in the mountains, I escaped from the cares I faced at home—the ever-present care of my husband and normal worries of a mother. This country set me free, if only for a week.

Dave rose early, prepared a hearty breakfast, and Jeremy slapped together some paper bag lunches. Our night had been restful as we became more accustomed to dressing and undressing largely in our sleeping bags, for privacy. Usually it was black dark when we undressed after the evening by the campfire anyway. Some removed only their pants and slept in their upper attire. During the day they could return to the tent and change clothes privately,

tidying up the mess made in the dark the night before. I remembered what Bob told me: "Always remove your day clothes at night. They are damp from your body heat and will keep you cold. Put on something, anything, dry to sleep in." I was listening. I found his advice useful at all times.

Late in the morning, after the horses were wrangled and the packhorses secured in an electric fence, our saddled horses were presented to us ready for riding. We put our lunches and juice boxes or water into our saddle bags, secured our camera equipment in bags or backpacks, and headed out for what Dave called his ridge ride, single file.

On the high ridge, we could see as far as the low clouds would permit. To the west there was a valley that seemed without end. Eagle's Nest Peak stretched its rocky head through the clouds to the sunshine above. Mercifully, the sun came out for about an hour up on top. At lunchtime, we sat around talking and quizzing Dave on the wonders of this great awesome country. He pointed out the mountain where he was detained in the snowstorm during the night we would not soon forget.

After bushwhacking up this mountain, I asked, "Why didn't you come up that trail that we crossed several times?" He gave environmental reasons for causing fewer disturbances in the thick moss under the old growth forest. But I'd already witnessed some pretty bad environmental practices with horses tied to trees, tramping on exposed tree roots, and trails far too deep in the soft tundra of the swampy bottoms. "Unavoidable," Dave said.

With the brief period of sunshine, we saw mountain ranges in all directions. This wasn't like my home Rockies in the southwest corner of Alberta. You could ride out of those mountains from any place in the day and be either on the prairie to the east or

inhabited country to the west in British Columbia. This huge wild wilderness was casting its spell on me. Dave pointed out different places where there were camps that we could use. "We're staying in our present camp, and taking rides such as we did today," he said. I knew there was no chance of me getting to those magic places without coming back. That I thought impossible. It was at least a ten-hour drive from my place to the Rock Creek staging areas.

After lunch, the others set out with Darwin for a photo shoot. I stayed back to talk to Dave and ask him more about this country that he knew so well. After a while, he did what I knew he was building up to do, just as Bob had given me a heads-up about before he left.

"If you come back for the next trip, you could cook for me and help out generally. The pay is rotten, but the benefits are many."

"Like what?"

"We'll move to other campsites far back in this country, and you can go on all-day rides so that you don't miss anything."

"I'll think about it," I said, pretending that I wasn't overly interested, in case he might think up some more convincing incentives. Actually, I was thinking mostly of how impossible it was. At the least, I had to go home and not leave Edith high and dry. I couldn't just leave my youngest daughter, my horses, my acreage, and Ed without making serious plans. I had already been away for ten days on this trip. I was a single mom, for all intents and purposes. It was time that I make a trip to Lethbridge to see Ed. I made it a practice to try and visit at least every two weeks. Institutionalized for thirty years in nursing homes, he had bonded with hospital staff, but had not given up the hope of walking again.

Having satisfied their urge to photograph the blue smooth gentian that grew here, the others returned, and we continued our ride. Dropping over to the other side of the ridge, we descended by sliding down an invisible trail, dodging trees as we went. Dave led the way, without so much as a glance over his shoulders at his guests, causing them to wonder once more what they'd gotten themselves into.

In the valley below we came upon a set of old abandoned log buildings and the remains of an old steam engine. Both were used in exploration for coal and other minerals before the area was declared a wilderness park. The long rays of the late afternoon sun made an excellent setting for photography.

Sebastian—tall, handsome, and dressed western-style—became useful as a model. Darwin instructed us on different angles, lighting techniques, and composition. We found some old whiskey bottles to incorporate. Being in dampness much of the time, the old logs were growing moss and lichens of several varieties. This was fun. We were doing what we intended on this trip. Dave headed back to camp to get supper, and Sebastian took over as guide.

What a remarkable man this Dave was turning out to be. He had a supper of baked potatoes, roast beef, and cookies for dessert. It started to rain again. Dave seemed oblivious to the elements. That night, he serenaded away as if the cold and rain didn't affect him at all. Years of being in this country with its harsh weather had taught him to take it all in stride. This guy was a part of this great wilderness. He radiated serenity, and soon I was feeling it too, as if it were wearing off on me. From that moment on, this trip became an adventure to treasure, regardless of the cold, dampness, and inevitable discomfort. That night I

slept content, anticipating tomorrow, determined to enjoy every second of this wilderness odyssey.

After a good night's rest, we awoke to the smell of bacon frying and the stomping of the horses, all saddled and readied for the day's ride. Obviously, only the guests had enjoyed the privilege of sleeping in, judging from the amount of work already done by Dave and his small staff.

Sebastian, now becoming a useful wrangler, rose at daybreak, took one horse—tied up all night—and went in search of the hobbled horses. In spite of their hobbles, horses can travel a long way. Fortunately, feed was plentiful in the meadow north of the camp, and Dave's horses, wise to the feeding range in the Willmore, didn't stray too far. The horse that was tied up now enjoyed a day of freedom. The amazing fifteen-year-old boy Sebastian did all the wrangling and saddling on an empty stomach. He was more than ready for breakfast. The fresh air and exercise of these trips served to enhance the appetite of staff and guests alike, especially the most youthful.

Up the valley, we rode with stunning scenery on either side. Dave stopped periodically to explain the rock formations and relate tales from previous experiences. The flora was not that different from my own in the Southern Rockies. I was able to identify most species by popular names. I became the plant authority from then on.

Cabbage Head walked well when he was in the lead. As soon as he was back in the string he took up his choppy packhorse gait, and I could not dissuade him from it. In the lead, he shied at everything. He had not noticed the rocks and old roots while following along behind.

"He's a good horse," Dave insisted. "Just continue in the lead and he'll be even better."

Well said, I thought, *as I train your horse for you.*

After about a two-hour ride up the long valley, past the high, somewhat-pointed mountain called Eagle's Nest, we crossed the Jasper Park boundary high in the alpine meadows, so high that the wind blew freezing cold and strong. Far to the west on three sides was Jasper Park, with its endless mountain ranges and glaciers stretching before us. Never had I seen so many mountains. There were mountain peaks on all sides.

To avoid the wind, we dropped back over the lee of the pass, snuggled in our raincoats for warmth, and ate our lunches. We were ever watchful of where our dropped horses wandered. We retrieved them if they so much as looked at the trail back to camp, miles down the valley.

This country was a photographer's dream. Wherever we looked, there was breathtaking scenery. We had the added bonus of an expert to instruct us.

As we headed back to camp, the rain clouds thickened. Dave went on ahead to prepare supper. We saw two sheep and two goats, high up on the rock walls. Numerous marmots whistled at us from the rockslides.

Rain began to threaten in a serious way, and soon it was pouring. We speeded up as much as the rough trail would allow. Once in the valley below, with a good trail, Jeremy and I in the lead speeded up in a big way, racing for camp in the driving rain, not even looking behind for the rest. As a result, we arrived in camp without them.

Dave gave us both disapproving looks, as if I too was paid to be one of his guides. He put us both to work preparing supper

and went in search of his lost guests. I was about to experience cooking for that many people on a small tin stove. Until now, I didn't know the contents of all those pack boxes. It was not my business to know.

This was Dave's Chinese food night. All the preparation time I dreaded evaporated when Dave said, "Just open these packages and heat them up." Before us was a whole Chinese supper vacuum packed in plastic. So he wasn't the wonder man that I thought he was—not in a culinary sense, anyway. Still, he was the mastermind behind the packing and planning of ten days of food for as many people—a remarkable feat!

He found the others in another camp, cared for, hoping to wait out the rain shower. That would have taken all night. Dave knew the weather patterns in the wilderness. It was socked in right to the mountain bottoms, with no letup in sight.

"Good that *I* was worried about you," Dave said to the delayed guests, as we wolfed down our supper, now late. He cast an accusing glance in the direction of Jeremy and me and said, "Frances and Jeremy sure were not!"

I did feel a little guilty since he was now putting me in charge of seeing the guests home every night, while he went on to get supper. But not too guilty—I was still a paying guest.

In our tent that night, Hans took over the duty of drying clothes. Organized as he was, he set up two tripods by the stove. Edith and I laughed at the expensive derby hats sitting on the tripod tops. Our cowboy hats didn't get any consideration. Jeanette rode bareheaded the next two days while her hat sat on a tripod, becoming perfectly dry.

We slept comfortably all night. Edith had finally convinced me to use the hot rocks every night. They were definitely the remedy for cold feet.

At 8 a.m., it was banked in with fog. We lay around the tent a while listening to Hans' suggestion on how we might all correct our inferior camping habits. He was just embarking on a camera cleanliness lecture when Dave stuck his head into the tent and said, "Let's go."

Hans and Darwin decided to stay around camp and make macro photos of moss, lichens, fungi, and old trees in all stages of decay. By this time, Hans was obviously the most interested in photography. I was not exactly unhappy to see him stay in camp. Without the combination of him and Eeyore, we could ride farther and over rougher trails.

As it turned out, Darwin and Hans had a lovely day without us; Dave dragged us through the damnedest bogs ever, and rode like a lunatic on the level. Over the flat ground that was once an airstrip, Sebastian, Dave, and I raced—why, I didn't know. Edith and Jeanette thought it wiser, and rightly so, to slow down.

The marshland was a new experience for all three of us. I pushed my horse right up on the rear of Dave's horse and followed him step for step, except when he fell through, at which time his horse floundered up to its belly and he turned his head, saying, "Don't go there. Stay on the willows." Stay on the willows I did. The roots held the horses up somewhat. "It's not as bad as it looks," Dave reassured us, as two riders remounted after being pitched off into the spongy tundra. "I only bogged one horse down, and had to pull him out by the tail."

Once out of the bog we meandered up a high ridge with no trail at all. Underfoot was deep moss with logs under it. The slippery logs caused our horses to stumble. Jeannette's fell and send her flying. About the time I was wondering whether Dave even knew where he was, he emerged from the trees in exactly the spot where he wanted to be. He gave me that "How was that?" look. I complimented him on his ability to do so, partly because he needed his man ego inflated, and more so because he deserved it. Also deserving were these wonderful trail horses. I decided to fear bogs from that day forth, knowing that we had to cross that same bog on the way back.

Ahead of us was a spectacular sight: a chain of three lakes with waterfalls joining two of them and boxed in by a high mountain wall.

"See those waterfalls and streams on the sheer face of that mountain? They run into the big snowbank and go underground. They emerge farther down and form these three lakes," said Dave.

High up on the ridge above this captivating site, we dismounted for lunch. Jeannette asked Dave if we had to go through the bog on the way back.

"We'll stay higher and see if we can miss some," he replied.

That made me feel a little better, and I stopped worrying about it long enough to really enjoy the scenery. I made several pictures of the group, the breathtaking scenery, and a profusion of wildflowers.

We had lunch in the shade of some wind-abused spruce trees. Dave made a small fire and pretended that he had just found the shell of a big mountain sheep horn. I had a feeling that we might be the thousandth group, at least, to see and photograph that same specimen.

The trip back to camp was just as frightening as coming up, if not worse. That bog was a sizable worry, and I hoped that not all the Willmore was like that.

"Is there no bottom to the stuff?" I asked.

"Oh yes, a few feet down there's gravel."

I took comfort from that; whether I believed it was a different matter.

After supper, we sat by the fire and discussed the day's adventures and plans for the next day. Dave's plans were all subject to change, but you couldn't say that he didn't have a plan. That evening Darwin introduced us to "light painting." We set our tripods and cameras and prepared for making time exposures. He took meter readings from the sky, the tent, and the flashlight with which he would paint. At a signal, we opened our shutters and Hans timed, while Darwin hopped about flashing the light on the photogenic equipment that hung from the tree branches. Then we closed all the shutters at the same time. It was great fun!

For campfire pictures, Jeremy sat near the fire pretending to play Dave's guitar. Darwin lay behind a nearby log, providing more light with his flashlight. Darwin had a storehouse of good ideas and they were all fun.

Now everyone could laugh about that cold night when we nearly froze to death. They were glad they had stayed. The man that they once thought was neglectful of their basic needs now appeared to be a wonder worker with a surprisingly appealing reckless side.

The next day was our Eagle's Nest Pass day, according to Dave—an important one.

"The scenery doesn't get so much better today, but there is a lot more of it," he said.

On the way up the pass, we diverted from the trail we took two days previous and headed up a mountain on a trail in the timber. We burst out of the trees right on a grassy mountaintop. The view from there was stunning in all directions.

Dave and Sebastian rode up on the peak to glass the country. "Come up here," Dave called to me.

"What now?" I said.

"See that wonderful high ridge way over there—the one that looks like the moonlight stays on it all day? I found it in the scope of my binoculars," Dave said. Its beauty made me gasp.

"It's called the Starlight Range," he continued. "The colour of the rock makes it appear bathed in moonlight most of the time. If you come back and work for me, we'll ride up the valley beside that range of mountains and over all those ridges to a camp at a place called Blue Grouse. That is my favourite camping spot in the entire wilderness."

"I really would like to go there," I said. "But I'm still thinking about it." I didn't want him to think that I was too much under his or this country's spell. He knew better.

"This country will get a hold of you if you get the bug," he said.

We descended the mountain by way of an old burn, beautiful with its blue-black charred logs against the lush green of the foliage, the brilliance of Indian paintbrushes, arnica, and promise of the red fireweed in the fall. We talked about the wildfires of the mountains, of how they were beneficial to the ecosystem, and of the beauty that they left in their wake.

"There is an old road up here that the government in all its wisdom thought it had to build," Dave said. "It opened up this

beautiful wild region and scarred the land where only trails existed. It did nothing beneficial. The fires burned out eventually, and nature's house cleaning resulted in what you now see." Our strong southern Alberta winds would not have allowed the timber to stand for years as it had here.

We had lunch around a campfire where another group just ahead of us left a fire burning. The fire would never have gotten out of the pit, but the whole practice was sloppy and a bad example for others. We poured water on it before we left.

Dave rode ahead to make supper as usual. He put me in charge of leading the rest back to camp. I took a wrong turn and nearly led them all back up the mountain. I had my directions mixed up, because I was deep in thought about coming back. I was not paying attention. When my mistake became apparent, I turned the leading over to Sebastian. After all, he was the wrangler. I retired to the back where I could try to solve my problem. How could I possibly get back to this country?

There was roast beef that night, baked potatoes, and chocolate pudding. We went straight to bed after supper. Tomorrow was moving day. That meant an early rising to get everyone on his or her way out of the Willmore Wilderness. Jeannette had an early meeting in Edmonton the next day. She would require a good night's sleep. Edith and I would drive a long way home. I had an overwhelming feeling of sadness at leaving. I was not sure yet that I could return to the job Dave offered. There was no time for campfire. I went back to the tent to wash up after my tent mates were off to bed. The lamp was out and the dishes not done, a regular mess left for morning. I thought about how I could improve that situation. But that was not my worry right now. That was the staff's job, and I was still a paying guest.

By 7:00 a.m. we were up, had breakfast, and were ready to break camp. Although it had rained as usual the night before, this very last day of our Willmore Odyssey dawned clear and sunny, the only such day in the last ten. The boys packed several horses to carry our belongings and put pack saddles on several more to carry supplies in for the next trip.

When we were ready to mount, Dave came along with a cloth and began to wipe the previous night's rain off everyone's saddle.

"That's a first time for that," I said. "I've never before had anyone dry my saddle."

"That's because you don't travel with the right crowd," said Dave with a smirk. He never had time to eat properly. He had a piece of bacon hanging out of his month as he looked over my saddle at me. "Are you coming back?" he asked.

"I don't know," I said, "I really do need to get back to reality."

"This is reality," he said. From that moment on, I was drawn uncontrollably to this man of the wilderness and the wild country that was so much a part of him—and him of it. Though I didn't give him the satisfaction of knowing how cleverly he had won me over, I began to plan my route back to the Willmore Wilderness.

Darwin tied his coat behind his saddle, preparing to absorb as much of the sun's rays as possible on the four-hour ride out to big Berland staging area. He was yearning for an ice cream cone. How good that sun felt after nine days of rain slickers, wet clothes, cold feet and hands!

This was the first chance we had to photograph the pack string, so I hurried ahead to get them coming and dropped behind to get them snaking down the trail. Hans and Eeyore were much better companions now. Hans was taking the initiative to keep up with us, but still leaving the trail and catching up with a flurry of

speed. That was Eeyore's unique trait, whether ridden or under packsaddle. It only made it more amusing with Hans aboard.

```
Menu                                          /3
① ✓ Stew - salad - French bread - Fruit salad / Bannanaloa
② ✓ Ham - Beans ⁱ - coleslaw  - pudding    (potatoe)
③ ✓ Spagetti - salad  -  pie
④ ✓ Stew /chili - salad - Fruit Bonnevma loaf
⑤  Pork chops ⁱ rice - canned peas - jello  (Jukini)
⑥  hamburgers - baked potatoe - salad - pudding
⑦  steak - baked potatoe - corn (cob) salad
```

My menu for a seven-day trip in the mountains.

I gave Dave more hope that I would come back to work for him, but still not a final answer. He planned to phone the next night to get my answer. We both knew that only a death in the family would keep me from returning to this great wild country. The spell of the Willmore Wilderness was indeed upon me. This trip had only whetted my appetite. The sight of the Starlight Range haunted me for the next two days as I drove the long road back to my place and prepared to return to the Willmore

Wilderness. There would be a new group of guests, and the outfitter that knew very well that he and the wilderness had captivated the adventurous side of me.

Over the next three years, I returned to the wilderness in the company of this exceptional man and a special wrangler named Jeff Person. With only the three of us on staff, we logged four hundred miles of trails back and forth across that awesome country so dear to Dave's heart. We guided parties from foreign countries to as near as the United States and Canada. I cooked, saddled horses, attached and removed hobbles, wrangled and chased the herd of packhorses through dangerous territory over trails used by no one for years. Dave, Jeff, and I went in ahead of time to clear the trails of snow and debris before the season's guests came. These were often the best experiences of all. Some of the wildest trips of the summer happened at these times.

One fateful day we drowned a young packhorse in a small but deep lake high on a mountain pass. We were guiding a family with children, and it was an unhappy event. The kids screamed, the adult guests tried to step in front of them to protect them from the drama, and we watched on the shore as the horse bobbed up a few times and sunk. An older horse that had entered the water with her made it out, its front legs bleeding from their struggle with the sharp rocks.

The next day, a couple from France came in and we took them back up the mountain to retrieve the saddle and pack. Jeff removed most of his clothes beside a late snow bank and swam out into the frigid water to attach a rope to the dead horse and tow it ashore. All the supplies in that pack were soaked and had to be disposed of. The Frenchmen watched in awe, an experience so far removed from their sheltered life in Paris as they could

imagine. Now we had to figure out how to accommodate an extra saddle for the rest of the trip.

I kept a journal of all my experiences in the Willmore Wilderness. One day, when I used precious packing time to write it all down, Dave jokingly asked, "Are you writing your memoir?"

"Maybe," I replied.

Wrecks On The Trail, Closer To Home

After coming back from that photography trip in the Willmore, I continued to outfit closer to home. The fall of 1996 saw another pack string with me in the lead, on the trail up Yarrow Canyon here at home. It is a trouble-free trail when the weather cooperates, and the packing goes well. This had been a quiet ride with only a few pack adjustments made. But pack trips are not without their wrecks. You can always count on a few to hash over around the campfire at night.

A few weeks prior, at Blue Lake, I'd met Mike Judd, a seasoned outfitter with a business called Diamond Hitch Outfitting, located near Beaver Mines, Alberta. I had ridden up to the lake with Edith Evans, my riding friend from Fort MacLeod, and a few friends.

Beside a small campfire, we were enjoying a cup of tea and our lunch when Mike rode in from over the summit in the

Castle River Valley. He came over to the fire at our invitation, and somehow the conversation turned to our eventful and subsequent trips to the Willmore Wilderness. Convincing a cook to come on these trips is often difficult; not everyone wants to bend over a two-foot tin stove and cook for ten people, and rifling through pack boxes being used for seats in search of food and doing dishes at 11:00 p.m. soon loses its romantic flavour

Cooking is just a figure of speech. In my experience, it meant a variety of tasks, such as sewing ripped tents, tending to the whims of guests on the trail, putting up electric fences, chasing horses through the mountains, and chopping wood when need be, to name a few.

Mike saw his opportunity. "Could you come and work for me on my next trip?" he asked. Also being an opportunist, I thought about the many trails I could discover with Mike Judd. His knowledge of the mountains was legendary.

A phone call did come two days before the planned departure. "Come up to the flat by the little horse gate in Yarrow Canyon," Mike said. "Bring your sleeping bag and horse. We'll meet with the Castle Crown hikers there at 9:30. I've got a helper for you."

That was encouraging—a first for me.

"We'll take the horses, camp equipment, and our stuff," he continued. "They have only to enjoy the wonders of the mountains on foot."

I got up extra early in order to be on time. The guests arrived on time, and the wrangler arrived on time—but the outfitter did not. I used the waiting time to get acquainted with the hikers. Mike and his dad finally pulled in with six pack horses and tack, the cook tent, collapsible stove and pipes, and all the food in

pack boxes. With all this to pack, it would be noon before we hit the trail.

"Wonder if you could make some noon lunches?" said Mike. "I didn't have time to make them. I was so busy." I looked at the pack boxes all prepared to be loaded on horses, and said reluctantly, "I guess so." That meant tearing into fully loaded boxes that had taken some effort to organize in search of lunch fixings, and putting the boxes back together again.

Mike suggested that the guests eat and then start their hike to the head of the canyon. That got them out of our way while we packed. Mike didn't use a scale as some outfitters do. His experience over the years made him an excellent judge of weight by lifting each one of a pair of boxes; he was usually right on. Of utmost importance is that the weight be the same on each side of the horse to prevent shifting packs and subsequent sore backs.

It began to rain lightly as we finally started up the canyon, with me leading, then Jim Tweedy, Mike's wrangler, dragging Zeke, a mule that Mike said was a troublemaker. Mike and Eleanor, my helper, were riding behind to detect unbalanced packs.

I led the pack train up the south side of the canyon, away from the gravel road, until we reached a lovely place at the head, under a high rock wall, where a falls poured a spray of water from some source out of sight over the ledge of sheer rock. There was a small swampy lake there where Yarrow Creek originates, good horse feed, a large fire pit and, today, no firewood. Mike would later drag in a dry log off the mountain with his horse. Solid trees to tie horses to were also scarce—the factor that led to our first wreck.

Our wrangler, Jim, being somewhat inexperienced, wrapped his reins around a wind-polished tree root and busied himself catching pack horses. While trying to eat the sparse grass, his

horse put its foot over the reins, panicked, and came crashing through the loose pack horses and guests with the ball of prickly terror nipping at his rear! I dove out of the way behind a bush, and Mike yelled at the guests, "Get the hell out of the way!" They were trying to help.

There ensued a period of utter disorder, with guests stumbling about, grabbing at halter shanks and screaming, "Whoa! Whoa!" Finally, the offending horse, saved by broken reins, lost his root and ended up some distance away, a little shaken but unharmed. When I came out of my place of refuge it was all over. I heard Mike say to the guests, "Always get out of the way and let the wranglers do their job when there's a wreck." Years before, my Uncle James told me the same when I worked for him as cook's helper. Jim, now gathering up horses, was looking a little guilty. He wouldn't be wrapping his reins around unstable roots for a while. Later, around the campfire, with the horses hobbled and belled in the grassy meadow, this and past outfitting wrecks amused and entertained the guests before they trickled off to their tents for a good night's sleep.

Next morning, I cooked breakfast over an open fire and accepted help with the dishes, and we proceeded over Yarrow Summit and onto an old shale trail that was all but invisible. We were hoping to get around the downed timber caused by the Castle River Fire that burned uncontrolled sixty years prior. There was another trail higher up on Avian Ridge, but after glassing it, Mike decided to take the shortcut to Sheep Lake on a trail that hadn't seen a pack string for years.

Down the windswept, poor excuse for a trail went our "fearless" leader with his three-person staff and a herd of loose pack horses in tow. Halfway down the windswept old "trail," Zeke

thought of a way to cause trouble. He switched ends, followed by most of the pack string, and proceeded back the way we had come. Jim grabbed for halter shanks as they went past. Mike jumped off his horse and handed it, and the horse he was leading, to me. I dropped my horse in order to keep those two calm. He headed up the mountain in a different direction altogether, digging his way up the loose shale.

His name was Jed, and he'd been an absolute fool coming up the canyon the day before. I was thinking that I'd made a mistake in taking him on this trip, and so far I was right.

The loose shale on the other side of the summit would have made it impossible to turn the horses until they reached the bottom. Then, as if by divine intervention, the hikers appeared in the narrow passage at the top of the summit. This time they could help, and they did so by grabbing and hanging on to all the errant horses. I looked up the loose shale just in time to see Jed sliding down on his rump.

Down at the bottom we encountered a pile of flat mossy rocks. "I'm not riding this crazy horse through there," I said as I dismounted to lead him. All of the horses ahead went between the rocks—but not Jed! He walked right up onto the biggest, most slippery rock, and fell flat on his side and slid off! I scrambled to get out of his way and shook my head in disbelief as I remounted.

We proceeded down a steep grassy slope, where there was at some time a trail. I glanced back at Zeke. His saddle and pack were riding on his neck too close to his long ears. The pack horses were difficult to hold back; they knew that a familiar campsite was just ahead. That feat fell to Eleanor and me. The men had to remove Zeke's pack and repack it before we could move on. With an actual trail now, we were soon in the meadow at Sheep Lake.

Mike turned in his saddle and asked, "Are we having fun so far?" I rolled my eyes and didn't answer.

We stayed in that picturesque spot for a few days while everyone, except me, hiked the mountain ridges. I was content to stay in the quiet camp and prepare the evening meal each day. The hikers were delightful people. They drank so much tea that in fear of running out, I boiled it until it was very strong, then diluted it as much as I could, still preserving its tea-like colour A day or two later, we tore down our camp and packed up to move to another lake farther up the canyon.

Calamity Lake is under the high wall of rock that forms the boundary between Alberta and British Columbia. We spent three days in that lovely setting while Mike led the guests along the mountain ridges around our camp. I stayed in camp and watched the horses as they rested and foraged on the plentiful mountain grasses. At 4:00 p.m. they all returned, thirsty and hungry but inspired by their day's hiking experience.

On the fourth day, the guests proceeded down the canyon, staying in the high country while the staff packed up and vacated the campsite. The guests left for the campsite at Sage Creek, just over the border in British Columbia, and we proceeded down the canyon.

Mike and I were riding side by side, enjoying nice weather and a decent trail on an old seismic road, not suspecting that there was trouble just around the next corner. Suddenly, our horses threw their heads up with their ears pointed down, and the trail came to a dead stop! Coming around the corner were two huge grizzly bears using the trail too, and they were coming closer to us by the second. The pack horses caught their scent, and after spotting them they were milling around looking for an escape

route. The bears, with their inferior eyesight, hadn't seen us yet, but they were getting dangerously close now. I was wrestling with my camera, trying to keep Jed still enough to get a picture.

Then Mike did what he had to do: he yelled at them! They stopped and stood up tall, about seven feet, and sniffed the air to locate the source of the noise. Jed kept whirling around, making it impossible for me to focus my lens. Our two dogs, Walter, Mike's small dog, and Pal, my big German shepherd, saw the bears at the same time. Brave Little Walter took off barking down the trail to accost the foe. He'd seen lots of bears. Pal, my "protective" police dog, let out a yelp, and with her tail between her legs, she scooted to the very back of the string where Jim was sitting on his horse wondering what all the fuss up ahead was about. With great leaps, the bear vacated the trail and, with a crashing of timber, disappeared.

Thoroughly spooked, the pack horses ignored our efforts to slow them down and charged down the trail in the general direction of home and safety, with Mike and I in hot pursuit.

When once more they strung out in a more orderly fashion, I turned to Mike and said, "You could have waited until I got a picture before you yelled." He laughed and said, "I had to stop them before we really had a wreck on our hands." Pal stayed at the back for the rest of the trip into camp.

That morning, before we left, Calamity Mike had announced, "Today we are going to blow through some of the park to get into BC and Sage Creek Campground,"

Uh oh, I thought, *we are defying the bureaucracy and rules of Waterton Park. This should be interesting.*

And blow through the park we did, past Snowshoe Cabin and up the switchbacks toward Twin Lakes. Near the lakes we came to a fork in the trail, with one branch leading to Sage Creek Pass and the other to them. Seeing his opportunity, Zeke dashed out of the pack string and tore off in the wrong direction. Soon there were horses, determined to follow him, scattered all over the winding switchbacks.

The chase was on! Mike and his horse came sliding down the grassy switch backs, right past a sign that read please stay on the trail. The wardens would not have been impressed; outfitting in the park was no longer allowed. I stayed at the forks to stop Zeke from taking the trail we came up in the first place. Mike brought the string back and got them strung out again. Zeke had managed to create still another wreck only a short distance from the BC border.

We set up camp on Sage Creek for a few days so that our hiking guests could explore the scenic spots around Font Mountain, with its water-font-like protrusion, and a good ridge walk. As in the previous camps, Mike guided them, and Eleanor and Jim went along. I was not able to hike like they could, and was happy to stay in camp, wander around there, and prepare for the evening meal. The weather was glorious—warm by day and crisp at night.

Sage Creek camp is not known for its abundance of pasture for horses. The first morning, as I was preparing breakfast, I looked out of the cook tent door and saw a string of horses high on the skyline, led by Zeke. They appeared to be headed north to the next campsite and the lush meadows with which they were familiar.

"The horses are leaving!" I yelled.

Jim leapt into action and proceeded to head them off on foot, a half mile of timber between him and them. Mike was fixing some equipment nearby. He didn't appear to be overly disturbed and continued his task.

"Those horses are headed for the Font Mountain campsite," I said. That was a whole valley over, and Jim's attempt to outrun them was fruitless.

"No they aren't," Mike said. A half hour later, Jim returned with the herd. He looked like he'd just run a marathon. "I knew they'd stop at that first little meadow, not far on top," Mike stated calmly.

On the third morning, the clouds began to form and the rain came as we were having breakfast. As so often happens in the mountains, the nearby stream that was just a trickle the day before escaped its banks, spread over our campsite, and, to our amazement, ran right through the cook tent!

When the shower was over, the water receded to its rightful place, the sun came out, and we proceeded to dry out whatever was unfortunate enough to be on the ground during the short flood.

On the eighth and last day of that hiker's trip, we packed up to move on out of Sage Creek. I was puzzled. "I don't know how we are going to pass through that much of the Park and get away with it," I said.

"We're going to blow down Red Rock Canyon, through the park, and get loaded on trucks at the staging area, without any flak from the wardens. Lead the way," Mike said.

You're the boss, I thought. I was thinking that there was still time for another wreck or two—this time involving wardens instead of bears, raging water, or our horses.

We did blow down that thirteen-kilometre trail, but we were not so lucky as to pull it off without one more episode. We were enjoying the good park trail, the hot sun, and the gentle easterly breeze; when we rounded a corner and came face-to-face with a group of riders from the riding concession near the town site. They were off to enjoy a pleasant ride up to the lakes. The two dogs running free with me were not allowed in the park off leash.

"What are you doing in the park with your pack horses? And dogs off leash?" the guide of this crew said, with a disgusted look at me.

"Talk to the boss," I said, "I'm only the cook."

Just then their saddle horses, spooked by the pack horses piled high with equipment, charged off the trail and scrambled to climb the steep grassy banks, nearly unseating their inexperienced riders. I didn't hear what Mike said to him, but I knew it probably wasn't too nice. While the angry guide was preoccupied with gathering up his flock, we slipped on down the canyon.

At the trail head of Red Rock Canyon, where the cars parked and the tourists gathered, we strung our pack horses across the foot bridge that spanned the steep red-walled creek down below. A group of appreciative tourists were witnessing an event that they probably thought happened every day.

Waiting at the lower staging area was a cattle liner that Mike had arranged to haul our horses out. That was the fastest unpacking job I'd ever been involved in, and probably the first cattle liner to load there all against the park's rules. We had indeed blown through the park with our outfit and dogs. Later, Mike got a reprimanding phone call from the head warden that he didn't appreciate and told him so. Mike was anything but fond of park bureaucracy.

Shorter trips in the mountains were not without their wrecks. Horses act up or get tired, and pack horses wander for miles or go right back to base camp. Freak snowstorms make high mountain trails treacherous. I was bucked off on Whistler Mountain, and I cooked in pain for a week. Around the campfire, the story told was about "the time Frances got bucked off when a lead rope got under her horse's tail first day out." In my twenty years of intense riding in the mountains, there was not one wreck serious enough to break bones or kill anyone—not to say that there were not close calls.

Wrecks are a part of outfitting, and are no reflection on the outfitter or wranglers. Chasing a herd of loose pack horses through the mountains is a perfect setup for them. Unless someone is badly hurt, they make good campfire conversation and many a good laugh. This was only my first trip with Diamond Hitch. I kept coming back to cook for Mike for eleven trips between 1996 and 2001. When not with him or in the Willmore, I went, usually alone, to explore the wonders of my beloved Rockies, where I grew up.

Ed continued to live in the nursing home. I made it a point to see him often between mountain trips. That fall I took him an ice cream sixty-fifth birthday cake in a big size, hoping he could share it with all the other patrons of the home. It turned out that most of the others had some form of diabetes and couldn't eat it. The nurses and help were the benefactors of my generosity. He was delighted, however. He'd been confined to a wheelchair for twenty-eight years.

From The Prairies To The Australian Outback

Dave Manzer made one memorable trip from his headquarters in Peers, Alberta, to visit me at my acreage near Waterton Lakes National Park. For a week we rode my favourite trails in the Park and near my home. I told him how I missed the Willmore and that I'd come back to his employment, should he need me.

In the summer of 1997, I turned sixty-one. The outfitting life was taking its toll on me. The osteoarthritis in my back was worsening, and bending over those low tin cook stoves was keeping it irritated. By now I knew many more trails in the back country I'd ridden most of my life. My mother took me on her horse with my brother Bobby behind the saddle, when I was two and he was four. I'd never wanted to ride the prairie. "Nothing to see," I said. "Flat and hot with no relief, and how about those lightning storms without cover?"

My friend Edith, from the prairies, said, "No! The prairie is beautiful. How do you know if you haven't tried it?" To me that was a challenge.

On Carmen's barrel horse, Yoshi, on the Boundary Commission Ride. Covered wagons are breaking over the hill behind.

That's when we heard about the Boundary Commission Northwest Mounted Police (NWMP) Wagon Trek (BCWT), made up of a group of covered wagons and various kinds of horse-drawn rigs that planned to follow as close as possible the trek of 1874. I thought one hundred and twenty miles of prairie from Ravenscrag, Saskatchewan to Etzicom, Alberta should acquaint me with it. That was the first leg of the trek. The remainder to Fort Macleod, Alberta would take place the following year.

In 1874, the first march endeavoured to cross the Northwest Territories from Dufferin in Manitoba to Fort Macleod, Alberta. Their purpose: to quell the uncontrolled whiskey trade at Fort Whoop-up and bring the rule of law to what is now southwestern Alberta.

They made their laborious trek to the Sweet Grass Hills near the international boundary with the United States. Assisting Commissioner MacLeod was Jerry Potts, a half-breed scout of some renown. MacLeod's troupe arrived at the present location of Fort MacLeod and built an outpost in October of 1874—the first outpost in the far west.

The BCWT was formed in Dufferin, Manitoba that spring of 1999, with only a few wagons and riders. As the trek moved on to Ravenscrage, Saskatchewan, the number of wagons and riders snowballed, with some falling out and many joining along the way. When we joined, there were eighty-six wagons and seven hundred riders.

There was little time for me to prepare since I was coming off an outfitting job with Mike Judd. I had one night to get some rest, and then leave for Saskatchewan the next day. Jim Whyte, a riding friend, had a pack horse, and I had the rigging. We thought it would be fun to take our tack and get some packing practice. It would prove to be not only fun but challenging.

The first day, we travelled to the starting point using Jim's horse trailer. The second day, we packed up and moved out of the first camp, adjusting the pack more often than we should have had to. All went well until the string Jim brought for our sling rope broke and let the pack boxes slide down his packhorse Rhubarb's ribs. All hell broke loose! She proceeded to buck and kick in a large circle, scattering our belongings all over the prairie!

Jim and I sat in amazement and watched her perform.

"There goes my sleeping bag," said Jim.

"And there goes my tent," said I.

We watched our possessions land and waited for her to buck her fill. Then she put her head down and commenced to eat as if nothing had happened. We laughed about the wreck as we gathered up our stuff. This was one of those very funny wrecks—not at all the horse's fault. Her point was well taken: Don't use a string to do a rope's job.

That wasn't the only wreck in those ten days—there were many. Horses bucked their riders off; others ran away and smashed rigs; some people couldn't take the prairie heat, and for some it was just too far—twenty miles of heat, very little shade, and a hot wind all day.

But great organization in the days before the ride took good care of the people in general. We had meals prepared and lunches provided; horse feed and water and tie lines and a short newspaper prepared most days. A big refrigerator truck pulled in every night with cold beer. A team pulling a fleet of portable toilets on a wagon stopped at intervals along the way.

And the prairie—it was beautiful! Wherever there was water, there was plenty good pastureland and trees. Cattlemen had dugouts along the way. It wasn't flat out there like I thought it was. There were hills and creek banks too steep for the overloaded wagons from the east. The wagon boss and outriders with lariats tied to the wagon fronts and snubbed to their saddle horns assisted the teams. Down steep hills the ropes went on the backend, and the saddle horses helped the teams to hold back. I conveniently befriended the wagon boss, Albert. Riding with

him, I saw chuckwagons pulled by saddle horses through water holes and up steep banks, and a broken axel being repaired with a pole and dragged on it into camp. I wanted the whole experience on this prairie trek of a lifetime.

All this moved across the prairie in a convoy that left a track on the prairie wool, but did not penetrate the hard dry prairie soil and open it up to erosion. We camped overnight at historical ranches: Gilchrist, Brost on Cottonwood Creek, Parsonage and Reesors. In the Cyprus Hills, trees and flowers grew, much like at home. Battle Creek ran cold and beaver swam in ponds. That oasis, in the prairie sharing the border between Alberta and Saskatchewan, was like being home in the foothills of the Rocky Mountains. My horse, which had been uneasy on the prairies, always wanting to hurry westward, now sniffed the western breeze and settled down in the familiar environment.

I washed my new jeans and a shirt and bathed in the Battle River, where we camped at the Ranger Station. I thought by morning my pants would dry hanging there on a barbed wire fence by my tent. Not so. The heavy dew, similar to ours in the Rockies, kept them soaking wet. When we broke camp in the early morning next day, they were as wet as when they came out of the creek. I couldn't pack them, so I hung them on my saddle horn to dry when the sun warmed the prairie.

A very long grade rolls up out of the Cyprus hills to the southwest and natural grasslands. I'd read about the prairie wool up to a horse's belly waving in the wind, before the settlers. I pictured buffalo in the wallows that were still visible, to remind me of the time before the fences. In my mind's eye I could see it all.

Albert saw me and rode up beside. "Just like it used to be," he said. "Without the buffalo," he added.

"I want to run my horse through that tall grass like my ancestors did, but we're supposed to stay on the track," I said.

"Come on," Albert yelled, as he kicked his horse into a lope. "Watch out for the buffalo wallows."

Together we dashed across the prairie. He pointed out the deep Red River Cart tracks on the Benton Trail, still visible after so long and heading south for the international boundary and Benton, Montana. "Those were my people, the Métis, that helped to make that trail," I told him.

"And probably mine," Albert said. "I'm a half-breed too."

I had felt a connection with Albert ever since I met him on the first day of this trek, and now I knew why. We had a kinship.

We slowed to a walk when we came up beside the wagons of our troop. I looked down at my saddle horn, and my new wet pants were gone! Around the camp that night, I heard a laughing rider say, "Frances lost her pants on the prairie today." Very funny—those were expensive Wranglers—but loping through the waving grass was far more valuable. My one and only pair of pants were white now; they wouldn't be after the next four days on the trail to Etzikom, where we ended our ride until the next year. Edith was right. I understood now why she loved the prairie.

The next year, 1998, we completed that ride into Fort Macleod, another one hundred and twenty miles. In the winter of 1999, I filed over three hundred photos of those two trips and sold several sets to the participants—not lucrative, but fulfilling.

In the summer of 2000, Dave invited me to visit the Willmore as a nonpaying guest, helping out where and when I wanted to. He and I both knew that everyone works on pack trips. To further entice me, he promised to let me ride his best horse, Jack. Again

I was overpowered by the call of that awesome big country, and a man who had become a dear friend. His outfit was no longer the one of my former trips. He now had a large staff and very efficient wranglers that could manage even in his absence. Dave required more rest now. I sensed that he was not well, but I was not privy to the nature of his illness.

Returning from the Willmore that summer, I joined a convoy of riders and covered wagons, bent on crossing the Canadian Forces Base Suffield Wildlife Area in south-southeastern Alberta, to the Hamlet of Suffield, north of the city of Medicine Hat. In late 1971, the Suffield Block, north of the South Saskatchewan River, was designated a base for military training. In 1992, a memorandum between the military and Environment Canada left an area of one hundred and seventy-five square miles wide. That was the area that interested us.

Riders and wagons from Alberta, Saskatchewan and the northern United States joined the trek. My interest was in the camaraderie of likeminded people, the riding, camping and photographing the flora and fauna of this intriguing part of our great country.

I'd hastily sewed up what we call a cowboy tent for camping at night. It turned out to be hard to set up, too small for me, let alone a friend from Montana named Marlin, who decided to share my accommodation under the pretence of helping with my homemade tent. The telescoping centre pole, designed to hold up the heavy canvas, constantly needed repair. A wooden substitute for the pole would have functioned perfectly, but there was not one tree to be found out there on the prairie; duct tape was the inadequate answer to our problems.

The catering, ably provided by the British Block, supplied us with more food than we could eat, excellent lunches for the trail, and refreshing showers at night—all set up in a sea of khaki army tents. The women and girls showered in a common one-room tent, with water pouring from pipes along the ceiling, the men and boys on the other side of a canvas wall. Some mothers complained about the modesty for the children, but since there are, thankfully, no children in our military, the army were unprepared and the parents were politely ignored. I've not appreciated a good shower so much since those long, hot rides on the prairie.

At night we sat around one of the big campfires and hashed over the pleasures and wrecks of the day. When someone showed up with a guitar, we danced on the prairie grass or just enjoyed the western music.

At 5:30 a.m., on the last day of the trek after a chilling night on the prairie, I created my own especially embarrassing wreck. The clear night before promised a spectacular sunrise, the kind that stirs the creative juices of an amateur photographer like myself and causes one to do whatever it takes to get that shot of all shots. That night, I set the stage for my special pictures, set up my tripod, pitched my tent near where a cowboy picketed his lone horse, providing me an object of human interest for the right-hand third of my picture. There would be only a few seconds to get this shot. The sun must not more than peep over the horizon, throwing its magic onto that great expansive prairie sky and spilling over the gently stirring native grass called prairie wool.

Our group of twenty covered wagons, buggies of every description, and numerous riders afforded an opportunity of huge proportion for a shutterbug like me. Nowhere are weather and sunrises more dramatic than on the wide-open prairie.

I was not in the habit of sleeping with my lower dentures in place; I had never talked about them, and had vowed years ago not to be seen without them. That necessitated their removal and spiriting them into some safe place in the tent after dark. That night, I slipped them out of my mouth and felt around for my hat, riding boot, or pocket in which to hide them from my friend. *Great*, I thought, *that feels like my camera bag. I'll just slip them in there and get some sleep.* Sitting around a campfire until late at night and rising at sunrise leaves precious little time for rest.

In what seemed like no time, my travel alarm went off, sounding like a fire bell, even though I had it buried in my sleeping bag to dull its impact on my partner or the rest of the camp. Without any care clothes-wise, I grabbed my camera bag slipped out of the tent and located my tripod.

Behold the magic of first light! I ran off an entire film, capturing the light on wagons, tents and horses. At moments like this I completely lost myself. All that mattered was to catch that morning light before it faded.

Feeling very tired, I put my equipment away and crept back to my sleeping bag for a little more sleep. It seemed that I no sooner hit the pillow when I heard the first group of wagons jingling past my tent. There were six groups, and we were the last to leave today. There was still time to grab breakfast, saddle up, and tear down the tent—my snoring partner's job.

I dressed quickly and reached to the bottom of my camera bag to retrieve my hidden teeth before he woke up. What the heck! *They must be under some of my lens*, I thought. I turned the bag over and shook its contents out on my bedroll. No teeth! I frantically tore at the covers, throwing them every which way and

waking Marlin. They had to be here someplace! Suddenly all the magic of the morning faded.

"What the hell's going on?" Time to solicit his help. My pride flew out the tent door.

"I can't find my lower plate," I blurted out. "Help me!"

"Didn't know you had one."

"You do now—just get looking." We shook and re-shook everything in the tent and still no teeth.

There was no humour in the situation at this point, and, had he seen any, he would have been sleeping with the rattlesnakes the next night. There was simply no option but to look beyond the confines of the tent. I had to get them before someone else did. Oh, the embarrassment of it! My fate would be hilarious to share, not only on this trip, but on future ones too. Great campfire conversation!

Where would they have fallen out of my bag? I had been all over the camp. The logical thing to do (if there was any logic at a time like this) was to start looking at the beginning point of my morning excursion.

I found them alright—smashed into the hard prairie sod by a number of covered wagons wheels! Dentures don't break into small pieces like glass does. No, they hold together like a smashed frog. I picked up the sorry mess and stepped back into the tent, where I held them up for Marlin to observe. He was not laughing, but he looked like he would blow up if he did not soon. I felt like crying, but the look on his face and the humour of the situation won out; I began to laugh. Together we laughed until we rolled on our sleeping bags with tears soaking our cheeks. Recovering slightly, we rushed out to breakfast—a very soft one on my part.

Marlin promised he would not breathe a word of that episode and I gummed it for one steak dinner that evening.

I had had an impossible dream to visit Australia. The likelihood of getting to that land down under was even more remote than the Willmore had been. Still, I began to formulate a new plan.

My mother was doing well in her nursing home, and Ed, though showing more signs of aging, was still well.

Crossing the Pacific Ocean, I saw as just another barrier standing between me and that home of the aborigines and kangaroo that I'd dared to dream about. Cowboy Poetry came to Pincher Creek every June. Musicians and poets from miles away came to take part in what is considered the best poetry session ever staged. One of the best ranching locations on the continent, Pincher Creek and area is cowboy country. They came from the United States and all over Canada to pour their hearts out in song and poetry, celebrating our western culture.

In June of 2000, one of another sort came from very far away. I was picking up a few groceries in our local IGA store when he pulled up to the building, riding a racing push bike with a heavy pack on it. He came straight over to the produce section where I was shopping and began to talk to me in a very friendly manner.

"Are you English?" I asked.

"No, I'm Australian, and I've come to take part in the poetry session. I was here last year and it is first rate."

"Really," I said. "I missed it last year." I didn't want him to think I was too interested in him.

What did interest me was that if the stranger was telling the truth, he was from that place down under where I would do most anything to reach. I became more interested by the minute. That

was the beginning of a relationship that lasted for the next three years and changed my whole perspective of the world. Brian Gale didn't really sound like an Englishman. His dialect and he were exclusively Australian, as I would learn.

Brian fascinated me with his uniqueness and free spirit. He didn't see any reason why I couldn't go to Australia, until I told him I didn't have the money. He raised his eyebrows and didn't offer any solution to my problem. No more was said about my financial situation until he was ready to bike off to Vancouver.

"I could help you with your money problem," he said.

Yeah! I thought. At that instant, I knew that if he were that interested in me, I'd maybe get to Australia, and I began to plan seriously. That was the beginning of a fascinating journey to reach the outback that I'd dreamed about for years, but believed was just that a dream.

At first, like so many people my age, I didn't want to embrace new technology. Computers frightened me, and my camera worked just fine. However, I needed information on Australia, airlines, and that mysterious island in the Pacific Ocean—Norfolk. Brian was inviting me to meet him in Sydney, Australia to travel to that island for a two-week poetry session. As my daughter Brenda helped me to get that information, I became more interested in the use of a computer. Over the fall I purchased one, overcame my fear, and learned to run it—somewhat. The idea of writing a book took root that winter, and I realized the importance of a computer. I read every book I could find on the mutiny on the *Bounty* ship and its fascinating history. Although this trip wouldn't get me to the outback, where I longed to teach in their

school system, or to a station, where I could muster cattle, it would get my feet on Australian soil.

I was not bargaining for the plane trip down there. I'd only been on a plane once, and I was with an experienced friend. I had no idea how to get through customs. While I was in the air, it was all fascinating and wonderful for me; in airports it was confusing and terrifying!

I boarded an Air Canada plane in Calgary, Alberta, and in three hours landed at the airport in Los Angeles, completely lost. I asked questions of other passengers, and particularly of two young Australian men. I learned that I must now go to the International Building. Somehow, by watching others, I retrieved my luggage, loaded it on a gurney, and pushed it to Building 115, two blocks away. It was 11:00 p.m. I was exhausted and weak with fear of missing the next plane, and my new knee was aching from sitting so long. I saw several people with their hands out begging. If I was in danger in that city, I was mercifully ignorant of it. There was probably a shuttle for such purposes. I didn't see one. While waiting for another shuttle that the Australians I met told me would be there to take us to the International Airport, I was able to look out over the city. The view was stunning. The freeway had more cars than I'd ever seen at one time. There was a racetrack lit up with horses on it, and the lights stretched from horizon to horizon and beyond in every direction.

When they announced the shuttle, I fell in behind the Australians and kept them in my sight. Two hours later, we boarded a huge Quonset plane, with me still following the Australians. It was loaded with luxuries. For the first time since I left Calgary, I relaxed. We were eighteen hours away from Australia and Sydney, New South Wales; with all the stress I

felt like it was days since I left the security of the small Calgary airport. I was supposed to walk in the aisle periodically to prevent blood clots in my leg with the new knee, and I was to try to get some sleep. I could barely get up the nerve to crawl over the person next to me to go to the bathroom when it was necessary. I'd insisted on a seat next to the window for the view.

My biggest thrill came when the sun came up next morning. How beautiful it was out there above the clouds. A pancake breakfast; a beautiful morning; a few more hours, and we were circling Sydney for landing. I wasn't sure how I'd done it, but we were about to land in Australia.

I'd left Calgary in a snowstorm, and I had no idea how hot it was in Australia's summer months. Brian was dressed in a light top and shorts. I was wearing a sweater with pictures of snowflakes on it. When we left the airport, I was overwhelmed by a wave of heat so intense that at first it drove me back into the air conditioned building. Soon we would board another plane for Norfolk Island. I felt safe at last. Brian was an experienced traveler.

The next ten days on the island were perfect. I felt like I knew the place because of my pre-trip reading. The most amazing of all was the climate. Coming from Canada, I had never felt air like that. The people had names right off the Bounty Ship: Christian, Young, Adams and McCoy. We attended numerous Bush Poetry sessions, but the history of the small island was foremost in my mind. It had once been a penal colony. Time had preserved the stone buildings, fortresses, and gravestones of the convicts.

The people that now inhabited the island were the descendants of the third effort by the British to colonize the island with people from the over-crowded Pitcairn Island. The first effort had

been somewhat kinder than the second from 1825 to 1855. This hideously cruel period in the history of the island was depicted in the literature and stone ruins preserved only by their ability to withstand the ravages of time. In 1856, all of the inhabitants of overcrowded Pitcairn Island were moved to Norfolk Island. Some could not adapt to life there and they returned to Pitcairn for good.

What a treat it was to meet a man from Pitcairn Island, so romantically portrayed in books. I had my photograph taken with him. One clear night, Brian pointed out the Southern Star, bright in the sky of the Southern Hemisphere. To the best of my knowledge, I was one of only two Canadians on the island at the time. I immersed myself in the history and all but forgot about the poetry so dear to Brian's heart. People were full of questions, especially about the grizzly bear. Did they really stalk to eat people regularly? Most of them had never seen snow or felt the bite of winter.

We walked every trail on the small 13.3 square-mile island, population one thousand. We watched the sun come up over the golden South Pacific Ocean and wandered between the crypts in an ancient convict graveyard.

After ten days, we boarded a small Flight West airplane from the modest Norfolk airport for Sydney, Australia, where I took a Quantas plane back to Vancouver and an Air Canada to Calgary, and Brian went back to Western Australia. I had only whetted my appetite for that country so opposite from my homeland. The outback of Queensland was beckoning, and I had no idea how to get there.

But opportunity was on my side. In January 2001, Brian wanted me to come back to attend the Tamworth Country Music

Festival in New South Wales and visit Longreach in the outback of Queensland. He didn't have to ask me twice. On January 18, at minus twenty-five below zero, I boarded a plane in Calgary, Alberta, and began my trip back to Australia. I had no idea how I'd get to a station in the outback, but I was getting closer.

I arrived in Sydney on January 18 at 9:00 a.m., twenty hours later, but the same calendar day that I left Calgary. Brian got there at much the same time. Fifty degrees of temperature separated me from what I'd left in Canada, and my body did not like it. The air conditioning in the taxi to the bus station rescued me for a while.

While waiting for the bus that would take us to Tamworth, we explored the grounds around there. Brian introduced me to the constantly chirping cicadas in the trees and the leaves that remained green year round. The air was saturated with bird calls. We boarded a bus shortly after noon for the long ride.

We arrived at Tamworth at 11:45 p.m. It was still hot. The bus dumped us off at the Paradise Camp Grounds in Queensland, where we were to tent for the next ten days. We hauled our few supplies to the outskirts of the Caravan Park and set our tent up under a tree on no particular lot. "Save one night's pay," Brian said. I was so tired, and my legs were so stiff from that long ride that I really didn't care if they caught us freeloading. Brian was prone to taking privileges in Australia that I wouldn't have dared take in Canada. Camping on that free ground didn't turn out so well.

Next morning, I woke up sweltering and crawling with tiny ants. Brian had opened the tent door in the night to get some fresh air, and the grass was alive with them. Next night we'd tent on the bare ground of a lot that we'd pay for. I credited a

small swimming pool in the camp for saving my life while Brian busked his poems on the hot street. The heat didn't affect him as it did me. I enjoyed the concerts in air conditioned buildings. I was fascinated with the quality of their bush poetry and their extraordinary humour They asked about my accent. I didn't know I had one. They were not fond of Americans like they were of Canadians.

There were possums in the trees above our tent. We shone a flashlight on them and saw their tiny babies peaking at us from their cozy nest in their mother's pouch. "What do they eat?" I asked.

"Fruit, but don't feed them," he said.

I fed them, and next morning there were muddy tracks all over our packs where they'd searched for food. When Brian woke with a track on his forehead, he closed the tent door, and we sweltered nearly every night thereafter until they decided to leave us alone.

I was anxious to move on north and closer to my desired destination. Brian made it plain that he was going no farther than Longreach and its Hall of Fame.

"I'm going to a station in the outback," I insisted. No one was going to stop me now that I was getting closer.

"You won't like it," Brian said.

We left Tamworth early in the morning on January 30, on a bus heading north. We had breakfast at Duralla, passed through Armadale and Glenninnes and over the Queensland border. This was the beautiful, prosperous country near the Gold Coast, where people lived in large, spreading houses in the rolling green hills, where all manner of farm animals pastured within the flawless fences. There was obviously money here.

We arrived at Toowoomba at 3:00 p.m. We had a six-hour wait there, among the flower gardens and clean streets. It was not hard to pass the time. The temperature was pleasant, and the air was fresh off the Gold Coast. There were parks and more flowers than I'd ever seen in one place. When we left at 9:00 p.m., we regretted that we had to pass through this wonderful country in darkness. We were now travelling inland.

The rain came down in torrents while we were attempting to grab something to eat at a small roadside bus stop. We escaped into the bus and were treated to a lightning display that lit up the plains and gave us some idea as to the country we were travelling through. In a pocket by the window, I saw what I thought was a hammer. I stared at it in disbelief. "To break the window in case of accident," Brian said.

I thought Brian should have been able to tell me more about Queensland, but we were a long way from his home in Western Australia and what was familiar to him. We were both exploring his country for the first time. Somewhere on that long, tiresome ride, with only a little uncomfortable sleep, we stopped at a shabby looking place where I wanted to splash water on my face to cool off. We found the bathrooms dirty, and the only sink was about four inches wide, and hanging precariously on a wall outside.

We thought we might get a cup of coffee. We sat at a table under a light, and when I looked up, I couldn't believe what I saw. This was a place where they served food. "Look up," I whispered to Brian. In the neon light cover was a dead rat in the last stages of decomposition. I was not about to trust even coffee in here. We got back in the bus and tried to sleep, hoping for better luck at the next stop.

When daylight came near Augathella, we were in open country with natural grass and clumps of acacia trees. At first, when Brian pointed to the kangaroos out on the scrub, I couldn't pick them out. They blended right into their habitat. I wanted a much closer look at them. Over the next two months I hoped for that chance.

We tented at a pleasant little caravan park called Gunnadoo in Longreach, as we explored the wonders of the Longreach's Hall of Fame and the country around there. Longreach is seven hundred kilometres west of the city of Rockhampton. Its large museum depicts Queensland's colourful history. It was to here that the drovers from the north and surrounding country delivered numerous herds of cattle to be sold to the big buyers. The Waltzing Matilda highway runs across a great sparsely populated country to Winton, where another museum is dedicated to that region. The Thompson River that is so prone to flooding runs near Longreach. The country around it is lush ranch land dotted with billabongs, half brahma cattle, horses, and cowboys buckaroos.

I was fascinated with the distinct Queensland-style houses. The big spacious stilted buildings stand fourteen or fifteen feet above ground for flooding and air circulation. Other low block houses are about three feet up; all were very big and single-floored. Some of the high ones had cars parked under them, while the low block type made excellent places for dogs and wildlife to hide.

A kind pair named Pam and Phil Morphett treated us well and showed us some of the things unique to Australia, which were almost everything. We woke up one morning to find a scorpion resting on one of our pack bags. If Brian had not been there, I wouldn't have known how dangerous it was. There were little

green frogs and geckos stuck by the suction pads on their feet to everything in the bath house—the sinks, toilets, mirrors and all over the walls, inside and out. They were harmless and charming. By noon it was very hot, but cooled down for a pleasant night.

The Australian ants impressed me in their numbers, sizes, and ferocious attitudes. They made trails through the grass and visible holes where they lived. They attacked us when we placed our chairs in the shade of a tree to have tea with the neighbours They climbed anything on their trail. After we rid our bodies of them, we turned to see the trunk of our Eucalyptus tree completely covered with them. They and other insects actually hollow out these trees but don't kill them. Strange things happen in the outback. While taking refuge from the heat in the caravan park swimming pool, Brian pointed out the red, blue, and green of the lorikeets hiding in the branches of the poolside shrubs.

Brian went back to Western Australia when his stay at Longreach was over, and I went in search of the school that the proprietor of Gunnadoo Caravan Park told me about. He said that I might find help there to get me into the outback. Longreach was the centre for the School of the Air, and I'd fallen into the exact place I wanted to be without knowing it. Brian's parting words as he boarded a plane for west Australia were, "Why do you want to go into that miserable country? Come to Western Australia where it's comfortable. You must be crazy!"

I didn't bother to answer. My mind was made up.

Jayne James picked me up there, and we drove two hours into the outback, to Glencoe Cattle Station, owned and run by her family. She and her husband Dick had four children, ranging in age from fourteen to six years old. I was anxious to meet the kids and learn

about the school on the station and how it was operated. Dick asked me if I could drive a standard truck before I even had time to get settled. Soon he and I were off to a yards he owned, about an hour through scrub, the termite mounds, and the gum trees. Once there, he boarded a larger truck, and I attempted to follow him back to Glencoe. He got there faster than I did. Jayne had supper on and the questions and show and tell began.

I spent two of the hottest months of their summer mustering cattle through the scrub, teaching kids in their School of the Air, bouncing in yutes (the Aussie name for a beat-up old truck that was battered by termite mounds and kangaroos) over the great distances that they travel to get anywhere. I suffered through temperatures that I couldn't imagine. It was impossible to get cool. I sat under a tree, but it was hotter there with no breeze. When it hit forty degrees, the kids and I stuck our heads in a pail of cold water (my idea) from the refrigeration room; in twenty minutes our heads were dry and hot again.

I saw huge snakes, emus, and wild pigs, millions of birds of many colours and voices, including my favourite—the laughing kookaburra. There were kangaroos of many sizes, from the great greys and reds to the plentiful wallaby. The cane toad wasn't as dangerous as made out to be; he could only shoot his poison one meter, and only when provoked. They were so hated that I felt sorry for them. They didn't ask to be dumped where they were. Ben, the teenaged boy, smashed flat every one he saw with a cricket bat. "That only knocks it out," he said as he went for the salt. "That dries them up." According to him, they could put themselves back together and crawl off.

The outback kids were the toughest lot I'd ever seen, and yet the most respectful and loving. I gave them everything I had with

me from Canada, and wished I'd brought more. A sweater with snowflakes on it was the most popular thing I had. The pair of baby moccasins was a close second. Finally, I got to see the iron-red sand blows and billabongs. Most things in the outback are capable of piercing your skin or biting you, except the wonderful, plentiful green tree frog and gentle little gecko. They keep the flies down and are allowed to crawl the inside walls with impunity. All the doors were screened, but somehow the tiny flying insects managed to come through and bother your skin all night.

There was no booze at Glencoe, but a few miles away at Jericho, a gathering of houses rather than a town, there was a huge bar, a post office, and a garage. There was no means of entertainment except to get drunk. Tamara, the nanny, and her friends found me a very dull companion since I could not be induced to drink. Still, I went to one of their parties in a park, down by the river, out of curiosity. It was a wild affair with everyone getting drunk and going swimming. When they got out, they gathered up branches and made a good-sized fire on the ground in front of a picnic table—no fire pit. We had lunch and more beer until they produced their swags (sleeping bags), crawled in, and went to sleep in the warm Australian weather. We walked home to Tamara's house for the rest of the night.

Australia's outback took everything that I knew in Canada and turned it upside down. I loved it all and wished that I could stay until the weather cooled a little for their winter. "You can ride horseback in comfort all winter," Jayne, the kids' mother, said. She'd been to the doctor in Rockhampton so far away that it required an overnight stay if they shopped for groceries. She brought back a medicine for me. My legs were swollen from the

heat and I was getting sick; soaking them in cold water was not working, but electrolytes did.

The school had two small rooms, with tables for the four kids, and no air conditioning. In the back room, where hordes of spiders and bees lived, there were computers, printers, and radio equipment that connected them with their teachers in Longreach. Their lessons were on a correspondence system like that in Canada. Tamara didn't seem much older than the oldest boy, Ben. In addition to supervising them at the school, she looked after them most of the day in the house. They had very little respect for her, and the youngest, Korey, was spending most of his time under a table doing nothing. He soon warmed to me, came out, and began to learn. He really had not advanced to where he should have been.

Ben wanted to go to a school in nearby Jericho. Since his dad, Dick, had quarrelled with the school officials, he stubbornly kept all the children at home in the School of the Air. This was Ben's sixth and last year at home. Next year he would be boarding in Rockhampton—the first time he'd be away from home for long, and he wanted to get away from his dad in the worst way. Dick wanted far more from him than he should have. The two in-between girls, Nicole and Casey, were doing well, but I was able to help them too.

Life on Glencoe Cattle Station was rougher then on many others. Frank, at the service station in town, told me not to judge all stations or schools by Glencoe. At first I didn't understand what he was getting at, but I would soon find out. Most of the stations were the property of absentee owners with a lot of money. Managers and hired help did the work. Dick owned Glencoe, and he did most of the work with his family and very little hired help.

Jayne used the mail run, which took all day, to get away from the turmoil at home and her overbearing husband.

The James's lived in one of those low block houses, had chickens (chooks), six work dogs, and several pets. The work dogs were chained at an out building where no one was allowed to handle them except to water and feed them. They were unfriendly, but they knew their job when it came to handling cattle. They were chained there in the sand, with very little shelter among the half-decayed sheep parts and meat ants. A runt pup died there with the ants eating him alive. Dick wouldn't let the kids rescue it because, he said, "It's a work dog, and if not strong enough to live under those conditions, it may as well die." His word was final. The kids were used to dogs dying and being shot.

When we heard several shots from out in the barnyard, Ben said, "Dad's mad at the dogs." Jayne said, "That old .22 misfires so often they're probably safe." I asked Dick about his gun and he said, "It may misfire, but when it doesn't, I never miss."

The James family ran two thousand head of cattle on twenty-three thousand acres of scrub and termite mounds. There were two bores (deep wells) with pipelines running for miles, carrying water on top of the ground to dams (dugouts). The well pumps were solar run, and there was a squeaky old windmill at each dam. All of this Dick managed and maintained. He was a very busy, over-worked man, and his temper reflected it. He controlled all the household, his family, and the large holding to the point of mental illness. He was two men—one who was very nice when away from home, and the other uptight and overburdened at home. In spite of the dysfunction that I saw, he would drop everything to take me to photograph a bird or some other strange and different animal. He was never rude with me.

Dick had a control problem that needed treatment, and his family and animals were paying the price. His kids had a love-hate relationship with him, and Jayne enabled him. When his temper flared, he was mean. The kids were getting mean too. I kept my concerns to myself while Jayne poured out her grievances to me and didn't do anything to improve things. After a long, hot day in the brutal outback, Dick came home to find fault with how the dishes were placed in the dishwasher. He'd take them all out and put them in "right."

Although disturbing, this all had very little to do with my outback experience. The whole family was out to educate me about life there. When there were cattle to muster, Dick appeared at the school door with a horse for me. I drove the yutes (utility vehicles) with the roo (kangaroo) bars through the scrub, dodging termite mounds and billabongs, and photographed the strange vegetation and Australian animals. Dick was determined to send me back to Canada with as much outback education as he could manage.

The Australian magpie would make you love the Canadian one. In breeding season, with ruffled feathers, they turned into flying missiles that pick holes in the chooks and send the kids for their hard hats. A commotion from the chook yard brought Ben on the run with the cricket bat. Their crows were beautiful birds, but they were killers too.

Dick took me to a well bore and enticed me up the windmill to a platform, from which I surveyed the land that he was so tied to. Back home at night, he changed into a tyrant and became unlikeable. He had a mean, abusive upbringing in very hard times. It was not reason for his behavior, but reason enough for Jayne to

make an exception. She made no effort to interfere on behalf of her children. She acted as if she had given up years ago.

I shared a room with Nicole at night. It was too hot for blankets, but necessary to use a light sheet to escape the small insects that got in through the screens. When nature called in the night, it necessitated a trip to the outdoor toilet where I thought I might step on a cane toad. Dave gave me a flashlight to take care of that problem. The toilet was no different from ours in our houses, except that it was unsanitary and the home of huge spiders and many other insects. The bathroom in the house proper was for bathing and washing up. There was no cold water to be had.

In the back paddocks was stiff buffalo grass that they sowed to replace the native spinifex, which is spiny, unpalatable, and flammable. The hearty brahmas ate the shrubs with thorns that our cattle wouldn't touch. When they were gone, they ate the lower branches of the trees as far as they could reach. In spite of these conditions, they were sleek and fat. They had a great area on which to forage.

Soon the Kookaburras woke and began their laughing. They woke flocks of budgie birds. The scrub was alive with bird music. The curious wallaby, springing along near the protection of the gum trees, stopped when I did and continued when I started again. Too much attention and they disappeared into the foliage until I disregarded them. They gathered at the dams at night and left their tracks and scat.

The big snakes stayed in their holes in the banks when you were near. They were shy and only dangerous when threatened or surprised. In the house and trucks were kits with antidotes for snakebites, along with instructions to administer them. Some of the smaller snakes were poisonous too. They seemed to hang

around the stations farther back in the outback. On a mail route where I accompanied Dave one day, a woman said, "I just swept one out of my house." Dick said, "The only good snake is a dead one." I thought it was a shame that the harmless ones were persecuted too. We saw them some six-foot-long, dead on the roads, along with numerous wallaby and kangaroo.

Dick brought home some fresh kangaroo meat so that I could taste it. It was good, but probably road kill; I never asked. The family wouldn't eat it. There were sheep and cattle to eat, and although very plentiful, "Skippy" as the kids called the plate of meat, was their national symbol, and not to be eaten in these modern times.

There was a man called the "Roo Hunter." He traveled at night with a truck, rifles, and a bright floodlight. His job was to thin down the kangaroo population and preserve the meat for human and dog food. The kids looked at him with suspicion eyeing his guns, but said little.

There were very few visitors to Glencoe. The police stopped by once in all the time I was there; an aborigine called Malee came by looking for work, and Dick hired him off and on to muster cattle and fix fences. Sometimes he bought his cute little boy, Wooly Wooly, to play with Korey. Mallee was a drover from the north. I was eager to muster cattle with a real aborigine drover. Dick yelled at him and Malee seemed to expect that treatment. I appeared to be the only one that Dick treated with respect. I went on with my Australian experience, trying to ignore Dick's foul moods and treatment of his family and hired help.

We mustered cattle through the rough scrub, with wild pigs and kangaroos dashing off to avoid us. The half Brahmas were wild when stirred up. They raised their heads and ran like elk,

sometimes with six dogs and Ben on the motor cycle in hot pursuit. Putting three hundred head into the yards for sorting took three days, and then it was doubtful if all the intended were there. Time and time again we got about a hundred of them to the gates, only to have them spook, and many got away. We kept what we could and went back for more. When the day was over we left our horses in a paddock there and came back with vehicles to gather another day.

In my Australian attire on Diamond, mustering cattle in the Yards at Glencoe Station, Queensland, Australia.

While we were chasing a herd of thirty bulls to another paddock, we met a herd of about twenty "wildies" that left the road and run through a fence as if it was not there. They disappeared in a cloud of dust. "Wild ones," Dick said. "No one's ever

been able to get them all in since they went that way. Sometimes a few come in with the others and we try to keep them."

Periodically we stopped for "smoko" when we were gathering, which means building a fire and putting on the billy (tin pail) for tea, even when thirty-eight degrees above. Surprisingly, that tea and lunch were refreshing, even though there was no relief from the heat. Dick had decided that if I was going to be an Australian for two months, I needed an Australian hat to wear. He found a heavy felt, floppy hat three sizes too big, stuffed the band with paper to make it fit, and made sure I had the sweaty, hot thing on every time we rode. How I longed for my cool straw hat at home.

We gathered up and confined to tall metal corrals (yards) cows, calves, and bulls in those few days. They were sorted in the dust and heat, some branded, some castrated, and others set free to grow into three-year-old bullocks ready for market. Malee and Jayne separated them with Dick at the gate—for once quietly speaking. Those big three-year-olds were impossible to handle when they were spooked. Chutes kept the angry ones at bay until they calmed down. The yards were about five acres, and into them went our three days of gathering in shifts. Two hundred were trucked back to the home place to send off to market in Rockhampton via road trains.

We chased a herd of Angus bulls to another paddock an hour away. When one escaped, Dick set the dogs on it. They never failed to bring it back into the herd, panting and much more docile. Before we went home, we left our horses in the small paddock. I was hot, dusty, bug-bitten and exhausted. The others seemed unaffected. It would have been impossible to chase a large herd with so few riders. Dick used his big yute to truck them all to the home yards.

Before the trucks came, the cattle were left confined at home for three days with water and no feed. "Makes them easier to handle," said Dick. Where there's no winter, there is no need to put up hay. The only feed I saw there was a huge pile of cotton seed that looked mouldy to me, and they didn't even get that. The road trains held eighty-eight three-year-olds each, and there were two such trailers fastened together and pulled by a huge truck. It was necessary for Dick to hire two trucks because of the long haul to market. Because the marketing in Australia is not seasonal, and the cattle so plentiful, he could repeat this performance whenever the need for funds arose—so it seemed to me.

Now I was seeing the famous road trains of Australian cattle country. Dick said, "Get out of the way if you see one of them coming." In all the time I was in the outback, I didn't see anyone concerned with the speed limit. They were all speed demons! Out there in the flat country there was no need for ditches. You could leave the narrow roads almost anywhere.

Visitors, which were very few, were invited in for tea and fruitcake, the staple offering. A date was set aside to bake cake and freeze it for the whole year. It was more like a fruit loaf, less heavy than our Christmas cake. Dick was the perfect host, belying none of his faults. He had his own cup, which he used on this and all occasions. It was big enough for a salad bowl. Tea was the favourite drink, next to water, in the outback. Water was frozen in pails and stored in a deep freeze that was especially for it. Blocks were then put in a water dispenser for drinking. The rain water collected a certain amount of debris from the roof in the rainy season. Some of it collected in the bottom of the dispenser.

Glencoe was exceptional. Many of the stations were comfortable, with air-conditioning in the houses. I visited some with

Dave when we traveled the all-day mail route. It was on those routes that I saw how the real outback Aussies lived. Some of the drovers I met were old and had spent all their lives in the outback without coming out. They were very curious about Canada.

By April the weather was getting cooler and the dryness had reached its peak. The billabongs were drying up to stagnant puddles, and the water level in the steel collection tanks was down. Less bath water was available, and I was beginning to wonder about the quality of the drinking water near the bottom of the tanks.

There had not been a good rain at Glencoe all summer. With fall and winter, the dry creeks would flood and the dams fill up; the rainwater would run off the corrugated steel roofs and fill the many holding tanks with household use, to again do for the dry summer months. Farther north, the ample rain would charge down the few Australian rivers and flood much of the territory in the central outback. The country would burst out in bloom when the water receded and the sun beat down for another hot, dry outback summer around Glencoe.

The hearty Australian lived constantly under threat of flood, drought, locusts, and fire. They were used to the ravages of nature. They braced for the worst and lived for the good times. Tough as they were in the outback, they were hospitable people, eager to show you the country they loved. The aborigines that I met were gentle and kind. They were artistic people and willing to share their culture, especially with a Canadian.

It was my distinct fortune to spend over two months with the Australian people, and my stay in the outback was about to end. I would ride with Jayne's friend Lynn to Balarama on the highway

to Rockhampton, and meet other good friends there, John and Joy Major. The drive would take most of the day. They were to pick me up for a few days at their home Nonda.

It was difficult to leave the kids. I'd become very close to them in those two months. Korey wanted to go with me, and I worried for his welfare. He was gentle and impressionable. How would life at Glencoe shape his personality and affect his life? What could I do about it?

With a group of Aborigine children at a school in Worribinda.

I saw my first field of cotton. Lynn stopped a while so that I could walk out into it and see the boles firsthand. We saw the bottle trees (boah), shaped like an old-fashioned milk bottle. The dry branches and leaves at this time of year were in a little blob on top. Lynn said the ones we saw were probably about

five hundred years old, and that some lived for fifteen hundred. The country became lusher with the miles. Soon we were out of the outback and into the choice farmland, and nearing the Gold Coast of Queensland.

I had spent time with John Major and his wife Joy at both Norfolk Island, where I met them and at Tamworth. They were both excellent bush poets and among some of the best friends I made in Australia. John was waiting for me with his friendly hugs. It was dark when we reached Nonda and the tasty supper Joy had prepared. They were anxious to hear about my stay in the outback, and we talked long into the night. They wrote poetry about the hard life in the outback, but they chose to live in a much kinder place.

Nonda was a large spread, where there was evidence of a very prosperous farming operation. They were readying their home for an auction sale and themselves for a new pace of life. John's heart was deciding for them, and Joy was worried for him. She was an avid quilter, and they shared such an interest in antiques that they'd furnished every room of the old house where they once lived.

I stayed there where they'd lived so much of their lives— among the trees, many buildings, and spacious grounds with a swimming pool—for four days. John showed me around their home town of Baralaba where he was raised. He had great pride in the machinery selling business, where he had obviously prospered.

Joy took me to Worrbinda (aborigine for "kangaroos sit down"), an aborigine settlement. They had stores, schools, a hospital, and state housing. We visited an elementary school where the children flocked around me, eager to have a photo

taken. In an art gallery, I saw real aborigine art being produced and sold right there—boomerangs and didgeridoos and huge nuts from the boah tree, painted with the bright colours that the people loved. One artist was eager to have his photo taken with a Canadian.

Jayne said, "The aborigines go into Baralaba to shop, but they are always home before dark and in bed. They believe the evil spirits that are active mostly at night live in the forest they must travel through." There was a tree on the way there that looked like Jesus on the cross. I recognized it before I was told. They called it the Jesus Tree, and they had great reverence for it.

Worrbinda was yet another highlight of my Aussie trip. While we had lunch there, I told Joy about what I thought was abuse at Glencoe. We agreed that we should try and do something. Before I left their place, I made a call to the Longreach School and told them that there was questionable treatment of their pupils going on at Glencoe. That was about all I could do in a foreign country. I was never to know whether that call brought results.

I tried to help Joy sort the antiques for sale. It was an overwhelming task. She was going to wash every one of those pots and dishes before selling them. With a tub of water in the shade of the house I started on the cream-coloured enamelware. Soon I was almost as hot as I was in the outback. The air nearer the coast was very humid. She would need a whole crew to do that kitchen alone. Joy was to drive me to Rockhampton the next day to start my journey home, and I regretted that I could be of no further help. On the way there, we motored through the Great Dividing Range, of which they are so proud—hardly bumps compared to our Rockies.

Rockhampton is a prosperous seaside town of lush gardens, flowers, a large zoo, and the beach. At the zoo I held koalas. They were the first I saw and I was thrilled. Of the birds, I'd seen all except the cassowary, and so many lorikeets in one place. The plane was due much too soon.

Joy and I shed a few tears as we parted, and I thanked her for taking the time to entertain me when they had so much to do. We knew that there was a very good chance that we would not meet in person again. They would be moving soon closer to the coast, and I would be back in Canada.

I changed planes in Brisbane and went on to Sydney. At Sydney I got into a dangerous situation due to my limited travelling knowledge and stupidity. It was dark by this time, and I knew that my plane from Sydney wasn't leaving until 6:00 the next morning. I thought I was at the International Airport, but I was not. No one told me that there were shuttles to get there, so I looked for a place to stay. I didn't know also that the domestic airport was in a questionable part of the huge city of Sydney.

I ended up in taking a taxi to a hostel and carrying my entire luggage a block. People were asleep on the street, so thick that you had to step over their legs. The proprietor at the upstairs hostel told me to stay inside at that time of night in that part of town. I prepared supper from a few junk food scraps there in the messy kitchen. There were both males and females in the common sleeping room. The bathroom was up another floor. She told me also that I needed to be all the way across the city. She phoned a taxi for 5:00 a.m. to get me to the right airport. He said he'd be at the taxi stop a block away. The woman from the desk left and no one came to take her place.

This was a big very old and run-down house. The tall windows were pushed up as far as they'd go to catch what wind there might be. The flimsy curtains flopped in the breeze outside. My bed was near the window where I could look down on the messy back alley. The climate in Australia makes it comfortable for many street people.

Since there was no supervision and the clientele were young, they were coming and going until late. I stayed sleepless most of the night because I didn't trust that woman to wake me up. I had my wallet under my head. The young people were very nice to me; they were all travellers with only backpacks. They said they stayed in hostels wherever they went, and this was not the best one. They must have been curious about me, an older woman all alone in this part of town.

Next morning, without breakfast, I lugged my considerable luggage around the corner in time to catch the taxi, and ride cross the city to the International Airport. As soon as I was safely on the plane, I laid my head down and went sound to sleep, relieved to be going back to Canada. That was my only really serious mistake I made in travelling twice to Australia. I wasn't sure that I'd tell anyone about it.

After flying all day and half the night over the Pacific, we landed in Vancouver late at night and changed to Air Canada for the rest of the flight to Calgary, where we touched down in a snowstorm. Back at Twin Butte, there was two feet of it. I hired a grader to plough my yard. My car was entirely covered with a snow drift. I pulled my luggage to my house on a sleigh and dug a trail to the door. From roasting under the burning Australian sun, I was plunged into the frigid temperatures of a southern Alberta spring snowstorm.

Jayne texted me often after that, always complaining about Dick. Finally, I told her that it was up to her to do something about his abuse. That was the last I heard from any of the family. I often wonder what became of the kids. Korey was such a loving little boy. Only his language was not delicate. One day he referred to his dad as a "bossy bitch." He always followed what he'd say with, "Don't you know?" in his priceless accent. He loved me and I missed him. The other three, influenced by their environment, were fast becoming bullies like their dad. Ben would be off to boarding school. He told me that when he got away he was never coming back until his dad was gone. I asked him, "Why are you so rough with Korey? He's just a little boy." "I'm making him tough," he said, "so that he'll survive after I'm gone."

I thought that Brian had had enough of Canada, but he returned the fall of 2001 and stayed for six months of fall and winter, the likes of which he hadn't imagined. He learned to put on warm clothes. He wouldn't listen to my advice. He tried to cross-country ski but didn't really catch on. When spring came, he biked to the Dakotas to see the location of Custer's last stand. He attended many native pow-wows. He was as fascinated with our natives as I was with the aborigines. We did a four-day trip riding the trails among the spectacular hoodoos of Writing on Stone Park, camping on the shores of the lazy Milk River each night. I took him with me for a week when I went back to the Castle River country outfitting with Mike Judd.

Soon after his six months were up, he left for Australia. The novelty of living with an Australian had worn thin. I had grown weary of him over the long shut-in winter. It was time for him to return to his family in Western Australia for good. We had both

met our goals and accomplished what we set out to do—more than I ever hoped.

I started a book of memoirs. At this stage, writing was just a dream, but I had always dared to dream. I began to think about seeing more of my own country and what it had to offer. I realized how little I had seen. I'd succeeded in taking the longest plane ride of my life, and survived it not once but twice. I could handle any airport now, and my sights were on eastern Canada.

A Man And His Boat

I left Calgary airport on October 3, 2004, for Nova Scotia in eastern Canada. Since the skies were clear and the season late, I enjoyed a smooth ride. Gazing down on our huge country of many lakes and dazzling fall colours, I was proud to call this great nation my home. Dave Manzer had agreed to introduce me to the wonders of sailing. Being a landlubber, I had no idea what I was getting into. I made up my mind to trust Dave, as I had through the muskeg in the Willmore Wilderness.

It had been four years since I'd last seen him. The cowboy that I knew now sported a fedora, loafers, baggy white pants instead of cowboy boots, and a hat—a remarkable transformation into a sailor. I would share his passion for sailing for the next eight days. I was afraid of water and I'd never learned to swim.

After friendly hugs, time dissolved, and we were the same buddies as we had formerly been. We commented on how we had both aged; my hair was grey, and he had lost a finger to the

machinery in his blacksmith shop at Peers, Alberta. "Luckily it's on my right hand," he said. "I can still play my guitar."

How better to start the week than to get in a wreck? Dave lost his parking ticket, trapping us in the parking compound. We searched all parts of the car and his body but it looked like we would have to pay the daily rate—twenty dollars for less than one hour. But as we drove away, he had a lapse of memory and forgot whether he had actually given the girl the money or not. I would have driven off, but he went back to where he had originally parked the car and searched the car and the ticket office thoroughly. Finally, I got out, searched the back seat, and found the ticket by my door. The problem should have been solved, but did he or did he not give the girl twenty dollars? He had turned the ticket in and now he should be getting the twenty dollars back. She kept no record and her memory was just as short as Dave's was. I felt like I was back in the Willmore Wilderness remembering where he last dropped his gloves, or placed his hoof nippers or bridle.

I sat in the car for a good hour while he, the girl, and the management tried to find out whether he had paid the girl the twenty dollars. Dave was determined to settle this matter fairly for all. Finally, the manager shut the booth down while they tried to trace the money. Then they decided to forget the whole thing and we drove off, still puzzled. I was definitely back in the company of the outfitter I knew so well four years ago. He had a reckless side to him, and this was going to be an interesting adventure.

I thought again about our experiences in the Willmore—like the time at Grande Cache, when I'd driven eighty miles round trip to pick up Dave's bridle from where it lay on a log at the Big Berland. At times like this, the wrangler, Jeff Person, would say, "I

can't believe he did that!" I was happy again that David Manzer's cowboy had transformed into a sailor.

Dave was driving his stepmother's car. I soon realized that his fast driving habit was not reserved for the Willmore. I mistakenly thought that his quickness was due to the long distances between places up north, but now I found that he drove just as fast here. In his haste he took wrong roads and had to turn around and find the right ones. I wondered how many times he must have travelled this road from the airport to his folks' place at Bridgewater—or had he travelled on the water more than on land?

"Your driving hasn't improved a lot," I commented.

He replied that Mary Isabel didn't drive fast enough to remove the carbon from the motor. "Only doing her a favour," he said.

Dave took me to a nice restaurant on the Halifax Harbour, where we caught up on the latest and ate some very good fish and chips before we went to his friend Dave De Wolfe's place. This other Dave was a real boat enthusiast. The wife and I had tea and conversation, while the men discussed and exchanged boat parts that Dave De Wolfe had ordered for Dave. I wanted to know both of them better. Apparently it was from De Wolfe that Dave had gotten his boat.

After that first visit, we went on to Dave's father's house at Bridgewater. I felt that they knew me—they were that friendly. Murray, Dave's father, was eighty-nine years old. He had a gentlemanly air about him in his dress and manners. His wife, Mary Isabel, was sixty-six years of age. She obviously loved him, and the age gap made no difference to either of them. Theirs must have been a lovely life together. Dave told me of their love story that went on for years before their marriage. She had not caused

his divorce, but had been there to pick up the pieces to their good fortune.

After lunch, we went down to the boat. The Coriolis III would be our home for the next week. We slept in the boat that night. I was in the bow. I had room for my sleeping bag in the V shape. Dave slept on a bunk in the cabin proper. He couldn't wait to explain all those gadgets and gauges on this boat that had become his home. I slept very well, knowing that this would be a great adventure.

My favourite spot on Dave's boat.

I was content to be back in Dave's company, and determined to trust him. I knew I would lose control once that boat left the wharf at Bridgewater. We both made good use of their shower, because for the next week we would be without. A barge went

by in the night, the waves moving the boat enough to wake me. Thinking I was at home in our part of the country, I thought it was the wind.

The next morning, I applied a small medical Band-Aid behind my ear to deal with the seasickness for the first eight days. We went for breakfast at Murray's house, just up the beach from where the boat was tied up. Dave made coffee with the same cappuccino machine that he used in the Willmore. It brought special memories of a time that was now history in both of our lives.

That day we scooted around Halifax doing Dave's business. We went to several marine shops, where everything was foreign to me. Dave, always the teacher and in his element, took time to explain the equipment. Like when I was in Australia, it was all new. We had a good look at Peggy's Cove, where I would have liked to stop and photograph, but Dave was on a mission. We parked and walked to shops in the old part of Halifax, where there were brick and stone buildings and narrow streets, the doors one step from them.

Ever the guide, Dave took me to Halifax Harbour and explained the workings of the different boats and ships. I never thought I'd be so interested. When we got hungry, we had chowder and fish cakes at a seaside shop—the best I'd ever tasted.

Having done all we could for Dave, and crossing the two big toll bridges over, to, and back from Dartmouth, we went back to Bridgewater. The scenery here was a place I'd like to be lost in for a week or two. There was rock with all its colours and lichens, combined with the greens of pine trees and changing colours of autumn. I wanted more time there in that photographer's paradise; this time I'd settle for just seeing it, and would get on with this sailing venture.

Finally, we loaded our belongings into the boat and were off down the LaHave River, headed for the ocean. All along the shore, there were brightly painted dwellings and boats tied up.

Dave told me about every new one as we passed. These people had a fascination with Wimbledon chairs, and we saw their bright colours all along the shore.

All was quiet until we entered the ocean, and we got into the big swells and stronger winds—just what Dave needed for his sails. I was frightened and wondered what I'd gotten myself into this time. Clinging to the lower side and leaning to the upper, I was sure we were turning over.

"Is this the way this whole trip is going to be?" I asked. Dave only looked amused.

After he got the adjustments made for the conditions, he explained all that he was doing and how the boat was built to stay upright. From there on I was resigned to trust this man, as I had in the Willmore Wilderness.

Most of the day we sailed past islands and shorelines until we came into Lunenburg Harbour—and it was beautiful! We sailed along its length so that Dave could tell me about tall ships and smaller fishing boats. Lunenburg is a beautiful place, with brightly painted old buildings all built on a hillside leading down to the sea. A replica of the Bluenose was being built in the harbour. It would take years of building, and much expense before Bluenose II would set sail out of Lunenburg Harbour I was fascinated with the old rusting ships that served as tourist attractions, their usefulness long since passed.

We found a vacant spot and tied up to have our first food since breakfast, after which we went over town to explore and shop for groceries for the next day. It got cold with nightfall. When we

returned at nine, we turned on the heater that Dave was so proud to show me. We wanted for nothing on this boat.

While Dave was away on business, I went walking down to a place called Blue Rock. The vivid fall colours on the dark rocks and flora of many concentrated shades made me gasp in amazement! All too soon, I had to shoulder my camera and return to the town proper, where I lugged my aging body up tiers of steps to observe those grand old houses with the protruding entryways called bumps.

Dave barbecued on the boat that night and later played his guitar and sang, reminding me of the wonderful adventures we shared outfitting. He told me then of his serious health conditions, and I sensed with regret and deep sadness that we'd never ride horseback together again. I found myself encouraging him to sell his beloved outfitting business and spend his quality time sailing. I knew he was planning to sail as far as he could down the southern coast of the United States and on to the tropical islands. Only an adventurer like Dave would attempt such a feat alone.

The next day we sailed past Indian point, with its boats, settlement, and a mussel farm. Now Dave was teaching me to steer the boat while he handled the vast system of pulleys and clamps designed to move the heavy sails.

In late afternoon, we sailed into the harbour of Mahone Bay, a lovely little seaport where the people had gone all out to put up life-sized scarecrows all over town—five hundred of them. They were part of a festival with boat races. We'd been sailing all day with only deck snacks. This time Dave dropped anchor out in the

bay—a process I felt had been done to enhance my sailing education, but it turned out to be a ploy to escape the tie-up fee.

That night Dave barbecued steak, which we bought and kept in the ice box from the day before. We enjoyed fried mushrooms and mussels for appetizers. For dessert we had bagels and cheese smothered in maple syrup and topped with sliced banana. We slept bobbing among the beautiful sailing boats, the pride of their owners.

We woke in a wonderland of reflections—sailboats, three lovely churches with towering spires, and scarecrows at every house and place of business. Dave had chosen this experience to impress me, and it had worked. We'd been living this life for five days, and I was not eager for it to end anytime soon. When we moved over to tie up at the harbour, I took my camera and went to town to photograph those intriguing scarecrows. What a remarkable sight! These people didn't do things halfway. I burned up rolls of film and walked until my feet would take no more.

Late afternoon we sailed out of Mahone Bay, past little and big Tancook Island, with favourable winds along the coastline. Ferries passed between the islands and us, causing huge waves. I was standing in my favourite perch at the far corner of the boat.

"You might want to sit down for this," Dave said. I dropped down onto the bench and hung on, expecting something dangerous. The boat rode the waves, jerking roughly from side to side. I didn't know normal from dangerous, but I did know about safety, and we were not wearing life jackets, nor did we for the whole trip. I thought I'd seen them once in a tangle of Dave's possessions under his bed. I knew that Dave could be careless, but I was happy that we hadn't had to wear those bulky things, so I said

nothing. I knew now that Dave's cancer was terminal, and for one last time I'd do this his way—without complaint.

Dave let me steer the boat down a narrow channel between markers, into a lovely little bay, where there were only a few small buildings. The reflections of the coastline rocks at low tide resembled large crustaceans in the water. This was the last time that Dave, in all likelihood, would sail into these lovely places. I was so elated that he chose to bring me here in these uncertain times. We dropped anchor out in the bay and talked long into the night. I wished that I could go with him when he next sailed out, and I told him so. It was not to be. This could be a long, dangerous trip in uncertain waters.

We had pork chops, salad, cheese and yogurt for supper that night—a very good visit, in which we talked about Alberta. He showed me a picture of a pretty young girl there who was more than just a friend to him. He told me about her unfortunate life of abuse, and his efforts to help her. He told me also about the horrifying accident in his shop in Peers, Alberta, where he lost a finger on his right hand. He had some trouble with the ropes and clamps.

Next morning, Dave woke me to appreciate and photograph sailboat reflections, the beauty of which I could hardly believe. "A sailboat is the most beautiful thing in the world," Dave said.

As the sun warmed the air above the water, a thin fog hung over the bay, giving it a mystic quality. It was warm in the bay, but Dave warned me about the cold morning air out on the ocean. Rounding the corner out of the bay we found ourselves in a different climate altogether. The spin drift lashed at our faces and the cold wind reminded me of our Alberta winds.

The wind and waves were much rougher than when we first sailed into Lunenburg. We were to pick up Dave's sails, part of his preparations for that long trip. They were being repaired. Out of the rough ocean, we saw porpoises surfacing. I was watching for my first sighting of whales, but saw none.

Back at Lunenburg, we went to see some friends of Dave that he'd taken out in the Willmore. They took us to a lovely old house used as a restaurant. The meal was very ritzy and expensive with several courses—squid, lobster, oysters, and more entrees. I tasted them all, even frog legs. Dave had lobster and kept shovelling it into my mouth. I wondered how either Dave or I were going to pay our share of this expensive meal. Dave, sensing my discomfort, whispered to me, "They're paying." Lucky, as the meal was about four hundred dollars. Five bottles of good wine were somewhat responsible for that. Ours alone came to nearly two hundred dollars. This was not my idea of a dinner out.

After the lengthy meal, they invited us to their house, where I got a good look inside one of those lovely old three-storey buildings. They proudly showed us around, and Dave regaled us with music on a guitar they had. We walked back down the hill via steps to the waterfront. Dave was a connoisseur of gourmet food. I was not.

The next day we had breakfast in a hurry, and got out of the harbour before the caretaker came to collect the twenty-dollar tie-up fee. This was the "old" Dave that I loved. The seas were even rougher as we made our way in the general direction of the LaHave River and Bridgewater, where our trip would end with a Thanksgiving supper.

We pitched and rolled with the waves all the way along the coast until we reached the milder waters of the river. Still, the wind made it possible to use the sails partway up the LaHave. I steered the boat and he jibbed the sails. I learned a great deal about this boat, the Coriolis III, and the south shore towns of Nova Scotia. More importantly, I came to know the sailor, Dave Manzer. I went back to the boat with Dave that night to sleep, content to sway with the waves one last time.

The next day, I expressed my gratitude to Dave for this and all the wilderness adventures he'd made possible for me. We parted with hugs and good wishes for the future. Dave did sail his boat to the tropics, where he became ill. He died at Edmonton, Alberta, on January 5, 2006. He was fifty-eight years old.

Closure Denied

In 2005, I seriously began to write my childhood memoirs, resulting in publishing *Washing at the Creek*, the story of my Métis childhood. It came out in late 2008 when I was recovering from my second knee joint replacement. It was an awkward time when I was using a cane and in considerable pain. I limped into the municipal library in town, did a reading, and with overwhelming pride, launched my first book. My proudest moment came when I finally held it in my hand and gazed down on seven years of gathering information and organizing it.

My friends and family came out to support me, and with Pemmican Publications out of Manitoba, my sojourn into the world of writing became a joyous one.

I traveled to some of the places that I most desired to visit in Canada. Many people that I met in those years became lifelong friends that bought joy and enrichment to my life after years of unrest.

Time was important now; the autumn of my life was upon me. For the first time I felt weariness creep into my body. I was getting tired.

On October 30, 2006, I walked into the St. Michael's nursing home in Lethbridge, Alberta, knowing that I was here to bring solace to my husband of fifty-nine years, who was about to take his final journey to his eternal rest. His seventy-five-year journey on this earth had been thirty-seven uncertain years, dogged by unexplained illness, followed by thirty-eight years in a succession of nursing homes in a wheelchair.

He'd never again use the wheelchair that sat idle in his room. Somehow I found that comforting. He was in a light coma and would soon be in a heavy one. He greeted me with a slight smile, his last sign of recognition. He had always loved me, and I him. But for the hand of fate, we would have grown old together. I held his invalid hand and felt profound sadness for his suffering over the years. I thought about our short life together in our home and the happy times. So much of our young lives had felt the effects of his debilitating and mysterious illness. Our children had suffered the loss of their father at such an early age. It had been hard for any of us to understand. I had to be strong for them, even now.

Diseases were identified and diagnoses discarded. It seemed like so many of my questions about his health problems would go unanswered. At this point there was no closure. All I hoped for was an end to his suffering and the strength to pick up the shattered pieces of our lives together and carry on in peace.

After a few hours, our fourth child, Lana, forty-three years old, arrived to spend her dad's last hours with us. Having not seen death, she was understandably shocked by his heavy breathing

and appearance, but she put on a brave face for the sake of all involved. For the rest of that day and night, one of us remained in the room while he faded peacefully from life.

,Next morning, Wayne, now forty-seven, arrived for his dad's very last hours. What a comfort it was to have them there for support until he drew his very last breaths. A nun looked in often and a priest gave him his last rites. Ed was always a devout Catholic and he would have wanted it that way. I had long since given up any faith I had in Catholicism, but I said the prayers with them. Ed would have wanted it that way too.

I remembered how we kneeled with our little kids at night when they were too young to understand, and recited the long boring rosary. "The family that prays together stays together," we said. I guess it didn't apply to us. I was confused about religion, but I followed along to please Ed. For him, I was forever being someone or something I wasn't.

I remembered too how we diligently prayed before and after meals; no one left the table until it was done, teaching our children to take their turn in offering the prayer. All that ended when he was taken from us. I tried to impress the need for prayer on them, but there seemed no reason left for the rituals of Catholicism. I continued to take the kids to church on Sundays until they were in their middle grades. Given the choice they ceased to attend. All these memories I pondered as he slipped away.

After we made our last farewells and his body was removed, I returned to the room he had known as home for so many years. I'd kept the kids visiting periodically and taken him out for visits as often as we could. There had always been questions about the cause of his illness. He was diagnosed with lead poisoning from industrial pollution, discounted by tests administered by the very

gas companies that were deemed to have caused it. That diagnosis was very unlikely since his symptoms went back to childhood. The next diagnosis was acute Intermittent Porphyria, a disease so rare that it was unlikely. There followed years of collecting urine samples in forty-eight hour jugs—no easy task with small children. That disease kept us hostage for so many years as I watched for symptoms and tried to prepare my kids for adult life, with its debilitating possibilities hanging over them. "Hereditary," the specialist said." Maybe one, two, or all of them, or maybe none. Probably occurring in middle life."

There were precautions they could take and, if caught soon enough, prevent any acute attack. I made lists of drugs to be avoided and gave them to my four children when they grew old enough to make the right decisions. Some of the drugs their father had taken in massive doses. Testing was advised, and they were warned to avoid street drugs. With the discovery of DNA, the likelihood of them being in danger of inheriting the disease was further reduced. I asked his doctor, who attended at the last, "What do you think was wrong with him?" She gave me an incredulous look and replied, "Didn't you know he had schizophrenia?"

No, I did not know that! It was news to me. Even though that one word summed up the situation that I found myself in before we were married, and for ten years after, there was still no reason for the very apparent brain damage.

I was not satisfied. "Is there any chance that an autopsy might reveal something else?" I asked of the medical director. He said, "It will show only brain damage, not the cause." Still, I felt that I had to go through with it, on the outside chance that it may just reveal something to help my children and me finally get some

closure. Seeing the autopsy in writing might offer me the only closure that I could expect in my lifetime. But it told me nothing except the extent of the brain damage.

The diagnosis of schizophrenia was sufficient for me at the time, but what of the positive tests for that mysterious disease? What also of the small, useless kidney removed while he was in the nursing home in Lethbridge? Did he have kidney disease when he was a child? There were far more questions then there were answers.

The kids were too young to know his mood swings. I'd shielded them from the effects of his illness on our home life. I told them only of the good times. In their childhood memory he was a mystery. In their adult life he was a stranger.

Could schizophrenia have been the reason for his delusions of persecution and fits of jealousy? Was the brain damage caused by the medical world that plied him with drugs and shock treatments? I turned to the Internet for answers. I looked up ECT, electroconvulsive and insulin coma therapy, which I'd seen Ed subjected to over and over again in Calgary.

What I found was a horror story of treatments with brutal histories. It seemed that the '50s were popular times for experimentation. It also seemed to depend on which part of the brain was altered. Was he the victim of the uninformed use of treatments not well enough understood then or now, and the indiscriminate prescribing of mind-altering drugs? I was an ignorant kid when I embarked on what I thought was the perfect marriage. I didn't know anything about sickness of this magnitude. Was what I was led to believe was a slight nervous problem actually mental illness? With his death, another part of my bittersweet journey through life came full circle with little closure but some peace.

The suffering was finally over for him. I had to accept that the mystery of his illness would never end for me. I'd been able to provide my children with what I thought was a measure of security by hanging on to the land and giving it to them to assure that they'd have a home base. To some I sold more land to give them a better chance to make a living at ranching, and I moved out of the home where there had been so much strife and happiness on a bittersweet roller coaster. Besides loving them and being there for them if they needed me, I could do no more. Age was catching up to me. I still had dreams. I would work on becoming a better writer and enjoy my family and many friends.

The Last Loop

On September 15, 2007, I was seventy-one years old, and my horse was twenty-four. I had one knee joint replacement ten years before, and one still on a waiting list. My back was not so good either. The doc said the cartilage was drying up, just like in my knee joints. Strange that whenever I got on a horse, I felt ten years younger. My mind just had not kept pace with my body.

I still had my horse trailer. Like me, it could have done with a few more repairs. I chose to procrastinate on both matters—after all, I was just doing short hauls these days. My old 1981, 4 × 4, three-quarter-ton truck had little paint for years. "Still the best truck in the country," I insisted. It took me an hour to hook up because the emergency brake didn't work and it kept sliding off the ball.

Spinner was getting gimpy, but now and then I pulled him out of retirement and tried to bring the past back, for even one day. He had spent twenty-two of his twenty-four years climbing mountains and making it possible for me to live the good life.

Now our rides started with a shot of "bute" (phenylbutazine, which killed the pain in his joints) and a generous serving of extra-strength Tylenol for me. However, with the promise of good weather and all this great riding country at my back door, I was feeling exceptionally young this day.

Spinner, one of the best horses I ever raised. He was twenty-eight here and still beautiful.

On the extreme northern bound of Waterton Lakes National Park, there's a trail that few people know as well as Spinner and I do. It's a round-trip. In trail riding language, that means that no part of it is traced, and you end up where you started. This one we call The Horseshoe Ride. It goes around a mountain and presents some of the wildest and most varied terrain that I've been fortunate to encounter in all my years of riding.

Spinner and I made this loop dozens of times, but that day there was at least one problem: no one seemed to know when the last riders used that part that we call the Indian Trail, or if our park trail crew had cleared it of downed timber recently. If I went alone, I wasn't exposing anyone else to the troublesome deadfalls and danger on the trail.

I'll just truck up to the gravel pit and ride up there and look at that trail. If it's too bad, I'll come back, I lied to myself. I can't readily recall when I've ever turned back because of the trail; there's always a way around, under, or over the dead falls—risk is a necessary component of backcountry adventure.

The Indian Trail, it is said, was used by the Stony Indians years ago. It was their route from farther north, down onto the prairie to gather berries and hunt the buffalo. The trail, or sometimes lack of trail, winds its way up the side of a timbered mountain—often only a game trail—sometimes following paths cut out by the park trail crew. The game trails that snake their way around and over the Rocky Mountains crisscross one another, following the path of least resistance, and fade away without warning. They are more likely to lead you astray than be of any use. In the big timber, the deadfalls are often impassable.

Once you've navigated that trail and descended to the big flat below, there is evidence of a well-used campground having been there years before. Buffalo bones and flint arrowheads sometimes surface on mole hills. Old timers that no longer live told me that the Indians shoved the buffalo from Oil Basin over the top, where they were ambushed by hunters on the other side and butchered on the flat where the women were camped. It all seemed feasible

to me. I relive the scene every time I do this loop. It is a place where my imagination runs wild.

Still other trails led them past that huge body of water, Waterton Lakes, over what we call the Stony Indian Trail, south to Chief Mountain country and the plains of Montana in the United States.

Today I intended on doing the loop in reverse, if indeed I could get up the Indian Trail. I heard rumours of the park trail crew clearing it of dead timber. I hoped for that eventuality, even as I mistrusted the source of the information.

Now at the staging area in Oil Basin, Spinner was on to my 'bute' treatment, and he didn't like the taste of it. At just the right time, he flipped his head and sent a syringe of it off into the air. I refilled the syringe and deposited a good amount onto the snaffle of his bit, and before he could get a smell of it, I shoved the bit into his mouth. He nodded his head a few times and accepted that he was duped.

I mounted and rode into the park, past the last gates—the last until I returned. Crossing the Boundary Trail, we slipped into the deciduous forest, where the pungent smell of autumn was beginning to replace the hot spiciness of summer. The trail disappeared in the tangled undergrowth of mountain flora, but Spinner knew where to go, and he took me out of the poplars and along the game trails with only a branch or two that we easily avoided, even as we were warned of bigger ones ahead. At the bottom of a slippery rise in the terrain, there is a small muddy pool where wild animals come to drink. I stopped to check the tracks there— deer, moose and hopefully not bear. Only bear tracks there could make me backtrack now. The thick bush above the pond is not the place to be when a bear is in the vicinity. Spinner snorted and

pussyfooted around the pond. There were moose tracks all over. They and bear are all the same to him—terrifying! He didn't really want to go on, but he did as he is told.

"Come on, Spinner, we made it this far. If we can get to the top, we'll be okay." If he could talk, he probably would have said, "Don't be stupid. We should go back and take the switchbacks into the horseshoe." But I was stupid. I had been stupid many times, and always Spinner knew better. He had managed to get me through all the hellish places that I forced him into.

Up the slippery mountainside we went. Wild cow cabbage reached as high as my saddle horn. It was always dark and cool in there. The rocky, open spots were behind us now, and the musty forest extended ahead with no sign of a visible trail. Spinner parted the lush leaves of the cow cabbage with his chest and followed the trail that I hoped was below—and he knew it to be.

The first deadfalls laid across the trail in a tangle of crisscrossed timber, some two feet in diameter. Spinner turned around sensibly. I turned him back, much less sensibly, and looked for a way around the mess. Every place I looked there were deadfalls, or it was too steep to climb with a horse. So I searched for the path of least resistance and persuaded Spinner to jump over some big logs by leaving him on one side and proceeding on foot. He didn't like me to leave him alone in the dense bush, so he clambered over to join me. After a few more such obstacles I deemed us past the point of no return. I was now completely off the trail and didn't have any idea where it was, only that we had to keep going up.

Encountering a bear in that thicket, where we couldn't escape in any direction, would be downright dangerous. To go back was no longer an option, since we were now closer to the top than

the bottom. I checked the cell phone that everyone told me to carry—no reception. "Screw that," I told Spinner. "I guess it's up to you."

Climbing back onto him, I released his reins so that he could go wherever he wanted. When I nudged him, he tried to go in a direction that I would never have chosen. Soon he stopped—another deadfall. I found our way through and around it and let him choose the direction again. We had now taken an hour and a half to go where it should have taken twenty minutes. After struggling up a steep bank that I'd never seen before, Spinner stopped short. There at his feet was the trail that I was not smart enough to find. He wanted to know whether I wanted him to go back down or continue to the top.

I sat there for a while enjoying the wave of relief and thankfulness that was now seeping through me. I was in a dangerous place a few minutes ago. I was now sitting on the trail, only by the grace of God and a good horse—not because of my good judgment.

But there were still hours left to get around this loop and back to my truck and trailer. Apparently no one had been over that trail since two years ago when I was. It was difficult even then, and I had to make it off this mountain, across the big flat and through a river bottom that was always difficult.

The beauty of this wild side of Waterton Park, where very few venture, is stunning in its pristine state. How many times have I been told not to go here alone? I could not think about that right now. I thought only of the satisfaction I'd feel after doing it again one more time.

When we cleared the timbered side of the Indian Trail and emerged into the clearing on the hogs back, I glanced out over the river territory and wished we could fly over it and land on the

far bank. Then I could make the turn at the toe of the horseshoe and head up the long valley over another summit and back to the prairie. But we could not fly, and that river valley was between us and the trail home.

On the way down the mountain, Spinner pussyfooted around fresh bear sign. A pile of their crap and the actual bear are both the same to him. I can almost hear him say, "Let's get the hell out of here."

"We will Spinner, as soon as we can."

He doesn't appreciate my fascination with this wild place. He doesn't approve of my study of the bear scat for signs of what they are eating—this time the berry of the twisted stock and the bracketed honeysuckle. I chewed one of those luscious-looking honeysuckle berries that I found growing on the trail—once. It was so bitter that only a hungry bear could appreciate it; it is not recommended.

Soon we emerged onto the flat ground, where, in my imagination, smoke curls from tepees and Indians butcher buffalo, while noisy children chase through the trees and bend to drink from the cool spring water that trickles down the little coulee the length of the big flat. I watered Spinner and kneeled down on my sore knees to scoop water into my mouth and over my face. Refreshed and determined, I continued down the flat and into the bush at a place chosen by Spinner. The next stretch, I knew, was difficult, but we had to move on since we had not yet reached halfway.

The direction that Spinner now took was through thick undergrowth—no visible trail. We stumbled through it and down to the creek. A small waterfall dumped a clear stream from a beaver dam down about five feet into the creek. Down it we slid, rolling

rocks along with us. I always thought that was a likely place to break a horse's leg. I held my breath and controlled Spinner's speed so that he would take care.

The sun, directly overhead, told us that we'd taken the better part of the morning to decipher the Indian Trail and reach the halfway point. It was time for some lunch, but Spinner wanted out of here. In moose country he showed his displeasure by whistling through his nose.

We had another creek bank to make, and I hoped that the wild animals had used the bank for a trail. Steep and slippery, there it was—cut down a little by the sharp, cloven hooves of moose and elk. We were doing just fine until I noticed the big red shale bank ahead. It had slid into a mess of unstable shelves. The place where we once sneaked down its steep outer rim was unrecognizable. If we could get up this, we would be home free.

I could not ask Spinner to tackle that impossible shale bank. Our only chance was to get around it. I started him up the steep rocky mountainside, glad that we were alone. How would I ever have gotten a group of riders over all that we'd endured so far today? The thought of that actually made me feel like I'd done something right. Probably tiring, Spinner, levelheaded and careful, placed one foot ahead of the other and slowly clawed his way to safety and the trail that opens up onto the long ridge, where we were safe at last.

I dismounted and sat on a rock to empty the dry pine needles from my pockets, pants, saddle bags, camera bag and from down my neck. I looked over the rough beautiful country we had managed to conquer one more time—probably the last time for both of us. It was past time for some lunch, and then we'd start around the toe of the shoe in much more hospitable terrain.

In the long valley of fall colours, I dismounted to photograph the burnt reds and oranges of the low shrubs. My back was seriously stiff and sore, and Spinner was favouring his left leg. From my saddle bag I took a tube of "Bute" and a sizable bottle of Tylenol. By the time we made the switchbacks to the summit, fatigue was our biggest problem, and we were still about two hours from our rig.

Late in the afternoon, we stumbled into the clearing from where we left hours ago. Taking my saddle from Spinner's sweaty back, I poured out a double feed of oats for him and a tea for me. I was overcome with gratitude as I watched him eat, satisfied that we'd made the last loop one more time.

That trail is like my life—always a struggle, but filled with rewards and satisfaction in completing still another circle. I had to stop riding a few years later. I could no longer ride in the mountains. The arthritis in my back became more painful, and long rides were out of the question. My chief interest now is in my writing. My old horse, Spinner, one of the many I had owned, is old and retired. He packed me for twenty years through the mountains, some of the best years of my life. It is payback time for him. My saddle will no longer be on his back, and his only job is to stay well as long as possible. He seems content to eat and sleep in green meadows. I wonder, does he miss the mountain trails like I do, or has he accepted aging more gracefully than I?

I am now the grandmother of ten healthy grandchildren. Because my daughter Carmen was born when I was forty-two years old, four of them are under twelve. I was always younger at heart than my age denoted, and they help to keep me that way. When I look up at the mountains on a clear day, I pause

to remember the trails I know so well, and thank God for the opportunity I had to heal from life's strife in such a special part of His creation.